MARVELLOUS GROUNDS

"*Marvellous Grounds* is a beautiful gathering of QTBIPOC artists, organizers, activists, and cultural workers that achieve the Morrisonian [Toni Morrison's] task of creating a map outside of the mandates of conquest, specifically its homonormative archival practices. Speaking across time and space, the Marvellous Grounds collective lovingly curates visual art, prose, intimate conversations and tender caresses taking place on Toronto's street corners that have the potential to heal both the ancestors and the generations yet to come. Creating marvelous ground in Toronto, this stunning collection resists inclusion into normative and homonationalist queer Canadian archives. It also refuses to help repair this archive. Instead, *Marvellous Grounds* beautifully disfigures the colonial project of archiving as it yearns and reaches for what the co-editors call "the something yet-to-be-done." *Marvellous Grounds* is a healing praxis that QTBIPOC communities can bask in as they soak up the sweet balm it tenders. This collection is a gift."

> —**Tiffany King**, Department of Women's, Gender and Sexuality Studies, Georgia State University

"As the lead singer of the radical duo LAL and co-organizer of the DIY QT2S/BIPOC space, Unit 2, I am so happy to see this important book that highlights some of the amazing work and stories by QTBIPOC/friends in Toronto. More than half of the contributors have shared space or gathered at Unit 2, so this book resonates in my body and soul. *Marvellous Grounds* is a necessary piece of writing that documents and helps keep our stories alive, in a way that is for us by us. This book will share important perspectives with a new generation of QTBIPOCs and friends, while honouring the stories, people, and places that fought and fight for justice and freedom, in this amazing but complicated meeting place, Toronto."

> —**Rosina Kazi**, LAL / UNIT 2

"The authors, artists, and activists gathered in this extraordinary book invoke an insurgent and untameable queer and trans history, one which confronts both co-option and self-congratulation. Boldly making space for the silenced, criminalized, and displaced voices of queer and trans Black, Indigenous and people of colour (QTBIPOC), *Marvellous Grounds* disrupts queer nostalgia, complacency, and white fragility, and testifies to QTBIPOC resilience, resistance, and healing. Whether you come to this book in search of a radically transformative decolonial theory and praxis, or to reclaim a displaced queer/trans lineage, these stories are guaranteed to move, challenge, and inspire."

—**Julia Chinyere Oparah**, provost, dean of the faculty, and professor of ethnic studies, Mills College and author of *Birthing Justice, Battling Over Birth, Activist Scholarship*, and *Global Lockdown*

"*Marvellous Grounds* is an incredibly important critical intervention into the ongoing creation and theorization of queer counter archives and their frequent whitewashing. The artists/activists/academics whose work is collected here offer a multilayered, sharp, original, and touching take on queer Toronto past and present that will be relevant to scholars and practitioners far beyond the local context."

—**Fatima El-Tayeb**, professor of literature and ethnic studies, University of California, San Diego

"Upending white supremacist, neoliberal narratives of 'gay progress,' *Marvellous Grounds* shows us Toronto's QTBIPOC communities surviving and thriving in the midst of violent forces of erasure. The essays, dialogues, and creative interventions gathered here offer an invitation to remember and learn from rich and resplendent stories—of organizing and activism, of dance parties, reading groups, performances, and everyday life. This is the history we want and the history we need."

—**Craig Willse**, author of *The Value of Homelessness: Managing Surplus Life in the United States*

"*Marvellous Grounds* describes a Toronto that makes sense and feels right. It doesn't suffer from impossible racial homogeneity or glib hollow triumph. This gentle, trusting, personal collection lingers over homelessness, racial profiling, protest, worship, and the struggle of queers of colour starting families, and so is a Toronto origin story that feels real."

　　—**Elisha Lim**, M.A., M.F.A., graphic novelist, *100 Crushes*

"*Marvellous Grounds* is a compelling and transformative site of queer of colour creation and ongoing creativity, collectively confronting and refusing dominant white queer archives. Together, the essays build queer counter-archives as their own form, where writing and genealogies of thought emerge in collective organizing, art practices, abolitionist work, disability justice, poetics, healing justice, performance, anti-racism, and spirituality. In this long-awaited anthology, the authors make possible the kinds of depth and life that come from an effort to pause, and take hold of what emerges in our struggles to find new ways of being with one's self and amongst others."

　　—**Lee Ann S. Wang**, School of Interdisciplinary Arts and Sciences,
　　University of Washington Bothell

"*Marvellous Grounds* is a foundational book for gender, queer, postcolonial, and critical race scholarship. Archiving and reflecting on four decades of queer and trans Black, Indigenous and people of colour (QTBIPOC) historiography, collective organizing, cartographies of violence and building communities of care and healing in the city of Toronto, this inspiring book is a must-read for activists, artists, and academics alike who radically question who the subject of queer history is and more importantly dare to ask "What kind of ancestor do I want to be?"

　　—**Onur Suzan Nobrega**, Institute of Sociology, Goethe University,
　　Frankfurt, Germany.

Marvellous Grounds

Queer of Colour Histories of Toronto

Edited by Jin Haritaworn, Ghaida Moussa, and Syrus Marcus Ware

Between the Lines
Toronto

Marvellous Grounds

First published in 2018 by
Between the Lines
401 Richmond Street West
Studio 281
Toronto, Ontario M5V 3A8
Canada
1-800-718-7201
www.btlbooks.com

Library and Archives Canada Cataloguing in Publication

Marvellous grounds : queer of colour histories of Toronto / edited by Jin Haritaworn, Ghaida Moussa, Syrus Marcus Ware.

Includes bibliographical references and index.
Issued in print and electronic formats.
ISBN 978-1-77113-364-7 (softcover).—ISBN 978-1-77113-365-4 (EPUB).—
ISBN 978-1-77113-366-1 (PDF)

1. Minority gays—Ontario—Toronto—History. 2. Minority gays—Political activity—Ontario—Toronto—History. I. Haritaworn, Jinthana, editor II. Moussa, Ghaida, editor III. Ware, Syrus, editor

HQ73.3.C32T67 2018B 306.76′608 C2018-902798-3
 C2018-902799-1

Text and cover design by David Vereschagin, Quadrat Communications
Printed in Canada

We acknowledge for their financial support of our publishing activities: the Government of Canada; the Canada Council for the Arts, which last year invested $153 million to bring the arts to Canadians throughout the country; and the Government of Ontario through the Ontario Arts Council, the Ontario Book Publishers Tax Credit program, and the Ontario Media Development Corporation.

Contents

Marvellous Grounds

An Introduction

Jin Haritaworn and Ghaida Moussa, with Syrus Marcus Ware

On May 28, 2016, activists, scholars, and artists gathered at the University of Toronto for a day-long symposium entitled *Paper Trail: The Legacies of The Body Politic,* marking the 45th anniversary of the paper's founding. White queer historians, activists and some founders shared largely congratulatory reflections on the *Body Politic's* impact and historical importance, performing a distinctly white version of the public archive that has become recognizable as queer Toronto. Few speakers offered critical reflections on the ways that anti-Black racism repeatedly played out within the paper's content and collective publishing process, e.g., a 1985 advertisement in the paper by a white cis gay man calling for a Black "houseboy."

At the time, the ensuing controversy became a catalytic moment of consciousness raising within both the *Body Politic* collective and Toronto's wider queer community about racism, classism and the sexualization of Black and racialized bodies. As David Churchill[1] chronicles, the collective's members met for three hours with community groups, including Lesbians of Colour, Zami, and Gay Asians Toronto, to discuss why the ad was offensive and had no place in the paper.

During the symposium, talks by Rinaldo Walcott, Lali Mohamed and Syrus Marcus Ware contested the evening's celebratory and nostalgic tone. Both Mohamed's and Ware's talks called the work and organizing of Black activists and ancestors (including that of Black trans women Sumaya Dalmar and Monica Forrester) into the room and into the conversation about what

rises to the status of a queer archive. They highlighted how queer archives celebrate white queer subjects as the only historical subjects and erase queer and trans Black, Indigenous and people of colour (QTBIPOC), thereby treating us as perennial newcomers with little historical agency and oversight of our own.[2]

In the question period following these talks, there was a dramatic backlash from white audience members who responded by explaining that the *Body Politic* had been under pressure at the time, facing raids and homophobic backlash, and there had simply not been time or energy to "address everything." These comments excused the lack of racialized content by imagining queer content as essentially white. They also ignored the very real issues facing racialized queers, many of which already existed at the time.

For example, LeZlie Lee Kam's chapter in this book discusses frequent raids and harassment against lesbians and gay men of colour in the 1970s and 1980s, leading to a lesbian-run protest outside the police station at Dundas Street and McCaul Street in 1977. The Black community, meanwhile, was facing ongoing attacks by the police. Is it a coincidence that the alliances Black queer organizers formed then gave rise to an abolitionist movement that outlived the brief period of white queer antagonism with the criminal legal system?

Around the same time as the *Paper Trail* symposium, the distance of many white queers from their anti-carceral history was brought home by their violent responses to Black Lives Matter Toronto (BLMTO) actions against police racism and its pinkwashing. In the same tradition of Black queer revolt, BLMTO resisted the Toronto mayor's apology for the 1981 bathhouse raids, as well as the presence of uniformed police in the 2016 Pride parade. They enacted a very different queer genealogy, where Stonewall is remembered as an abolitionist moment led by Black and racialized transgender women.[3]

The *Marvellous Grounds* collection renders problematic the ways in which dominant queer historiographies archive and remember white queers as the heroic makers of history. These whitewashed and supposedly impartial records of history leave out the longstanding contributions of nonwhite subjects and communities to queer life, art, political organizing, and spaces in the city. Out from the fabric of time and space, they rip racialized and colonized folks, whose ever-evolving attempts to intentionally name ourselves

and our complicated and sometimes conflictual relationships with each other currently take the shape of "QTBIPOC" (queer and trans Black, Indigenous, and people of colour)—the acronym used by many of the contributors to this book.[4]

The resulting white(ning) queer archive disappears us from the origin stories of queer life—from past accounts of art, research, and activism. In the event that QTBIPOC are mentioned at all, we form the check-mark-diversity objects of white queers' benevolence. We are "there" not because we fought to be part of the struggle, let alone lead it. Our incorporation is a gift, and the achievement of white people, who remain the only makers and recorders of queer history. Our exclusion and inclusion thus work together to assure that we remain strangers to the white queer archive, mobilized, modified and "improved" in the service of a Eurocentric story of time and progress.

Regardless of these politically correct gestures, the archive, understood here both in a Mbembian[5] sense—as the house that stores historical documents—and in a Saidian[6] sense—of the colonial canon that socializes our work, and our world—begins and ends with whiteness. Its whiteness is inherent not only in who is centred as the subject of history, but also in what moments are commemorated and memorialized. The historical horizon that arises from this is as colonial as it is presentist. More often than not, the road to progress that opens up on it leads us to "rights" (gay marriage), "protections" (police contingents at Pride and in the gaybourhood), and "inclusion" (gays in the military and the corporate world). Its milestones thus resemble white, cis incorporation into national, global, and neoliberal subjecthood.

What would it mean to archive beyond such inclusion? Toronto, home to the "largest independent LGBTQ+ archives in the world,"[7] is clearly gripped by an outbreak of "archive fever."[8] Recent documentations of queer pasts—from the white-washed commemorations of the bathhouse at white-centric symposiums to the erection of the pompous monument for Alexander Wood at Church Street and Alexander Street, the "gay pioneer" whose settler activities in the area are cited to territorialize it as the "Gay Village"—celebrate white cis-gay men (and occasionally white cis-lesbians and trans people) as the heroic foreparents of gay Toronto.[9]

The subjects, places, resistances, artistic contributions, and momentous events that we are made to remember in these narratives belong to

the architectures of European settlement.[10] QTBIPOC, in contrast, are often absent from these feverish mobilizations of the past. At most, we appear as bystanders or newcomers to queer history, tagged on as a footnote or invited as an afterthought to join projects that otherwise perform the archive and its keepers as white. We seemingly follow in the footsteps of white subjects who are positioned as worthy of remembering, and who have apparently paved the way for what queer is and where "we" came from.

These victorious commemorations are shaped by what Haritaworn[11] calls queer nostalgia: an attachment to oppressed pasts that now appear overcome. They follow a progress narrative whose temporal binaries are palpably imperial. On the one hand, a Toronto that is touted as one of the most LGBT-friendly cities in the world—a "beacon for the world," for the "over 2.5 billion people in this world who are gay, lesbian, bi, trans, intersex, who are not safe in the countries that they live in," as Ontario's "first openly gay" premier Kathleen Wynne said in her World Pride address.[12] On the other hand, BIPOC populations and communities that are stuck in time, and needing to be incorporated into civilizational time. In this temporal frame, QTBIPOC are either absent from queer movements or trying to catch up with their movement. We remain the annex to a homonationalist and gay imperialist story that is palatable precisely because it reassures its cis-heteronormative publics that this city, province, nation and the "West," those interchangeable, familial scales, are superior to the West's rest: "other countries" and "communities" whose queers are not quite "there" yet.

This archive remains entrenched in colonial voyeurism, persistently obsessed with the Other's sexual and gender transgressions. QTBIPOC remain to be found, and found again. In order to become an object worthy of inclusion, we must claim our own newness and allow ourselves to be collected and classified. Not only are our communities considered anachronistic and diametrically opposed to progress (then too queer/not cis-heteropatriarchal enough, now too queerphobic).[13] We are ahistorical subjects who, as Marx[14] claimed in his articles on India and China, cannot make history but must be brought into it, by force or collection.

The resulting colonial archives, and their hetero-, homo- and transnormative sections, are "fetishistic" in Sara Ahmed's sense.[15] They appear as though by chance, without accounting for the affective and material labour,

and the displacement and dispossession that are at the root of their production. It is noteworthy that one of the first queer of colour archiving projects that reached a bigger public, the beautiful blog series on Stonewall warrior Sylvia Rivera by Black trans feminist Reina Gossett, was instantly plagiarized by white anarchist zinesters. Having lifted whole sections from her blog without attribution, they accused Gossett of "identity politics" when she called them out on it.[16]

To archive against these erasures, we propose a *counter-archiving* methodology that is not unlike Sherene Razack's concept of unmapping. Razack's theory of race and space is "intended to undermine the idea of white settler innocence (the notion that European settlers merely settled and developed the land) and to uncover the ideologies and practices of conquest and domination."[17] Similarly, *Marvellous Grounds* counter-archives QTBIPOC writing, arts and activism, both to challenge colonial logics of time and place, and to re-engage with the past in order to denaturalize the present. The counter-archive proposed here thus does more than find ever more diverse subjects in unlikely times and places. It refuses a curatorial approach that "collects" QTBIPOC objects and subjects for an ever more colourful archive whose foundations remain firmly white. Instead, our counter-archive renders visible the logics that reproduce QTBIPOC as randomly interchangeable or entirely forgettable in the first place.

These logics are inherent to racial and colonial capitalism.[18] Our absence from the archive, as well as from the spaces and times that it covers, directly intersects with racist border, welfare, policing, and military regimes.[19] QTBIPOC are missing from times and places that are legible as "gay," "queer," "LGBT," and "trans" as a direct result of policing, gentrification, eviction and other processes of exclusion, erasure, displacement and dispossession. It is impossible, therefore, to read the current archive without investigating, in its creases, whose work has been pillaged, whose land has been stolen, who has been lost or left behind, murdered or displaced, erased or deemed disposable. To counter-archive thus means to investigate the racial and colonial logics that shape which "subjects, objects, conducts, events and histories are heavily inscribed and remembered," and which are "forgotten, erased, or denied altogether."[20]

And yet, the counter-archive that is assembled in this book reveals these erasures to be imperfect and incomplete. Attempts to violently erase us often

fail in the face of our communities' collective brilliance and persistence, at times consciously remembered, at others hauntingly felt. As such, the *Marvellous Grounds* archive has affinities with the palimpsestic timeline that Jacqui Alexander describes. The palimpsest is "a parchment that has been inscribed two or three times, the previous text having been imperfectly erased and remaining therefore still partly visible."[21] Similarly, our counter-archive senses earlier traces and memories. Imperfectly erased and overwritten many times, these animate and enable our renewed attempts to remember what happened, to mourn what was forgotten, and to renew our commitment to what might still happen.

This palimpsestic counter-archive contrasts with the nostalgic archive identified above. It asks us to pause and consider: What archiving practices are required in the face of the growing chasm between those who progressively move "with the times" and those who pathologically remain stuck in a past that is antithetical with progress? What subjects and methods rise to the status of the archive, and what futures do these practices orient us towards? *How* do we remember, *what* is deemed worthy of archiving, *who* is deserving of remembrance? How do we acknowledge that we are not the first, nor the first to remember—that attempts at archiving are themselves often subject to erasure?

Diana Taylor's[22] distinction between the archive—written and recorded—and the repertoire—transmitted through performance, orality, activism, and other embodied and everyday uses of space by subaltern subjects and communities—is insightful here. The stories assembled in this book resemble the repertoire rather than the archive: many of them have long been traded orally but never before in writing, let alone print. Relegated to the untimely, these "belated archives" lead us to different pasts, but also presents and futures.[23] They bear the potential to open up futures beyond homonormativity, transnormativity, and gay imperialism.

In contrast to the presentist archive, which celebrates the victors of colonialism, the pasts that our authors orient us towards are not finished. On the contrary, they haunt us with a something-to-be-done.[24] Racialized, Indigenous, working-class queer and trans people have been at the forefront of movements across North America, leading the Compton Cafeteria riots in 1966, the Stonewall riots in 1969, and the riotous activism in the wake of

the 1981 Toronto Bathhouse Raids/Operation Soap. These "events" are often told as a story of white gay heroism. In Toronto, QTBIPOC histories date back to at least the 1970s, and they encompass a diverse range of political and collective issues, including anti-apartheid, homelessness, HIV/AIDS, and disability justice. QTBIPOC wrote letters in support of activists fighting against apartheid on the continent, including to South African gay rights activist Simon Nkoli, and were involved in political arts initiatives like Mayworks Festival of Working People (since 1986), Desh Pardesh (1988–2001), and the Counting Past Two transgender film festival (since 1998). Groups like Gay Asians Toronto[25] supported racialized queers found in the 1981 bathhouse raids.

The current generation of organizers, some of whom have contributed to this book and its online sister forum, are actively stepping into this legacy.[26] They frequently use artistic and performative expression in order to build a counter-archive that reflects a "permanent readiness for the *marvellous*," in the prophetic terms of Afro-Surrealist Suzanne Césaire.[27] Indeed, we view the QTBIPOC spaces that this book is dedicated to as marvellous grounds in Césaire's sense, where alternative timelines are forged, and liveable worlds prefigured.

The stories assembled here feature subjects and settings that are rarely named historical. These include reading and discussion groups, endless dance parties, apartment art shows, second-floor poetry nights, and large-scale festivals like Blockorama—the internationally renowned Black queer stage that has claimed space in and beyond Toronto Pride since 1998. Disrupting the privileged place given to the Toronto "Gay Village" surrounding Church Street and Wellesley Street, contributors foreground different spaces where history was made: the suburbs, the park, the performance stage, the kitchen table, the trans sex workers' stroll, and the community acupuncture clinic in Chinatown. They remind us what was sacrificed in buying into the neoliberal vision of the Village: such as "The Steps" in front of the old Second Cup on Church Street, where QTBIPOC youth gathered when there was nowhere else to go, because planners, politicians, and business owners were openly reserving the Village for neoliberal white gay consumer citizens. The queer settings discussed here further include Parkdale, then dismissed as a "degenerate space," as Sherene Razack[28] might say. According to Leah Lakshmi

Piepzna-Samarasinha's chapter in this anthology, 1990s Parkdale was home to marginalized folks before it fell prey to the neoliberal city, including in its queerly gentrified face as the "Queer West." It was here that QTBIPOC collectively began to think through what we now call disability justice: a politics that always already occurs on the intersections of racism and colonialism. More recently, this counter-archive has included the legendary roundtable of Arab queers at Beit Zatoun, a social justice oriented community centre, the El-Tawhid Juma Circle and Toronto Unity Mosque, a gender-equal, LGBTQI2S affirming, mosque started in 2009, and Salaam: Queer Muslim Community, a volunteer-run organization and support group originally founded in 1991 and reborn in the year 2000.

These stories urge us to remember differently—to look to a different set of ancestors. They refuse a presentist agenda that selectively highlights and erases in order to increase its own spotlight. Unlike certain white queer temporalities, they do not let go of the past, nor do they belittle our desire to survive, and our demand for a better future.[29] On the contrary, they actively turn to the past and let it incite us with impulses to join unfinished revolutions.

The pages ahead were written with transformative desires in mind. They ask what happens if we start with the affective maps of those who always remain newcomers to the city—who arrive with timelines that must be instantly assimilated and forgotten, precisely because they bring us dangerously close to pasts and futures that threaten and incite. This threat is brought home to us whenever we witness an elder's memories of exclusion from white LGBT spaces being labelled false. On more than one occasion, we have been pressured by white gatekeepers and their racialized informants to "correct" QTBIPOC memories, to the point where they threatened to discredit both our elders and our own work as scholars and editors. These pedagogies and performances of the archive are designed to remind us that only white subjects are capable of remembering "true history," and of properly recording it.

At the same time, the chapters ahead are testimonies to white supremacy's failure to quiet, erase, or disappear QTBIPOC. The sites and acts described here rarely reach the status of the event, yet they shape us.[30] They serve as "proof that a life truly existed"[31] and expand our ability to image a future in which our peoples deserve to live and thrive. Mainstream accounts of queer

Toronto have dismissed these embodied repertoires, told from ear to ear. Yet the radical educational work of socializing each other in oral traditions of telling and retelling has informed our sense of self, of place, of what happened, of what is possible. It continually equips us with maps and intentions for organizing beyond homonationalism, gay imperialism, and racial and colonial capitalism. These whispers confirm, in the words of Black transgender elder Miss Major, that we are "still fucking here"—that other ways of living together are possible.

The Book

Marvellous Grounds began as a mapping rather than archiving project.[32] However, it quickly became clear that there is an unmistakable desire in QTBIPOC communities for history and lineage. Younger folks in the city crave elders, who are missing and dismissed from a white archive that passes itself off as "*the* queer history" while robbing us of elders and ancestors who could give us perspective on what needs to be done in these times of unabashed racism, eroding entitlements, and wars without end. This further stems from a context where QTBIPOC art, activism, and activists themselves frequently disappear from memory, and from actual organizing spaces, as a result of myriad factors, including conflict, gentrification, burnout, and premature death. Elders crave an intergenerational movement that both remembers what has already happened and imagines together a freer future. A counter-archive provides an opportunity to connect and relate across generations as QTBIPOC.

Marvellous Grounds features a range of voices, genres, and methodologies, including academic writing, poetry, roundtables, and photography. By placing academic, artistic, and activist genres side by side, we mirror the wide range of artistic and intellectual expression used by QTBIPOC in the city. Much of this work is happening outside of the academic industrial complex, where it is often reduced to the status of pre-theoretical "experience" to be mined for the production of "proper" theory. In contrast, *Marvellous Grounds* highlights the organic intellectual status of this work.

Our anthology contains new and unpublished work by prominent community leaders and elders such as Richard Fung, Alan Li, LeZlie Lee Kam, and Monica Forrester. It presents one of the first written intergenerational

dialogues between older and younger voices, such as the newly emerging migrant sex workers' movement and the QTBIPOC performance scene that has mushroomed since the 2000s. We also feature artistic contributions by a range of established and emerging artists, such as Natalie Wood, Zahra Siddiqui, and Nadijah Robinson.

Contributors write about four decades of QTBIPOC organizing, from the early days of consciousness-raising and HIV/AIDS organizing to later interventions into Pride and the creation of QTBIPOC-specific arts and performance spaces. They join the new archiving fever around Desh Pardesh, a multi-disciplinary arts festival celebrating South Asian queer and trans folks that thrived over thirteen years in Toronto between the late 1980s and 1990s.[33] They reflect on the momentous community building that led to QTBIPOC movements, spaces, and knowledges that still feed us today. They witness and critically engage with current issues, including migrant sex work organizing, the first-time arrival of significant numbers of LGBT refugees, and the resurgence of Black queer and feminist resistance to police violence. They form part of an intentional QTBIPOC turn towards feeling, grieving and healing as modalities of individual and collective transformation. Most importantly, these chapters challenge how QTBIPOC are erased from queer history and narrated as bystanders to the historical moments that they have often spearheaded.

Contributing to this growing critical body of work grounded in Toronto, the authors and artists in *Marvellous Grounds* radically rethink who is the subject of queer history and what constitutes "queer" organizing. They are testimonies to the central role played by QTBIPOC in shaping and inventing queerness in the city. They call into the archive an ancestry that is often deemed forgettable. The remaining sections of this introduction guide the reader through some of these spaces, and through the three themes according to which this book is structured: counter-archives, cartographies of violence, and communities of care and healing.

Counter-Archives

The chapters in this first section pull into view QTBIPOC histories that have long been legendary but have rarely appeared in print.[34] They feature QTBIPOC Toronto-based historiographies of activism, performance, and

community life from the 1970s to the present day. The historical sites discussed here encompass street corners and other outdoor spaces where trans sex workers and youth of colour have built community, which often fall prey to the "revitalization" that accompanies gaybourhood development across the neoliberal world.[35] They include the lesbian meetups that took place in the 1970s on Jarvis Street under constant threat of raids by the police. They recall the collective living rooms and kitchen tables that gave birth to organizations such as Gay Asians Toronto (in 1980), Zami, the Black/Caribbean group (in 1984), and Sister Vision: Black Women and Women of Colour Press (in 1985).[36] Together, these chapters set QTBIPOC histories within a different kind of urban landscape, and a different kind of archive, that goes beyond the white neoliberal zone of the Village and its homonormative institutions, while also naming the Village as a space that QTBIPOC have actively inhabited, contested, reinterpreted and intervened in.

The collection opens with "Street Corner Community Building: Trans Sex Worker Activism in Toronto," Syrus Marcus Ware's interview with Monica Forrester, which revisits the respected elder's contributions in conversation with her long-time co-organizer Chanelle Gallant. Forrester, who founded a thriving, if embattled, community of trans sex workers, articulates the need for a trans history that both intervenes in the respectable homo- and transnormative archive of the nonprofit industrial complex and acknowledges the vital work that trans sex workers of colour have done across Canada, which has been foundational for much of queer, trans and LGBT activism today. Instead, the interview highlights the alternative methods, knowledges, and socialities that arise on the street corner. Commenting on the historical erasure of trans women of colour from LGBT mainstream organizing, the creation of Forrester's organization Trans Pride Toronto, and the need to link trans organizing with #blacklivesmatter and other initiatives, the chapter opens up an alternative horizon for contemporary organizing. There, survival and collective self-care can coexist with revolutionary change and upheaval.

The second contribution, an interview with international filmmaker and community organizer Richard Fung by Jin Haritaworn, sheds light on further chapters of QTBIPOC history in Toronto. "It Was a Heterotopia: Four Decades of Queer of Colour Art and Activism in Toronto" reflects on

nearly four decades of arts-based LGBT activism and self-organized queer of colour spaces in a changing cityscape. Looking back at Desh Pardesh, Gay Asians Toronto, Zami and other cultural sites that bridged arts-based, left-wing, queer, Asian, Black and Indigenous communities in Toronto in the 1980s and 1990s, Fung complicates queer space discourses by locating queer of colour organizing beyond the white(ning) Gay Village. QTBIPOC sociality here happens in unlikely spaces, including in the heterotopia that is Chinatown, in the suburbs, where racialized communities are concentrated, in the complicated encounters between queers who are Black, Indigenous and Asian, and in the global north and south. The chapter thus presents an honest review of what it has meant to make art and build multiracial coalitions across gender, class, and race, in contexts of homonationalism, settler colonialism, and anti-Black racism.

Fung is followed by his contemporary Alan Li, the influential Toronto-based physician, community organizer, and human rights activist. In "Power in Community: Queer Asian Activism from the 1980s to the 2000s," Li reimagines a fascinating geography where gay Asians used to meet, in living rooms and "rice bars" off Yonge Street, that has largely made way for the city's voracious condominium development. The chapter discusses key moments in queer Asian community organizing in Toronto, from the founding of Gay Asians Toronto in the aftermath of the 1979 Third World Conference and National March in Washington D.C., to the first gay Asian contingent at a Pride parade through Chinatown, to the later shift to HIV/AIDS organizing and the foundation of Asian Community AIDS Services, which till this day survives as one of the key NGOs in the city. Li highlights the importance of queer of colour self-organizing, in a white gay scene that found us undesirable and an NGO landscape that could not or would not intervene in seeing us die.[37]

LeZlie Lee Kam, co-chair of the Senior Pride Network, then creatively revisits the author's four-decade track record of developing queer women of colour programs and resources in Toronto. "Loud and Proud: The Story of a Brown Callaloo Dyke Coming Out in 1970s Toronto" chronicles a long history of queer women of colour organizing against police violence in Toronto, and of early queer of colour interventions into Toronto Pride and other white gay spaces. It vividly describes the everyday romantic, social, and

political lives of lesbians of colour living and loving within a largely white lesbian community. In this fictionalized account, the personal is political. The journey of coming out and falling in love with women is mirrored by that of falling in love with activism, embracing a politicized dyke identity, and eventually becoming involved in founding many of Toronto's early lesbian and gay of colour collectives and organizations.

Aemilius "Milo" Ramirez's "Speaking our Truths, Building our Futures: Arts-Based Organizing in QTBIPOC Communities in Toronto" builds on this legacy by fast-forwarding to the spaces that the author, a key figure in the current generation of QTBIPOC spacemakers, helped innovate in the 2000s. These spaces gave birth to a performance scene that centres our lives and our stories. The chapter tells the story of the forerunning production collective and cabaret-style showcase Colour Me Dragg, which ran from 2006 to 2011. The collective was the first of its kind and was born in resistance to the prevailing whiteness in the Toronto drag scene, and in response to the racism, policing, and gentrification in Toronto's Gay Village, where most performance venues were located at the time. The chapter opens up geographic and historic possibilities beyond these gentrified horizons. It urges us to live the future we hope to leave behind, and to become the ancestors we've always wanted to have.

Closing this section is Laureen Blu Waters' poem "Time Capsules." Waters powerfully invokes the scattered and abandoned bodies of missing and murdered Indigenous women. Their violent deaths are part of the ongoing genocide against Indigenous peoples, and a colonialism which triangulates non-Indigenous peoples of colour as failed yet aspiring settlers.[38] This genocide has always targeted women, LGBT, queer, trans and Two-Spirited people for sexual violence and murder.[39] The poem refuses a linear history that reifies the colonizers' sense of time. Instead, it performs an archive that insists on remembering the dead, who—all attempts at cultural and biological annihilation and assimilation to the contrary—remain alive and, indeed, agentic, to resurgent communities. Not only are missing and murdered Indigenous women grievable. They are ancestors, family members, and part of mother earth: the more-than-human world that reproduces Indigenous communities by producing, in Waters' words, "medicines we harvest to heal our sicknesses nourished by their bones."

Cartographies of Violence

The second section of the collection further maps the intersections of violence and the parameters along which QTBIPOC community in Toronto are forming community. Contributors Alexandra Williams, Kusha Dadui, Asam Ahmad, Melisse Watson, Chanelle Gallant, Elene Lam, Kate Zen, Tings Chak, Natalie Woods and Zahra Siddiqui intervene in oppressive discourses, analyze instances of institutional and community-based oppression, comment on the shortcomings of sites that are privileged in existing historiographies, such as the Village and the nonprofit industrial complex, and share moments of QTBIPOC resistance and community formation. These chapters innovate and illustrate new movement methodologies, including prison abolition, migrant sex workers' justice, queer Muslim organizing, and Black and Indigenous solidarity. Instead of seeking inclusion into existing maps and archives, they create new worlds, often by engaging intellectually and artistically with personal and collective histories.

Opening this section is "Cops Off Campus!" by Alexandria Williams, best known for her leadership in Black Lives Matter–Toronto. The chapter grants a unique insight into the author's politicization in Black campus-based organizing at Toronto's York University. Williams questions binaries between the police and the University—often reified as the "nicer" institution—by locating her story firmly on the carceral campus. Reiterating the theme that the personal is political, Williams describes getting involved in Black queer student activism after experiencing racial profiling in Jane and Finch, the Black neighbourhood that surrounds York, and that the University is actively involved in gentrifying, demonizing and criminalizing. Retelling the creation of the queer-led organization Cops Off Campus, Williams makes the abolitionist argument that York and other neoliberal universities are unsafe environments where Black women, queers and trans people are targeted for gender-based violence, as well as for institutional violence by campus police and security who consider straight white students and faculty the only subjects worthy of protection.

State violence against sex workers, many of whom are migrants and queer, is also the theme of the following piece by the Migrant Sex Workers Project. In "Migrant Sex Work Justice: A Justice-Based Approach to the Anti-Trafficking Movement," co-authors Tings Chak, Chanelle Gallant,

Elene Lam, and Kate Zen counter the "trafficking" discourse that has come to dominate global discussions of sex work, gender violence, and migration. This discourse treats migrant sex workers as voiceless victims who must be "rescued and repatriated" by police and immigration officials. In contrast, the authors bring into view the multiple systems of oppression, including a racist immigration, policing and labour system, a sex-negative, cis-hetero-patriarchal society, and a white-dominated sex worker rights movement trying to become respectable at the expense of migrants, that produce migrant sex workers' vulnerability to exploitation in the first place. In the place of criminalization and border control, the authors make a case for treating sex work *as work*. They propose an abolitionist approach towards prisons, borders, and capital that offers a compelling alternative to existing LGBT structures that are increasingly joining the state.

Kusha Dadui's chapter "Queer Migration and Canadian Border Imperialism," which continues on the topic of borders, critically engages with the anti-Black notion that Canada is the final destination of the "new underground railroad," deployed by LGBT organizations such as Iranian Railroad for Queer Refugees and Iranian Queer Organization. Through careful archival work, Dadui exposes a Canadian (homo)nationalism that has always selectively excluded and included migrants along race and class lines while presenting the settler nation as a safe haven for refugees: first enslaved Africans fleeing across the border, now queer and trans refugees "rescued" from their "backward and barbaric" countries and communities. Not only is the Canadian immigration system rooted in an ongoing history of racism and colonialism that reifies the majority of Black, Indigenous and people of colour as degenerate and disposable, but also the "safe haven" claim ignores the everyday violence facing queer and trans refugees who are attempting to survive in the city.

Both Dadui's and the following chapter by Asam Ahmad, "Queer Circuits of Belonging," comment on the whiteness of the very organizations often celebrated as milestones of LGBT-friendly Toronto. Ahmad provides a fictionalized account by a Muslim teenager who leaves his birth family in Scarborough, the racialized suburb, as a result of a social worker's racialized assumptions, and is subsequently forced to navigate downtown LGBT services and spaces as a homeless youth. In these spaces, the narrator's community

of origin is treated as backward, inferior, and anathema to queer liberation. This is underlined by his experiences in the mentorship program of the LGBT Family Program set up by Supporting Our Youth (SOY) in 1998,[40] where he experiences anti-Muslim racism, classism, and fatphobia at the hands of his white middle-class mentors. The enforced binary between his queer and his racialized identity is resolved when the narrator finds QTPOC spaces. He experiences his homecoming on the board of *AQSAzine*, a print zine launched in 2008 by queer and trans Muslims.

The section ends with three creative pieces that revisit the themes of state and communal violence through the genres of poetry and visual arts. Melisse Watson's poem "Collateral" is a dystopic account of a young queer's turn towards the impending environmental devastation brought on by colonialism, antiblackness, transphobia and human greed. Watson's poem offers a caution to those who are waiting for things to get worse before choosing to fight for our freedoms, even if it means giving up creature comforts. Watson's poem, rooted in their own activism across Black and Indigenous communities, tackles issues of colonialism, resource extraction, anti-Black racism, and state violence. Despite its apocalyptic tone, Watson's poem reveals a deep yearning to return to the Land, to traditional practices, and a desire to connect and build new communities of belonging outside of the mainstream. In short, the poem hopes that we make it to the moment beyond revolution.

Natalie Woods' mural *Kiss and Tell* was created as part of the 2013 Church Street Mural Project, which members of the Marvellous Grounds collective have elsewhere introduced as a spatial and archival intervention into the Village that features a number of QTBIPOC artists.[41] To create this mural, Woods asked queers of colour to share any print material, novels, anthologies, and manifestos that they read and that sustained and fed them when they were coming out. She was interested in highlighting the politicized culture that queers of colour were creating in the 1980s after the bathhouse raids and the first Pride march, including the founding of Lesbians of Colour, Zami, and Punani Posse, and the flourishing of women/queer of colour publishing during this period, much of which is lost on the white archive. The *Kiss and Tell* mural references Gran Fury's *Kissing does not kill* poster, which educated people about HIV/AIDS and likewise featured a diversity of couples

kissing. *Kiss and Tell* is located in an alleyway on an unpainted wall to denote that even as QTBIPOC were being marginalized in the movement, we still created spaces for ourselves and were an integral part of the environment now known as Toronto's Gay Village at Church and Wellesley.

The final visual arts contribution in this section is Zahra Siddiqui's *Yung Bambii* and *Shi Wisdom*. Siddiqui is known for her large-scale queer geographies and stark Toronto cityscape settings, often featuring images of artists and activists of colour portrayed alongside their street art. The two images—close-up portraits of Black musicians, singer/songwriter and MC Shi Wisdom and world-renowned local DJ Yung Bambii—break with this tradition in their use of a more private setting. They depict each artist writ large, and offer a contrast: *Yung Bambii* looks away from the camera while *Shi Wisdom* confronts the viewer's gaze head-on. Dressed in decidedly queer and afrofuturistic makeup and adornments, these subjects and their presentation claim space, and right to city. They are classic and emblematic of Toronto in the second decade of the 2000s.

Communities of Care and Healing

The final section of our book collection is dedicated to dreaming up better futures "where we can all make it," as our collective member Syrus Marcus Ware likes to say. The chapters in this section conjure marvellous grounds. They feature some of the visionary projects that QTBIPOC have led in the city, including around decolonization, disability justice, spirituality, transformative justice, and healing. They revisit the past in order to commune with ancestors who anticipated futures that break from the endless present—futures where we still exist. They bring to a halt the dynamics that oppress us, dynamics that we have internalized, by imagining alternative ways of being and being together. They help us dream of healing and breaking free, of structures that are tumbling down, of communities that are built from the heart out. These dreams, often expressed in QTBIPOC art and activism, are not empty—they are the beginnings of breathing another world into being.

The section begins with the ground-breaking historiography of disabled organizing and community making by and for sick, disabled, Crazy and Deaf QTBIPOC in Toronto by Leah Lakshmi Piepzna-Samarasinha, the seasoned writer, organizer, and performer. "Toronto Crip City: A Not So

Brief, Incomplete Personal History of Disabled QTPOC Cultural Activism in Toronto, 1997–2015" grounds its rich archive in a tradition of grassroots working-class, disabled and psychiatric survivor intellectualism. It takes inspiration from the historianship of author Joan Nestle, who recorded working-class femme, sex worker, and queer and trans histories, blending personal experience and community-based research. Starting from her move to Toronto in the 1990s to the present day, Piepzna-Samarasinha traces key movements and actions that were formative in drawing links between disability, gender, class, and race, and brought to life communities and spaces once considered unimaginable. These include *Bulldozer Community News Service*, a radical prison abolition oriented newspaper that began in the 1980s, the above-mentioned Desh Pardesh, Mangos with Chili, a queer of colour-led performance arts company, and the Creating Collective Access initiative at the Allied Media Conference, the yearly social justice and media activism space in Detroit, which many Torontonians regularly attend.

The next chapter, "Healing Justice: A Conversation," is a roundtable discussion between nisha ahuja, Lamia Gibson, Pauline Hwang, and Danielle Smith, queer of colour practitioners who have created unique community spaces in the city where QTBIPOC can heal from the trauma resulting from generations of systemic and interpersonal violence. The chapter argues that healing modalities and practices are fundamental to our collective liberation—that they constitute a movement for justice in themselves. The authors argue that by linking our individual and collective healing, we can gain access not only to denied pain and trauma, but also to spirit, ancestors, intuitive wisdom, and our most expansive powerful sense of being. The roundtable asks how healing spaces can be made accessible, and what role racism and colonialism have played in severing QTBIPOC from healing in the first place. It addresses questions such as the following: How do we challenge disembodied expert-delivered medicine and create self-determined communities of care? What might access to healing and healing justice look like in our current urban context of gentrification, higher rent, fewer state resources, and shrinking entitlements to health care? What roles do our ancestors and spirituality play in our healing justice work?

The last question is taken up in Shaunga Tagore's "A Love Letter to These Marvellous Grounds: Living, Loving, and Growing in a City called

Toronto." This personal history by Tagore, a dancer, poet and healer whose work is emblematic of the current generation of queer of colour cultural producers creating collective spaces in the city, shares how she migrated across the country and came of age, and into community, by building relationships with other QTBIPOC in Toronto. Her love letter, a raw tale of finding and losing homes, of betrayal and interdependent healing, speaks to the symbolic place that Toronto holds in transregional and transnational imaginaries. It chronicles leaving behind single-issue movements, and the institutionalized academic and nonprofit spaces they have given rise to, in order to make art that builds movements without burning anyone out. The communities that Tagore describes are not essential givens but the result of hard work, risk-taking, shared vulnerability and, indeed, conflict. They enable a homecoming that is created through affinity and coalition rather than sameness. Notably, these communities are not confined to the realm of the living: Tagore describes the painful but necessary process of learning to communicate with ancestors and becoming "a channel of communication between the past, present and future, and in the in-between dimensions."

In the following chapter, "Race, Faith and the Queering of Spirituality in Toronto: Reflections from Sunset Service," David Lewis-Peart explores the possibility of a spirituality that places QTBIPOC at its heart. The chapter tells the story of Sunset Service Toronto Fellowship, an inclusive, interspiritual ministry founded in 2012, whose distinctive foci on the arts, social action and community building, and the conscious inclusion and leadership of queer of colour youth, have created a unique space in the city. Bringing this space to life, Lewis-Peart uses autoethnography, storytelling, prayer, poetry and quotations from Sunset Service community members to ask what becomes possible when spiritual community not only welcomes those at the margins but positions them at its very helm.

Audrey Dwyer's chapter, "Creating Community and Creating Family: Our QTBIPOC Parenting Group," asks a similar question in relation to marginalized families. The chapter is a personal account of the creation of an alternative group for QTBIPOC parents. This monthly gathering space, housed in rotating homes over plentiful brunches, was born out of a need for support systems that responded to the specific interpersonal and institutional barriers facing queer families of colour. Critically reflecting on the existing (largely

white-dominated) LGBT parenting networks and supports in Toronto, the author discusses her desire for a community that visions what it might mean for queers of colour to raise children and build families. Thus was born the QTBIPOC Parenting Group, which began from need, from specificity, and from a collective vision that locates QTBIPOC at the forefront of creating new and distinct families rooted in love, care, and collective transformation.

The book closes with "*The Mourning Dress*: Creating Spaces of Healing for Black Freedom" by Nadijah Robinson, with Amalia M. Duncan-Raphael. The chapter confronts the "rhythm of death and grief . . . without end" over the genocidal killing of Black people, and particularly Black trans women, whose deaths are frequently treated as ungrievable. It retells the making of *The Mourning Dress*, an art project created by Robinson at the Art Gallery of York University and performed at Pride Toronto in 2015 by Duncan-Raphael as part of a mourning procession. Punctuated by paper rose tokens, glitter libations, and the reading of the names of trans women of colour killed that year, the mourning dress created a rupture in the celebratory atmosphere of corporate Pride. It movingly illustrated the potential of art in prefiguring the world we deserve, however fantastical it may seem in the moment: in this case, a world where Black trans women are respectfully mourned when they go missing, and surrounded by loving community while they are living.

The pages ahead follow this fantastical spirit and leap into marvellous grounds. Far from attempting to be a definitive history, they instead attempt to honour a rich history that is largely still waiting to be retraced. The resulting burden of representation is heavy, and our attempt to step into it can only begin to do this hauntingly beautiful legacy justice. We hope that you will get something out of this book, and that these pages will be joined by many.

Part One
Counter-Archives

1 | Organizing on the Corner

Trans Women of Colour and Sex Worker Activism
in Toronto in the 1980s and 1990s

*Syrus Marcus Ware interview with Monica Forrester
and Chanelle Gallant*[1]

*Monica Forrester is a long-time activist and organizer in
Toronto. In 2004, she founded Trans Pride Toronto to develop
supportive resources and programming for trans people in
the downtown area. Over the past twenty years, she has
also developed sex worker outreach programs for the 519
Church Street Community Centre, Maggie's Toronto Sex
Workers Action Project, and other organizations in the city
of Toronto. What follows is a conversation between Syrus
Marcus Ware, Monica Forrester, and Chanelle Gallant, a
long-term sex worker and organizer in Toronto who contrib-
utes to this conversation by sharing the important intersec-
tional lessons that she learned from Monica and other trans
women of colour.*

Monica Forrester: My work focuses on visibility and awareness for trans
people. I was doing activism before I knew what activism was. When I was
young, like eighteen, I was educating trans women on the corner about safer
sex. The corner was the only community that existed at that time, the only
place where we could share information. And that's where I learned about

organizing, where I got the determination to make change and the inspiration to be an activist almost thirty years later.

When you approached me to do this interview, I started thinking about the history of archiving, and I thought, "I wish I took pictures!" We were in such a different place back then. Survival was key. Nobody thought about archiving things because no one really thought we'd live past thirty. Our lives were so undetermined. No one really thought: "Oh, we should archive this for later years." The only thing I really thought about was the deaths— how trans people were dying prematurely because of injustice, violence, and stigma.

I sit back and think about the deaths I've seen in those days. I've seen so many people dying at twenty-one, twenty-two. At that time, to make it to thirty was super big. It seemed like a long life for them because of the lives they lived out there since they were twenty. I'm forty-five now, but these things are still going on. Not at as high a rate, but we still see people dying. And then I think, I'm forty-five, shit, I still got another forty years.

I came to formal organizing and activism around 1999 because the murders of trans women had skyrocketed. In 1997, two trans people and one cisgendered Aboriginal woman were murdered on the corner in Toronto. Mirha-Soleil Ross, a long-time radio programmer and activist who helped start the Counting Past 2 transgender film festival[2] in Toronto, myself and a few other people got together to demand a space safe for trans people *now*. The direction at the time was going good. This informal coalition included trans people of colour like me, Mirha, and others. Then it kind of went sour when they started adding more white people, people with more academic skills, people with more policy experience, people that really didn't know the real issues. It made a lot of us without that formal training feel pushed out, and we got pushed out. Perhaps in a different way, these issues remain relevant and trans-specific activism is still very much needed.

Chanelle Gallant: Hearing you talk really reminds me of how hard it is for us sometimes to recognize our work as activism and as worthy of recording. I am a white cisgender organizer and I've lived and done activism in Toronto for about twenty years. My first activism was around the raid on what was called the *Pussy Palace*, a bathhouse here in Toronto, in the year 2000. This led to a three-year court case, a three-year human rights complaint, and

mandated policy changes against the Toronto police. So, out of that human rights settlement came the policy that required cops to ask trans people what their preferred gender was for the officer they would be searched by, which was later copied by the New York City police. That was my first introduction to activism. Racialized and Indigenous trans women were teaching me about intersectionality, even though we didn't use that language at the time.

Monica, I saw you in *Red Lips, Cages for Black Girls*,[3] Kyisha Williams' film about the impact of the prison industrial complex on Black women. I saw you and thought, "I want to know that girl. That girl is going to be my friend if I have anything to say about it." And then, shortly after, you started working at Maggie's![4] One of our first projects was the Aboriginal Sex Worker Education and Outreach Project. Since then, Monica and I have worked together through an organization that we started calling STRUT, and we brought together the first national gathering of racialized, Indigenous, and street-based sex workers and allies. The reason we wanted to do this kind of work was because we both really wanted to see and support more people, specifically those who had experiences of criminalization, in leadership roles around sex work activism. Because it was confidential, we actually did all of our outreach and fundraising for it quite quietly and without much fanfare.

MF: Maggie's was the only driven sex work agency for sex workers. For a brief little moment there we thought: "Oh my god, this is the only place that sex worker-led activism on sex work goes on." We wanted there to be more options for supporting sex worker-led activism, so we started STRUT. Initially, STRUT was a three-day conference. The first day was the Indigenous-only pre-convening, and it was all Indigenous people who either had experience in the sex trade or were allies. The second two days were for everyone. We wanted to build relationships and networks. One of the biggest goals, ultimately, was shifting the sex work activist agenda—what we're fighting for and how we do it. Even though Maggie's was doing a lot of great work across Canada and the States, we were not connecting with as many places. We wanted to see what people were doing on the East and West coasts. We wanted to get new ideas, to connect with the successful work they were doing with programming and outreach.

Syrus Marcus Ware: What is unique to the activism that you and other sex workers, including trans sex workers and sex workers of colour, are doing

in Toronto? Is there something that's different about organizing here than say, in the Yukon, BC, or Montreal?

MF: Because Toronto is so diverse, and because it is such a trans hub, we can't just organize on one particular single issue—we need to connect issues of transphobia with issues of anti-Black racism, for example. I think that there's a lot of work left to do. I read rants on Facebook about Black Lives Matter, and I just want to yell at people because they really just don't get it sometimes. What is hard to understand about ensuring that we as Black people get to live our lives? Trans people are at the forefront of Black Lives Matter organizing, as well as other activisms around interconnected issues like homelessness and the stigmatization of sex work. I think connecting Black Lives Matter and other trans-focused organizations is important because the issues of transphobia and anti-Blackness do overlap for Black trans people. I'm pulled in all kinds of different directions as a Black trans activist.

In my experience, a lot of people come to Toronto because of lost community or to find community because of stigma, due to being trans or a sex worker or whatever. They are isolated, so they build new community over here. I worked with organizers in BC, where a lot of the sex workers are Indigenous or of colour. I found how they embrace their community and culture within their sex work inspiring. The organizers in BC were empowered by community, and they educated their community about their bodies, their work, and all these different parts of who they were. It was beautiful. Whereas here in Toronto we're a little more political, but perhaps less focused on personal development. We don't talk about our own needs a lot, which is hard sometimes because we need that individual support, too.

There's always such a limited capacity within organizations to support individuals. I work at Maggie's, but I am only part-time. I'm aware of how understaffed we are. And yet a lot of the other, non–sex worker specific agencies haven't really picked up on sex workers' needs. So where do we go to get our needs met? For example, if I need to provide a referral to another organization for a sex worker client, where do I send them? What organizations are knowledgeable about our issues? I mean, there is the 519 Church Street Community Centre and other great places where I'd like to send them for support, but looking at the 519's programming now, there's

nothing for sex workers there anymore, although there used to be. Their trans programming has shifted away from supporting trans sex workers—it's as if we've totally forgotten what the program existed for. Past 519 program co-ordinators, like the late Kyle Scanlon,[5] had a different understanding of what the 519's Trans Program mission or vision was. There has been a shift in institutional mandates.

We try to fill the gaps left by these program shifts in other agencies. For example, I do a monthly program for trans women of colour—but it's too short, the time flies by. We can't really do much together during the program because it's only two hours. By the time we eat, talk, and check in, it's already over. So we're really not even getting to the deeper issues and needs of trans women because it's only one day a month for two hours. I worry that we are just throwing money at the program but not really getting involved in a capacity that is changing anyone's lives.

And then where do we go? We do a lot of our convening and together-ness in the streets: in spaces that are dangerous, in spaces that are targeted, in spaces that are visible. For example, we have a lot of trans people of colour who are continuously targeted and carded by the police because they look street involved. So, I do a lot of education to make sure that they're aware of their rights in order to challenge this targeted policing. I'm not knocking the programs—there's a lot of great programs. I access them, I do outreach in them, but there's really not enough going on in them.

CG: And that's what we wanted to deal with in STRUT. We need services, but we need organizing too. We want to be part of a movement, not just a sector that has slashed or abandoned these essential programs. I really don't want to see that continue to happen to sex work organizing. Frankly, the selling out in the gay and lesbian movement is my worst case scenario for what could happen if we abandon the early principles that came out of organizing on the fucking corner and don't make sure that we honour and carry them forward. That's where the principles of sex work activism come from. I want to retain that and share that with others. Also, I feel like I would be remiss not to talk about the enormous impact of Mirha-Soleil Ross on the Toronto community.

MF: She had a vision. As an activist she started a bunch of programs and did research about trans women and access to shelters. She had a radio

program and a 'zine where she would showcase sex workers. Her work was so groundbreaking and innovative for that time.

SMW: I actually wanted to talk about her great video project, *Madame Lauraine's Transsexual Touch*,[6] which is an educational sexual health narrative film for trans women of colour sex workers. You star in this video! It's such an important resource.

MF: The Ministry of Health gave us a bunch of money and said: "Don't put our name on it, but here's a grant." We wanted the video to shape the movement. We did a lot of networking in preparation for this project. We knew it was important to connect with Montreal and Vancouver, the more populated areas where there were a lot of trans sex workers, so we went to Vancouver to talk to sex workers out there. There were a lot of stars in that video! One of the actors was a well-known trans woman for many decades. To learn about her history from the 1960s and 1970s was really extraordinary. The film was also about taking the onus off of sex workers to practise safely, but saying to the john: "Hey, you're just as responsible for safe sex as we are." It was fun to work on this project.

SMW: There were some really funny parts in that movie. There's a scene with Mirha where she's having sex and all of a sudden she puts on glasses and gives all this health data. It just seemed too good to be true. There really was *nothing* out there and to this day there still really isn't a lot out there that is so user friendly.

MF: I was part of the *Happy Transsexual Hooker*[7] sexual health resource project, too. It was a little booklet that focused on harm reduction for trans women of colour and talked about HIV and STI transmission and intravenous drug use. There were two characters, one of whom was HIV positive. And they talked about HIV/AIDS—how you don't have to look HIV positive to be HIV positive—and harm reduction and tried to empower people to have safer sex and take care of themselves while doing intravenous drugs. It was meant to shed light on the experience of living with HIV, especially because a lot of people think you have to be sick to be HIV positive. It was great because the whole story came from the community—we created it with community, and we tried to get it in different languages. So the project was something that they owned, that they could relate to, that made them feel like "I was part of making this project happen."

I was a part of the Fred Victor Shelter organizing community at the time because the street-involved community became a strength for me. This connection was part of what inspired me to be part of a big project with the City of Toronto called the *Trans Shelter Access Project*, which focused on making a trans-only space in shelters. So we went to fifty, sixty shelters, asking the shelter organizing committees and the front-of-line workers about accessibility and inclusion. We held focus groups with trans people and asked them what they needed and what they wanted, and in turn, this helped to build a sense of community and strength. There was a big issue in New York City because trans women were being housed in men's shelters—shelters where there were two thousand men, and so much sexual abuse going on. We went to a conference there and found people figuring out solutions to trans shelter access. We talked to people there about how we could adapt their ways of working to make things more accessible for trans people here in Toronto.

It was during that time that more trans-specific stuff was being produced, more trans inclusion stuff. But then it just became normalized, right? Even though nothing really changed in many ways when it comes to marginalized people, services became more widespread. One of my next initiatives is to see where we're at and do more consultations with the community around how accessible our services really are for people. Why are trans people still under-housed? Why are trans people still dealing with all these other things in their lives, like HIV transmission? Why are all these things still happening?

CG: There was this moment in 2001.... Do you remember the *Sexin' Change* conference? It was a trans conference at Ryerson. Viviane Namaste did a keynote and discussed how trans politics were increasingly focusing on identity and queer theory and less on lived realities, like survival issues, poverty, prisons, sex work, and health care, and why those issues were all still completely unresolved. What she was calling out in 2001 is still going on. A lot of trans politics got taken over by white trans guys. But there's also been more of a push back against it since the 2010s. In the 2000s, so many folks were just like, "What? Poverty and sex work, whatever!" and then like, "Trans women of colour, who?" But then, I feel like in the last five years, there's been more of a public push back against this whitewashing and malewashing of actual trans lives.

SMW: What is it that we need now? Where do you see us going in the next little bit?

MF: Well, we definitely need more than one day a month for trans women's programming! I applied for some funding recently for a trans women of colour space. We need more going that focuses on the lives of people of colour and trans people of colour. A lot of these agencies that have funding for trans people are just a place to get tokens and eat. We're not really talking about issues. They're not Black-centred or sex work–centred. There's been a shift. There's so much accessibility now. But we need more systemic change and more connecting.

Maybe we need to sit down on a monthly basis and connect and ask: How can we support each other? How can we move forward to really make change? We all have lives, but I'm always up there trying in some capacity. When I'm on the corner doing my outreach, it feels so good to be out there listening to people and looking at the women there, the young trans women, and it's also bringing me back to a place. It's good to engage and listen to the things that are going on in their lives—the good times, and the bad times, and the struggles. It's definitely a community that I'm very much a part of and that I'll probably always be a part of. My life as a marginalized sex worker has its moments. I've paid for it in different ways. I think about my health, you know, not being able to eat properly, being housed properly, having proper shoes—these things have affected my feet. I've got diabetes; I think that was from not eating properly due to many factors. Maybe I'm mad at my body for what it was, but I am not fighting with it anymore. Now I'm not trying to be a certain weight or to sleep a certain way. Poverty might have played a role too. There are so many different elements. These are things that are touching me now. I definitely attribute a lot of my health issues and a lot of things that are going on with me today to my past. But when you're living in that moment, you're not thinking about how those things are going to affect you ten, twenty years later. And I am grateful; I'm managing, and I wouldn't change a thing, 'cause I've lived a pretty beautiful life. But I see value in empowering my community to have more self-love for each other and for themselves, their bodies, who they are and stuff like that.

When I think about mapping our lives, I wish we could Google areas where trans people used to live in earlier times. Like where I used to live, in

this abandoned house on Charles Street and Church Street in the Village, now it's a condo. Or when we lived in an underground garage that was boarded up by Bleecker Street. There's another condo there now. A lot of trans people used to live under there. We would drop in through a little hole and people used to live in one of the rooms and have fires to keep them warm. And these were realities in the 1980s and early 1990s. I can document and visualize those things in my mind. We didn't have cameras or anything to take pictures. Like I said, we never thought we would live to see this time. We all worked in the Church-Wellesley Village until they slowly pushed us out.

Bleecker Street was a very prominent sex work stroll for years. I used to go there when there was no money on the other corners. Being pushed out from the better-paying streets made us have to work this cheaper stroll. It was back-to-back work. So, you'd make the same amount of money you would selling at another stroll, but you'd do more clients. Just like in Vancouver, you'd work downtown, you'd get a really good day, but if you went to Hastings, you'd do a few of them, and you'd get nothing.

They did eventually create another sex work area close by at Homewood Street and Maitland Street, a neighbourhood just east of the Church-Wellesley Village. They put a traffic light there to limit the stroll. Most of the resistance to us being there was from gay men, who were blaming the trans women who were around for the condoms found on the ground. And so I had to say: "Listen, I live in the gay community. There's always gay men having sex when I look out my window. Why do you get to have sex and we don't?" They had a website, these residents who wanted us out, on which they posted pictures of us. They were also attacking trans women and gay women working in front of the condominiums there, using flashlights and stuff to scare us off.

And then Toronto City Councillor Kristyn Wong Tam said: "That's illegal, you all can't do this." So she was actually supportive, and then she did a canvas through the whole area. But the residents still blamed the sex workers for anything wrong with their neighbourhood because they wanted us out. It's weird, even now if you go to a sex work area you'll see that they have either shut down all the twenty-four-hour coffee shops or they'd limit the hours that the cafes could be open. They don't want sex workers hanging in those places.

I have more stories. Lots. When *Street Outreach Services* (sos) formed, which was one of the first agencies focused on sex workers, there were a lot of front-line workers that were really supportive of trans people, because I think they were just moved by our situation. They loved the trans women that they were meeting through connecting with sex workers. At the time people were like: "We got these things for them. We've got these things." They did a lot of things just under the table.

CG: I want to speak to the white and cis readers and say your job is to support what Monica just said. Actually, I think you have to. You must really, in concrete ways, support the leadership of poor and working-class trans women of colour around the work that they're doing, whether they're innovating the work or resourcing the work. Literally, just ask: What do you need to support your work? Do you need bodies? Do you need connections? Do you need money? Do you need resources—what? Training? To be brought to the table on things? And then the other piece I see is really having those conversations and building up the capacity of other white cis folks to do that work as well, so that it is not left for trans people of colour to do.

MF: Yeah, because how much are people actually recognizing this reality and listening to us? We're at a time in history where the transsexual and genderqueer community is freer; we can be who we want to be now. There's still stigma, but we can have our own identities. We have shifted enough people to be seen in a different way.

I think people are ignorant of the life experience of people of colour and trans people of colour. It bothers me that people are not getting it, or that trans people of colour are not given validation. I can just talk from my own experience, being a trans woman.

I'm really committed to the work that I do, and sometimes I just hate when people question what I'm doing, or if I'm doing enough. If anyone knows me, they can see that I'm helping. Would you save that scepticism for someone else? Or they think that the work that I'm doing is not hard work. It is hard work, mentally and physically. It's a lot to be able to get through the day sometimes and to see things that you can't change. As a person of colour, I've experienced that I have to prove over and over again that I'm valuable, that I deserve to be validated and recognized. I get a lot of high praise from people that I'm around, but when you shine too bright people don't like that.

I'm also expected to move away from my street community. I get people who say: "Why do you hang with those types of people?" I reply: "These are people that have sheltered me, educated me, given me family."

CG: It's so infuriating because you and other folks who are part of your community have just created so much that so many of us continue to benefit from. You're recognized as a community builder, and if somebody doesn't know who you are, there's a problem. What are you doing with your life that you haven't figured out who Monica Forrester is?

SMW: I started my transition early and it was back in the day, in 2000. By 1999, I already knew trans people, mostly trans people of colour—trans women of colour, Indigenous trans women, trans men of colour. It was because of the organizing that you all were doing. I would say hundreds upon thousands of people's lives would be different if you hadn't done the work that you've done—the space to come out and find a sense of home and, as you said, love themselves and love their bodies and love who they are.

MF: Well, I even came out at a time where you needed to sleep with women or with cis-people, look a certain way, dress a certain way, all in order to be accepted as a trans woman. You had to be hetero, whatever that looked like. I kind of broke all those kind of boundaries. I never differentiated gender and sexuality. I'm more queer-identified now, and back then having to sleep with just one sex to be validated as a woman was just hard. I'm glad, because today we can identify sexually and in terms of gender. It's so different now, which is a great thing. But we're still in a place where trans women aren't being validated for their great work, which is very patriarchal, and about colour and creed. I know a lot of trans women from different areas, and I work with a lot of Black trans women and trans women of colour. Understanding their analysis is important.

People need to understand that sex work is not only about survival, but also about building community. Sex work and the corner was where we found our partners, where we were validated for who we were as people who have beautiful bodies and as people who love those bodies. People need to understand that. Trans sex workers in Toronto have created communities and built networks across this country. We developed resources that have put crucial information into the hands of trans sex workers and their allies— resources that will allow us all to survive and thrive!

2 | It Was a Heterotopia

Four Decades of Queer of Colour Art and Activism in Toronto

Jin Haritaworn interview with Richard Fung[1]

Jin Haritaworn: You are not only an internationally acclaimed writer and filmmaker but have also co-founded and been part of various queer of colour spaces in Toronto. How did you come into queer of colour consciousness?

Richard Fung: Queer of colour, that convergence for me first came about in 1979, when I read an article by Gerald Chan called "Out of the Shadows"[2] in the pan-Asian magazine *Asianadian*. It was the first time I'd ever seen gay identity articulated within an Asian context, so I became involved in the magazine. In the same year, Tony Souza and I went to the First National March on Washington for Lesbian and Gay Rights and attended the First National Conference of Third World Lesbians and Gays, which was organized by the National Coalition of Black Gays. Audre Lorde gave the keynote speech, and that was the first time I came into conversation with other people who identified as gay and lesbian Asians. A year later, I helped found Gay Asians Toronto (GAT). That was the main period of organizing.

JH: You've written a lot about that period. Could you take us back to a few of these organizing spaces? Since we're both interested in queering urban space, I'd love it if you could map them out for us.

RF: Let's start with Gay Asians Toronto (see also Alan Li, this book). Three spaces were significant. The first is the 519 Church Street Community Centre at Church and Wellesley, which is where we met. At that point, things were just shifting from Yonge Street, which is where all the gay bars had been until then. The second is the *Body Politic* (*TBP*) journal, which

was in many ways a forerunner of what later became queer theory, through which GAT was advertised. A lot of early articles were published there. The *Body Politic*—located at Richmond and Duncan—was then the most exciting queer intellectual publishing venture. My partner Tim McCaskell was a member of the *TBP* collective and I volunteered. The third significant space would be Chinatown because that's where we first advertised outside of the Yonge Street area.

JH: You mentioned that things were happening in Yonge rather than Church then.

RF: At the time, people hung out in that strip of Yonge Street between Bloor and Carlton. That's where all the action was—where all the bars and the clubs were. In fact, when I first came to Canada as a student, before I came out, I remember hearing about people going to Yonge Street to throw eggs and tomatoes at the drag queens entering the St. Charles Tavern on Halloween. So queerness was very spatialized in that area. There were gay baths, but they weren't really part of my world then. Paul Cheung says in *Orientations*,[3] my first documentary, that race mattered less in spaces for anonymous sex. For example, if you go to parks and have sex at night, you're not really seeing people that well, right? From what I've heard from friends who did washrooms, it was less about hierarchies of body types, including race. He says where race mattered more was if somebody saw him in a bar and did not know whether he spoke English or not.

JH: Were there specific bars on Yonge Street that gay Asians would go to?

RF: Yes, there was a place called The Quest, a bar just south of Bloor on the east side of Yonge. Paul Cheung, in his interview for *Re:Orientations*,[4] my follow-up to *Orientations* in 2016, reminded me of that. He says you'd see all these Asian guys lined up against the wall. So, talking about space, I remember in the early 1980s going to a bar on Yonge Street. I forget the name, but it was upstairs, just south of Wellesley, it didn't last long. I'm going upstairs, and the person at the door is asking over and over, "You know this is a gay bar? This is a gay bar. You know this is a gay bar?" And then my realizing that somehow he was thinking that "Asianness" and "queerness" were mutually exclusive. Because I'm pretty faggy, but he couldn't even read the code. He just assumed.

JH: Was that more likely to happen then than now?

RF: I think so. It was a homophobic period. I haven't recently seen that kind of concern about security, about who might get in and cause trouble. I think now they'd be happy to have anybody in the Village. My sense is that the neighbourhood is dying. I think this is due to a number of things, including the way nonconforming sexual and gender identities have become more naturalized and are able to flourish in other parts of the city, particularly in the West End, Queen Street. And so it's very much generational and subcultural, who hangs out on Church.

JH: How did queers of colour engage with Church and Wellesley?

RF: It was a place where everybody went. There wasn't a lot of choice after things moved from Yonge Street. Yonge Street was interesting because it's also the major spine of commerce in the city before Bloor Street, right? Bloor Street was on the rise, but it wasn't upscale the way it is now, where you could walk on this block and see the names of international designer brands. Yonge Street had more traffic, was more important to the life of the city at that point. Queer folks could go there but you would also blend in with everybody else because it was not a queer-only space. You couldn't really tell who was there and for what. It provided a certain visual or spatial alibi. But when things moved to Church and Wellesley, you definitely were in Church and Wellesley—there was nothing else there. It became suspicious why you were there, right? There is a way in which queer bodies or queer and trans performances became more visible in that space. There was not much choice of where to go, so people all went there. And I think there are different registers of the space. You might have read about The Steps in front of the Second Cup coffee shop, where a lot of youth and less entitled folks hung out. And there were all kinds of debates as to whether they should get rid of The Steps (see Aemilius "Milo" Ramirez, this book).

JH: The third significant space was Chinatown . . .

RF: Yes. We would put up posters in Chinatown. Tony Chung would tell us which places we shouldn't poster on because they were connected to triads. He knew the Chinatown community really well. Tony died in the AIDS crisis in the 1990s. He came from a working-class Chinese family from Hong Kong, and he lived down the street from me in a Toronto Housing complex. He was one of the earliest, most committed members of GAT. In many ways, he was the backbone of the organization, but he never took a

leadership position. I think this had a lot to do with class and language—English fluency and cultural capital, basically.

JH: So it was the middle-class people who ended up in leadership roles in Gay Asians Toronto?

RF: People like me. I've always reflected on the fact that I'm Asian but also that I'm from the Caribbean, so English is my first language. There are all kinds of privileges that allowed me to ... even come out, right? A lot of the people who were involved in that early movement were international students from places like Hong Kong. In some ways, they literally had the capital, they had time and a certain entitlement that comes with class. But also, the families were mostly not here, so they could enjoy the freedom to be out and move through space and not worry about who saw them. One of the early people involved was part of a set of identical twins. I knew the family because they were also from the Caribbean. He had never discussed his sexuality with his identical twin. And he lived in terror because someone might approach his brother thinking it was him and have a conversation they shouldn't be having. As it turns out his brother, who was married at the time, subsequently came out as well.

JH: How about power distributed along intersectional lines of gender, race, and class?

RF: I envisioned Gay Asians as a pan-Asian and multi-gendered organization. But there were many more people of Chinese descent than any other ethnicity, both in the city and in the lesbian and gay scene at that time. Tony Souza, who is from Kolkata, India, was one of the four founders but he fell away relatively quickly. There were some Filipinos who came and stayed involved, like Nito Marquez. I remember one particularly active Vietnamese man. There were no Koreans, which had to do with the later migration history. So Gay Asians became very much Chinese dominated. Before we launched the group, we tried to find other people. I remember having a conversation with the poet Suniti Namjoshi and trying to convince her to join before the official founding. But she wasn't interested, and there was never a critical mass of women. So, you know, we would get one woman, and there wouldn't be any other women there. She would not return the next week, but another woman would come the next week. So that remained the case.

JH: What do you think about the new generation of queer Asian organizing?

RF: In 2014, I went to a Freedom School performance in a church on Bloor Street. I was taken aback because it was the *Asian Arts Freedom School*, but it was very mixed.[5] There were white, Palestinian, and Black participants, and there were different kinds of Asians. So that was really interesting. Also, I'd say Tim McCaskell and I were the oldest people there by far. There were a lot of teenagers, some with their parents. It was certainly not a space that I had experienced before. There were parents who were supportive. The odd parent would come to events at Asian Community AIDS Services, Gay Asians Toronto, Khush, or Desh Pardesh. But we weren't teenagers. I think there is a big generational shift among parents who came of age after the 1980s and who have themselves grown up in an era of sexual and women's liberation, in which questions of gender and sexuality are thought of as much more fluid, which influences the way they are thinking of their own children.

JH: In *Re:Orientations*, self-reflexivity is key. You invited a few of us to watch the rough cut at OCADU together in 2015. And you spent a lot of time reflecting on who was represented in the earlier *Orientations*, and who wasn't.

RF: Already in the making of *Orientations*, I was doing some engineering. Even at that time, I remember having a critique of a certain "born again" Asian sensibility that was developing. It was developing because for many people, their Asian identity, living in this particular diaspora, was a source of pain, of shame, of minor traumas, of feeling outside, feeling unattractive, feeling unwanted. This was around questions of desire, but also around stereotypes of Asian cultural expressions—like the media controversies around dog eating in California. So people were rediscovering their identities, but I had a number of critiques. One of them was around the question of class. In order to justify queerness, people were reclaiming stories, for example the Chinese stories of the shared peach or the cut sleeve, which were really stories of emperors. And I was thinking, what does my queerness have to do with emperors? What do emperors have to do with my peasant background? Another thing was my having come to thinking about organizing gay Asians through an anti-racist framework that was formed through Black Power in Trinidad in the 1960s. I was disturbed by an incipient ethnic nationalism, where Asianness was only thought of in relation to white supremacy and not in relation to other people of colour, and not in relation

to the relative privilege that Chinese origin, say, has in relation to people of other "racial groups," including other Asians. I remember having this conversation with Nito Marquez, who was from the Philippines, about the way Filipinos signify in an Asian regional context, where Filipinos are often domestic workers in places like Hong Kong or Japan. So I became disturbed by the self-satisfaction that I saw among some light-skinned Asians, to put it crudely. I'm not talking about GAT; this was a continental phenomenon. And so I found myself kind of drifting away from that organizing and into doing other things. This was a period when I didn't feel connected to a lot of initiatives that were happening around Asianness because I didn't see the Asian umbrella being necessarily progressive. I feel more connected to the QPOC or QTBIPOC reframing because it is more of an anti-racist and social justice framework. In terms of my own journey, I moved into doing other things that were more anti-racist and perhaps less queer-focused. As a filmmaker, my next project after *Orientations* was *Chinese Characters*,[6] which is about gay Asian men's spectatorship of porn. And then I felt I was being made into a kind of "gay-Asian-video artist," and that's when I did *My Mother's Place* and *The Way to My Father's Village*. In that same period, I made *Out of the Blue*, which was about police racial profiling of a young Black man whom I knew. And I started thinking about questions about colonialism particularly in relation to the Caribbean.

JH: You were also part of Desh Pardesh, "a festival of culture, politics and activism," which became one of Toronto's major cultural events and one of the most important expressions of South Asian contemporary culture and politics in the diaspora in the late 1980s and 1990s.

RF: I was not an organizer of Desh Pardesh, but I think I attended every one and was close to that crowd. Having grown up in Trinidad, in a country in which the majority of the people are of South Asian origin, I always felt comfortable in South Asian spaces. I worked with Ian Iqbal Rashid, the poet and filmmaker who was an organizer of the South Asian gay group Khush. He initiated Salaam Toronto, which then became Desh Pardesh. I still feel more comfortable in South Asian spaces in some ways than I do in Chinese spaces because in South Asian spaces, most people have come through the same British colonial formation that I have. I've now also spent a fair amount of time in India, so when I'm around people with a background in Hong

Kong, say, I feel outside of the conversation, whereas in the South Asian context, I have much more sense of the landscape.

Desh Pardesh happened at the Euclid Theatre. The Euclid was at the corner of Euclid and College Streets, west of Bathurst. It was birthed in 1989 by the Development Education Centre (DEC), where I worked alongside Ian Rashid. I was part of DEC films, which at that time distributed the largest collection of documentaries in Canada. The Euclid was an interesting queer and anti-racist space. In 1991, it hosted the launch of Inside Out, Toronto's LGBT Film Festival. And that same year we organized Race to the Screen, a series of panels, lectures, workshops, and screenings about race/ism and cinema. We had people like Kobena Mercer, Molly Shinhat, Atom Egoyan, Jamelie Hassan, and Richard Dyer come to the conference. It was an anti-racist film festival with a queer component.

DEC was a huge organization that housed a radio project and independent left-wing publisher Between the Lines. Another publisher that was a hub of Black feminist, Black queer, and queer feminist of colour organizing in Toronto was Sister Vision Press. Sister Vision was founded in 1984, in the same year and place as Zami—in the Dewson Street house, which is close to Dovercourt and College. In that collective house lived Makeda Silvera and Stephanie Martin who ran Sister Vision. But it also housed other Black, Indigenous, and Asian queer folks including writer Connie Fife and Debbie Douglas and Doug Stewart who in 1984 helped found Zami, the first Black lesbian and gay group in Toronto.

The timing of the Euclid Theatre was just slightly off. We were at College and Euclid, which at that time was not yet fashionable. It was just not a destination. I think today it would totally be sustainable, but at that point it wasn't.

JH: I am interested in this intimate history of contact, both spatially and politically, between Black people and people of various Asian origins. How did these coalitions, solidarities, and affinities play out in your personal and professional life?

RF: Relatively early on, Gay Asians organized the Grassroots Conference with Zami at 519 Church Street. It was Toronto's contribution to the Third World conferences. In 1993, the gay Black men's group AYA succeeded Zami. AYA's fashion shows and GAT's CelebrAsian concerts were important in

Toronto's cultural calendar. AYA collaborated with artist-run centre YYZ to bring the theatre troupe Pomo Afro Homos to Toronto in 1994.

Now Zami's interesting because it was Black and Caribbean. This is a problematic to be worked out, because Caribbean spaces are so different. If you come from Jamaica or anywhere in the Anglo-Caribbean north of Trinidad, it's very much an African Creole space. But if you come from Trinidad or Guyana, the majority are Indian. It's interesting to think of that geographical relationship, because I'm from the Caribbean. I have one foot in the Asian community and one foot in the Caribbean community.

I was pretty close to Debbie Douglas and Douglas Stewart, who were very much the leaders of a number of organizations around Black queer convergences. In fact, Debbie and I met when we were both students working for Tony Souza at the Toronto Board of Education. She was a high school student and I was making videos, and we became friends. So in that period, there was much more solidarity among the groups that, decades later, have now come back in the form of QPOC and other initiatives. I see a critical mass of different groups of people of colour working more closely together now.

JH: How have queer of colour solidarities developed over the years?

RF: I see more of an openness, even though people may not be of African descent, to be attentive to supporting Black Lives Matter, for instance. I think that's a kind of political literacy that affects people who are QPOC identified, because QPOC identity has more of that anti-racist orientation. It is a kind of pan-ethnic, pan-racial identity, which means that people are negotiating the differences.

JH: There's something about being in a small community that's shot through with difference, right?

RF: Yeah, people have to be aware that they're different from each other and it seems to be negotiated more elegantly, whereas much of Chinese Canadian discourse was thinking only in relation to white supremacy. When I did *Chinese Characters* in 1986, I purposely cast Lloyd Wong making out with Doug Stewart. Many of us had never seen Asian-Black bodies in a sexual embrace in film. It's always the white man who's imagined as the object of desire.

This was also one of the big issues for GAT. There, it was more around the right to have Asian-only spaces. We often had discussions about people

bringing partners, particularly white men who wanted to attend meetings because they somehow felt Asian or were interested in Asian men or whatever. I was one of the people who remained firm about this because the kinds of things people were sharing, when it was their first time in an Asian-only space, about racism, couldn't happen in a mixed space in the same way.

JH: I'm struck by how much of your work is about de-centring whiteness in our interactions with each other and with other people of colour. Could you speak about the relationship between non-Indigenous people of colour and Indigenous people in your organizing?

RF: In the 1980s and 1990s when Indigenous cultural politics really blossomed, there was a tendency to create a separate space. In discussions between people of colour and Indigenous people around filmmaking, for example, Indigenous people would often say "This is not just about racism, but it's primarily about sovereignty," and make clear the difference between just an anti-racist lens and an anti-colonial one. Since that period, I think racialized activists and artists have become better at recognizing the settler colonial character of Canadian identity, and I for one have been in more working relationships and friendships with Indigenous peers.

JH: You once mentioned Chinatown as a queer space to me. Could you talk about that?

RF: One of the first Pride marches was at the Grange, which is near Chinatown, and went through Chinatown.

JH: That's interesting, because in summer 2015, there was an event in Chinatown that in the invite was announced along the lines of "Let's reclaim Chinatown." Chinatown was described as a homophobic space. Some queer Chinese folks I talked to actually had questions about this, because they didn't experience Chinatown that way.

RF: No, in fact, Chinatown was a site of early lesbian culture in Toronto in the 1940s and 1950s, which is documented in Lynne Fernie and Aerlyn Weissman's feature film *Forbidden Love*.[7] It's a classic of Canadian cinema, a classic lesbian documentary, and has just been re-released. I was doing a book project with Elaine Chang, who is a Korean Canadian film scholar and English scholar at Guelph University. We wanted to do a book on Keith Lock, who is the earliest Chinese Canadian filmmaker. We couldn't find a publisher, but one of the things in Keith's amazing recollections is hanging

out as a child in his father's pharmacy in old Chinatown. Keith actually has a lot of memories about Chinatown as a lesbian space. He remembers the dykes and their partners and the whole scene. You know there's the idea that in Chinatowns, anything could happen and the outside rules didn't really apply. Yes, it was a heterotopia.

That was one of the frustrations I had within the group discussions at Gay Asians. People would always narrate the homophobia they'd experienced with an Orientalist explanation. "My parents are Indian," or "My parents are Chinese, so therefore they can't deal with these sexualities and will throw their kids out." But when I thought about the levels of acceptance and rejection, it's not really different from the stories of white families that I know. Except white people don't narrate their homophobic experiences as about whiteness: "Oh this is like a Christian family." Whereas racialized people tend to use that fall-back.

I just had this conversation with El-Farouk Khaki. Twenty years ago or so, he asked me to write an affidavit in support of a Trinidadian refugee claimant. And I remember having to write that letter, which I was happy to do, to get this person out, but also realizing how I had to construct that space as barbarous and this space as tolerant. I remember thinking that the stereotypes that had to be engaged to get the claimant in would then dog him once he came to Canada.

I still find it interesting how so many people are still resistant to acknowledging that space is always complicated. Like the discourse around Jamaica, for example. When you talk to people who are very close to Jamaica, there is an acknowledgement that things are changing. For people who are in Jamaica, often there is no choice. They're committed to that space. Whereas the refugee discourse is: "We have to get people out." And in Canada, Jamaica often stands in for the whole Caribbean. People seem shocked that in Trinidad and Tobago, according to a survey a few years ago, sixty percent of citizens support LGBT rights. So who speaks for the space? How does space get characterized?

JH: I'm interested in how the suburbs emerge as a geography in *Re:Orientations*—interviewee Paul Cheung talks about growing up there. Because the suburbs are also racialized spaces, right? There's Peel Pride, which was QPOC organized, but got defunded, I think in part because of

racism. It was an interesting attempt to queer Peel and de-centre downtown Toronto as *the* place where queerness happens. Because for many QTBIPOC, in our context of gentrification, the downtown is a whitening space that's no longer where it's at.

RF: In *Re:Orientations*, Ponni Arasu says that one of the first things she did when she moved to Toronto was to participate in one of the first conversations about queer issues in a Tamil context. This happened in Scarborough, I think it might have been Malvern. She said that if you look downtown, talking about queer stuff, moving in queer circles in academia or the arts, racism would be the experience you feel. That would be the thing that marks you. But if you're Tamil or Sri Lankan and living in one of the city's working-class immigrant neighbourhoods, racism might not be the most pressing issue—like if you're living with your family, among all the uncles and aunties and the extended community. I really appreciate this insight because I think that's true.

JH: That's really interesting. I still think racism impacts why this isn't happening more. Now that homonationalism and gay imperialism have become *the* queer discourse, there are more opportunities for racialized queers to claim voice and visibility. There are more incentives to go on about the homophobia in our communities. At the same time, there's less incentive to actually engage in this complicated work to challenge queerphobia in racialized communities and anti-racist and anti-colonial struggles, and transphobia in lesbian and gay of colour spaces. I think the people who specialize in performing their communities as barbaric, who capitalize on the gay imperialist discourse, are actually less likely to engage in this complicated work. Because racism orients us towards whiteness and away from other people of colour, straight and cis POC, but also other QTPOCS.

RF: That's exactly so. I think there was a way in which people talked about homophobia back in the 1980s that would often orientalize it. But then those of us who are more conscious around anti-colonial discourses, we sometimes avoid that discussion altogether, right?

3 | Power in Community

Queer Asian Activism from the 1980s to the 2000s

Alan Li[1]

There is a popular myth that I co-founded Gay Asians Toronto, which isn't true. But I have been involved with queer Asian community organizing since I moved to Toronto in 1981. I consider my primary community to be the LGBT Asian community and communities of people of colour. I have been part of LGBT organizing, HIV/AIDS work, the anti-racist movement, immigrant/refugee rights, and work to advance health care access for different marginalized communities.

I first moved to Winnipeg from Hong Kong when I was sixteen. I spent five years there before coming to Toronto. At the time, I was only somewhat out and aware of my sexuality. There wasn't any queer community in Hong Kong where I had come from, and there was a gay community in Winnipeg, but you could count the queer Asians on one hand or less than two hands. There were perhaps four Asians that I would see at events, and maybe a couple of Black people. It was many years ago, and I wasn't very involved, but I don't think there was a whole lot of community organizing happening. I just vividly remember how isolated I felt whenever I went to the gay community events there.

Before I got into med school at the University of Toronto, and before I became so active in gay Asian community organizing, I started to stumble upon gay literature and gay novels like *The Front Runner*. I remember going to Coles bookstore on Portage and Main Street in Winnipeg. It's a mainstream bookstore, but my "gaydar" would look out for paperbacks with two

men on the cover. I'd buy those books and read them. There were also some newsstands that sold gay magazines. I first connected to print media to find gay spaces in Canada, and that's where I saw an ad for Glad Day Bookshop. So when I visited Toronto, I went right to Glad Day. I think it was on Collier Street then, under the public library on Yonge and Bloor. It was a wealth of different worlds I hadn't been exposed to, so I was really excited. And then when I moved to Toronto, I think in the summer of 1981—the bookstore might have moved to Yonge and Wellesley by then—the store manager told me about an event that was happening called Chopsticks. That's where my real connection to communities and organizing began.

On the Beginning of Gay Asians Toronto (GAT)

Gay Asians Toronto had just formed months before the famous bathhouse raids in February 1981 (see also Richard Fung, this book). In those raids, over three hundred people had been arrested in a sweep of Toronto's gay bars, and it was an incredibly eye-opening time. I'd estimate that one hundred or so people were there in the auditorium at the 519 Church Street Community Centre, where Gay Asians Toronto hosted Chopsticks. This was a fundraiser for the Right to Privacy Committee, an activist organization that had formed in resistance to the raids on gay homes and businesses that were prevalent at the time. Before I experienced Chopsticks, I'd never realized that you could do something like that or have a community like that. There were songs and dance, poetry, performances, and speeches about the bathhouse raids and the need for organizing, all hosted by a core of Asian organizers from GAT, one of whom, Tony Chung, later became one of my best friends. Other core organizers of the event included Paul Cheung and Pei Lim. They were both interviewed by Richard Fung—the queer Asian filmmaker—in his first documentary about gay Asians called *Orientations*.[2] I remember that Pei Lim performed dancing and poetry at the event. Later on he would become one of the earliest AIDS activists among the Asian communities in Canada. He passed away in the early 1990s. I remember the poster better than I remember the actual event. It was an Asian man with huge chopsticks. Most of the connections that I had made before that event had been through print and mail, but the organizers of Chopsticks invited me to discussion groups, and that's how I got involved.

According to my early history lesson about our community's history, GAT was conceived when Richard Fung attended an LGBT conference in Washington in 1980, where he met other gay Asian activists from Boston, San Francisco, and beyond. When Richard came back, he wanted to see if there was any interest locally. Around that time, Gerald Chan, a Chinese gay man from Hong Kong, wrote an article in *The Asianadian* magazine about gay Asians called "Out of the Shadows." So they connected, and then they put an ad in *Body Politic*—the Canadian gay liberation magazine at the time—and called a meeting. Tony Souza and Nito Marquez showed up, and the four of them started to plan and formed GAT. I joined about half a year later. By then GAT had established enough of a community base to organize events such as Chopsticks for issues that affected the whole community.

GAT started as a bi-weekly discussion group which happened on Saturday afternoons at the 519. We usually had between eight and fifteen people each time. We discussed topics like coming out, family, sexuality, identities, and intraracial and interracial relationships. There was no such term as sexual racism at that time, but people were talking about the challenges they felt due to not being considered attractive in the gay mainstream. There was a bar called The Quest, which was on Yonge and Isabella. That's where all the gay Asian men went on the weekend. We would see flocks of Asians that were probably ten times larger than what we would see at GAT meetups. It kind of begged the question: "Why don't any of these people come to our discussion groups?" There was a sense that our discussions were too serious and too political, and that the social spaces were for fashion queens who didn't care about anything. There were divisions, but after having come through many years of difficult relationships with straight-identifying men, I really appreciated the fact that there was a gay Asian community. And I really wanted to bridge those two worlds.

I wasn't really set out to be a political queen, and I wasn't set out to be a fashion queen; I think people can do both, and I think that the social is political. There's value in social spaces and events that are trying to connect people. So I got more involved with GAT and advocated for more social activities to bring people in and explore ways to tap into other people's energies. People get a little tired of the recycled discussion topics after a year and a half, because the same people talking about the same issues loses its newness or

need. I think that a lot of the core organizers were Canadian-born Asians or people who were not born in Asia, so there were some cultural and language differences. But Tony and I were both first-generation immigrants, and we shared a lot of similar interests. I think he also wanted to bring in the more "social" Asians to the more political organizing, and so growing from the idea of Chopsticks, we started to organize parties. We also organized creative projects where people could work together. A lot of the Asians who wouldn't ever come to discussion groups showed up to our events.

We organized an event called CelebrAsian in 1983, which was also at the 519. It had the same name as the magazine we later put out. I think it was the first fundraiser for HIV/AIDS, before the AIDS Committee of Toronto was even formed. It was at that very beginning, when HIV wasn't even identified yet. People were just dying mysteriously of a gay plague. And we thought it would be helpful to make the event a benefit for something broader than our communities, so we did. I think we raised five hundred bucks. It was a smash hit at that time by any standards. We filled the auditorium at the 519, and people were very excited because we had created something together. The next year it became much more elaborate and we had a drag show and other performances. Before then GAT was pretty much an exclusively male space, and then in 1984, at the second CelebrAsian, we had Asian lesbians performing and co-hosting the event. I went in drag and Ming, an Asian lesbian, went in male drag and co-MC'd the event with me. One of the highlights of CelebrAsian 1983 was a slideshow called "The Visible Invisibles," created by a student called Jonas Ma who was interested in doing an oral history project on gay Asians. The smart title of the slideshow referred to the visibility of race and the invisibility of sexual orientation. At that time there was also a very popular drag group called The Oriental Express. It initially had four people who started performing at The Manatee, which was a club on St. Joseph and Yonge, right where all sorts of condos are being built now. Oh goodness, it makes me feel old. The Manatee was a short street across from The Quest, which was the "rice bar." On weekends, The Oriental Express would draw hundreds of people to see their shows, and they agreed to perform for CelebrAsian.

We were galvanized by the event itself, but also by the process of organizing it. Having people who had no sense of community before, who were

willing to identify with a queer organization and come together for a cause, may not have been overtly political, but it was definitely meaningful and important. As I will discuss later, CelebrAsian(s) has been one of the key themes and threads running through the history of GAT. It became GAT's signature event, hosted again in 1984 at the 519, in 1985 at the Ontario College of Art (later OCAD), in 1988 at Jarvis Collegiate, in 1990 at OCAD again, and in 1995 at the York Quay Theatre in Harbourfront. Shortly after the first CelebrAsian show, we also started putting out a quarterly newsletter magazine by the same name, and it published over twenty issues until the mid-1990s.[3] In addition, *CelebrAsian* was the title of an oral history collection by Gay Asians Toronto (1996). Today, CelebrAsian is the biannual fundraising event for Asian Community AIDS Services. Through the CelebrAsian event series, GAT and its successor organizations have become a much bigger and more inclusive community.

In 1985 we co-hosted the International Lesbian and Gay Association (ILGA) conference in Toronto. GAT members were involved in the core organizing, and *CelebrAsian '85* was the conference's closing event. It was held at OCAD, in the auditorium, which looks very different now. It wasn't an Asian-only event; it was an event for the whole conference, so we had many different famous local LGBT performers like David Sereda and Faith Nolan. Wayson Choy, a gay Asian teacher who later won the Trillium Book Award for his first novel the *Jade Peony*, wrote a play especially for the show called *Smashing Borders*. It had a lot of different people in it, including many other activists and community leaders like Mary Woo Sims (who led the campaign for same-sex spousal benefits in Ontario), Doug Stewart (who co-founded the Black Coalition for AIDS Prevention), and gay and AIDS activists like Pei Lim and Russell Armstrong. Some professional theatre actors who hadn't been involved in the community before volunteered to costar in the play. We also had out of town guest performers among the delegates. Asian Lesbians of the East Coast from New York did a Hawaiian dance and some skits on coming out to parents for the event.

GAT also co-organized a whole series of people of colour workshops for the conference. We planned discussions and workshops about POC and diasporic issues in white-dominated societies. We co-organized various workshops with other people of colour LGBT groups such as Zami (Black

lesbian group), Khush (South Asians gay group) and ALOT (Asian Lesbians of Toronto). During the planning, we connected with groups from San Francisco, LA, New York, Calgary, and Vancouver. There were people at the conference from all over the world. One of the people who attended was the publisher of a gay magazine in Japan who was planning a gay Asian conference in Japan the following year. So through that conference we made connections, and we sent one of our members, Gary Joong—who also appeared in Richard's *Orientations* video—as a delegate. I think that was our first connection outside of North American Asian organizing. The connections being made and the growth were amazing.

On Rice Bars

I mentioned The Quest as a place where queer Asians hung out. It was by no means an exclusively Asian bar, but Asians would hang out there, and it was considered a rice bar. I don't think The Quest marketed specifically to Asians. I think what happened is that people started to go there and then they realized there's enough of a critical crowd of similar people hanging out that they just started to claim that space. In every city, in every place there is your lesbian bar, your Latino bar, your African-Caribbean bar. People will find their own space and somehow claim it. People migrate more to a place where they see more people like them. It's where queer Asians would go to have a sense of community and social space. It's kind of like why people form Chinatowns; it's because the rest of the place is racist so you need a safe place to live and survive. It was somewhat hostile in the larger gay environment, so people went there to feel like at least they wouldn't stick out so much, and they wouldn't feel like they didn't have anybody to talk to.

So instead of going to mainstream dance clubs and bars, we created our own spaces and ethnic gathering places. The Quest was one. The Manatee was more like a youth bar; it was an after-hours dance club, so after the other bars closed people went there. It was for dancing rather than drinking, and community groups would perform. That's where the Oriental Express drag group became very popular. On Saturdays, we would usually go to the Quest from ten to midnight, and then we'd migrate to The Manatee and watch the shows, and then people might go out for late night snacks and whatever else they do when they don't want to go home. Since then, different bars got

created and the ethnic concentration has become a little bit more diffused. I don't know if there is really so much of an Asian bar now.

I think people tried to find those spaces because the sense was that we were the exception rather than the mainstream taste. So if you go to a bar where a lot of white guys hang out, the chances of you getting picked up or people finding you interesting is less. If you go to a bar with a lot of similar people hanging out, then the people who are attracted to people like you will probably frequent those places. Most couples were interracial at the time. I think Gay Asians Toronto organizing kind of changed that, because a lot of people found out they were actually attracted to each other. There were more Asian-Asian relationships. Before that, it was very isolated and we were just at the mercy of being picked by white people.

On Gay Asian Cultural Interventions

1982 was a historic year for GAT. We led the Pride march through Chinatown that year. I think that was the second year Pride happened. The Pride cele-bration was supposed to take place at Grange Park, which is in Chinatown. The first year it took the community by surprise, so there were no protests or oppositions to it. I think when the Pride organizers went and applied for a licence the second time, they had some opposition from the neighbour-hood and the Chinese Canadian associations there, who said that this was "not culturally appropriate," that there was "no queer Asian community," etc. At that time, after Chopsticks, I also started volunteering at Glad Day Bookshop and hanging out there because I loved the books. One day I met one of the Pride organizers at Glad Day, and he spoke about how they were trying to find a gay Asian speaker for the event to counter the assertion that there were no gay people from the Chinese or Asian communities. For some mysterious reason, nobody else in my group was able or willing to do it. I was a relatively newer member, and it ended up in my lap. I wasn't really that out then, but I just thought it was too important an opportunity to miss, and so I had seven mentors who helped prep me emotionally and write my speech. My speech was about coming out and negotiating how my family would feel. It was actually quite well received, and we were able to convince twenty-some people from GAT to march through Chinatown together, which is probably nothing by today's standards but in 1982 it was groundbreaking.

Marching through Chinatown was not like marching in the gay neighbourhood. There were no people lining up the streets to welcome you or applaud you. It was really quite scary but also very liberating and very inspirational. I think that it was a turning point; some of the less politicized Asians also felt that it was a moment of pride for them.

Later in the 1990s, after GAT formed the Gay Asian AIDS Project and eventually ACAS (Asian Community AIDS Services), GAT itself became quite dormant. But at the same time, the queer Asian community had also become more diverse. There was a group from Mainland China who called themselves the Toronto Tongzhi Club or TTC. Tongzhi is a Chinese term for the LGBT communities in China that means comrades in the traditional sense, but also gay. There was also the gay Vietnamese Alliance, a group called Scented Boys that specialized in organizing outdoor parties, Asian Express that hosted monthly dances, and an Asian Lesbian group that was trying to re-form again after many reincarnations since Mary Woo Sims first formed ALOT (Asian Lesbians of Toronto) in the early 1980s. They all marched in the 1998 Pride Parade. I remember this because I had a friend from Hong Kong who was here and we went and took lots and lots of pictures, and there were six or seven different banners from queer Asian communities. However, even with all these diverse groups, there was no central place where people actually discussed and strategically organized around issues or planned programs. So at the end of the 1990s, some gay Asians started to talk about the need to revive GAT because there seemed to be a void in community planning and advocacy. One of the issues that were brought up was that a lot of Asians were being carded at bars and events. It seemed discriminatory, and there was no place in the community that would take on those kinds of incidents. So we actually came together and formed a new GAT board. It became a more gender diverse and racially diverse group.

The emphasis during this time was on visibility. A major milestone was the above-mentioned oral history collection *CelebrAsian: Shared Lives*, which includes the stories of twelve gay Asian men, including Richard Fung's and mine. Both the book and the longer-running *CelebrAsians* magazine featured people's personal stories. Back in those days, having your photograph published in a gay magazine was a big political coming out statement, and we had to negotiate and get explicit permission from each person before we

could print their picture, even if it was from a public event or party. Now, hundreds and hundreds of Asian people march at Pride and aren't afraid to be photographed. But it was a different world then. Having our life stories published was a pretty major historic thing.

More importantly, the book was a catalyst for another event that became one of the key defining moments in our community's history. Our book launch was covered in all the Chinese media, and that raised quite a few eyebrows from the homophobic sector of the Asian communities. A month or so after the book came out, the father of one of the guys who was interviewed in that book, Chung Tang, brought a Chinese tabloid to our office that had the front page headline: "Do people afflicted with homosexuality deserve to have pride?" He said that we should do something about it. This was the first time ever in our community's history that a parent asked us to stand up and fight homophobia. It ended up kick-starting a whole anti-homophobia campaign for the queer Asian community, which was truly groundbreaking. The article talked about homosexuality as a disease, and that gay people should be ashamed rather than proud of themselves. They printed pictures of GAT in the parade as part of their story, so we decided to use that as a ground to threaten to sue them for libel. With pro bono support from some lawyers in our communities, we threatened them with a lawsuit, and we also mobilized many allies from diverse communities to flood them with protest letters. Within weeks we were able to get them to issue a full apology and retraction on the front page of their next issue that said: "We are wrong and we are sorry, we apologize to the lesbian and gay communities." They also gave us equal coverage to run our side of the story.

These kinds of gay Asian cultural interventions worked to transform the mainstream Chinese Canadian community too. They were only possible because of the coalition building and partnerships we built during the years of organizing around HIV/AIDS when our communities finally came out of the shadows and claimed our place at the table among the mainstream Chinese and Asian Canadian community services network. Through our coalition work, we also built relationships with progressive allies, high profile social justice advocates and Asian community leaders like Olivia Chow, Susan Eng, and Dr. Joseph Wong. So when the time came to take a stand, we were not alone.

On the AIDS Crisis and the Creation of
Asian Community Aids Services (ACAS)

Even though I am a physician by profession, I think I came into HIV/AIDS work mostly as a community member and a volunteer. One day in the mid-1980s, when I was still a medical student, Doug Stewart from the Black gay group Zami, whom I knew from my GAT organizing days, called me from the AIDS Committee of Toronto where he was working as a counsellor. He had a Vietnamese factory worker with pneumonia there who needed a buddy. The first few cases in our community really highlighted the need for culturally specific support. For example, the Vietnamese factory worker wasn't gay-identified, even though he was an MSM, a man who had sex with men. He did not speak English, and he was brought up in a very hierarchical society where you don't question your physicians on anything. When I met him, he had already had two bouts of PCP pneumonia, which was the biggest AIDS-related infection that most people died from. He went to a Chinatown doctor who did not know anything about HIV, and he was not on any prophylactic treatment to prevent him from getting pneumonia again. During those days, alongside Tim McCaskell, Richard Fung, and other AIDS Action Now activists, we were fighting hard to get access to aerosolized Pentamadine for treatment and prophylaxis to prevent PCP pneumonia. Even though I gave him all the information about where he could access support, he was too afraid to question his doctor. So with the stigma, shame, isolation and lack of proper treatment and support, he was pretty much waiting to die. There was no organized or culturally appropriate support in the community, everything was just starting, we were all learning together. ACT at that time didn't really have the infrastructure or volunteer pool. I think that Doug and I were the first people of colour who worked or volunteered at ACT. At that time, the City of Toronto was giving out AIDS prevention grants, so all the established community services, of course, ran to get that money. At the time of the AIDS crisis, GAT and a lot of LGBT groups weren't publicly funded. We all just organized as volunteers, and the 519 was our safe haven. All the programming was done on a volunteer basis, and we had the space, and we met there. Hardly any groups were incorporated as a nonprofit, I think, so we didn't have access to funding.

A turning point for me was when Olivia Chow, who was a school trustee at the time, nominated me to be on an advisory committee for an HIV

prevention project at the St. Stephen's Community Centre, which is a large settlement social service agency. I think I was the only person from the queer Asian community on the committee. It was like pulling teeth to get the centre staff to address LGBT issues. They were totally resistant to even person-alizing the education messages to make them more human and relatable. To not just show people a wooden penis and how to put a condom on it, but to actually tell a human story so that people connect to the issue. I remember that one weekend Olivia and I sat down and spent the weekend trying to write out a script for a slideshow that they were doing, and we presented it to them, and they said that it was beyond their funded mandate, and the script was watered down to almost nothing. After six months of struggling with that committee, I realized there was no point. They had no interest in providing support or addressing the needs of the gay Asian communities. We needed to create our own services because we couldn't wait for other people to save us.

Richard and I and a bunch of people from GAT really started to seriously ask how we could advocate for ourselves. We weren't experienced in accessing public funding and we'd never really created professional services before, so that was a huge learning curve. We applied to create a Gay Asian AIDS Project (GAAP) through GAT. But since GAT was not incorporated we partnered with ACT, who trusteed our money, and we got a desk space from them to "run our service." We decided to start GAAP knowing that we had to emphasize the gay part. At that time we were the only HIV program that had "gay" in its name. It wasn't about showing off pride, but a survival strategy. I realized that if we were going to affect the system we had to access public funding and public institutions. Otherwise, we wouldn't be counted. It might not have been our personal comfort or preference, but we needed to demonstrate that we were not duplicating existing services and that we were dealing with a population that was not being served. ACT was quite supportive, but after a year or so people realized the importance of having your own space and iden-tity, and being able to independently access resources. That's when, in 1990, Gay Asians Toronto got incorporated, and we moved into our own office.

ACT was at College and Yonge at the time. Before then, if not at the 519, then all our "programs and activities" were happening in people's homes. For example, at Richard and Tim's home on Seaton Street, which was a house

owned by Jearld Moldenhauer, the original owner of Glad Day, where a whole bunch of gay activists from the *Body Politic* rented and lived. Later, in the early days of the Gay Asian AIDS project, before we had our first office, many of the gatherings and workshops took place at my apartment at Isabella and Church Streets.

Our first office was on St. Joseph, just west of Yonge. It's no longer there; it was torn down. It became a gym then and now it's a condo. We were there for a few years. We really tried to make it a home. We went to the government surplus places to pick up dirt cheap recycled furniture, and we rented a truck to move every single piece down to the office ourselves. I think that was the first time I remember feeling like we were actually building our own space. It wasn't so much an office—we really did see it as a home base. Having a desk at ACT wasn't a home, and having a meeting room at the 519 every other week wasn't a home. People's private houses weren't community homes. It was really good to have your own physical space, but more than that it helped our members build a sense of community. We had a lot of meetings, workshops, and events there.

In 1990, Richard Fung made his video *Fighting Chance*[4] because he came to one of the workshops and realized that some of our mutual friends were positive. During the prevention workshop, people were talking as if there were no positive people in the room, and it was quite stigmatizing. So he realized that combatting that invisibility of HIV among Asians was quite critical, and he made that video to help give voice to the lived experience of people with HIV in the Asian community. Soon, we were really struggling to take care of the people with HIV in our communities. A lot of our friends were dying of AIDS, and most people didn't know what to do about it. There was a lot of shame, stigma, and gossip. And the people who were even less connected didn't feel they had anywhere to go to access services. People were devastated and also exhausted from the epidemic and the multiple losses.

Our funding came from HIV work, but I think we also realized that GAT was an important venue to connect to people. So we had a lot of social events because people don't all want to come to workshops and do HIV educational stuff. We had a lot of events, and we revived CelebrAsian. In 1988 we had another CelebrAsian show and did a play on HIV-related themes. We got a very negative review in the GLBTQ newspaper *Xtra*. They thought that our

story internalized too much oppression. The reviewer was not an Asian person, but that's beside the point. They said that our character was too sad. I think one of the characters with AIDS was struggling with family issues, and struggling with coming out to his family and the stigma and shame that are very real for our community. But it wasn't, I guess, "proud" enough for the dominant "activist" viewpoint. They tore our events to pieces. Of course, we had no access to the *Xtra* editorial board. Other people were involved before an article about them would go out to the public, especially if it said anything controversial about them. But we were not part of gay journalists' inner circle, so the only "media coverage" of our hard collective work wrote it off as an oppressed piece of theatre, and that was really not helpful at all.

My best friend Tony died at the end of 1992. I was burnt out from all the losses but also the intensive work of organizing and chairing the multiple projects and groups related to HIV in the Asian communities. By the mid-90s, many of people that were involved in the early years of GAT/GAAP organizing—Kirby, Lim, Lloyd, Alex, Neal, Jose—had passed away. Many of them had been quite instrumental in pulling the community together and mobilizing the volunteer forces, and, most importantly, had broken the silence and denial about HIV in our community. We also realized that it would be more strategic to consolidate the various efforts within the Asian communities to build a bigger, more co-ordinated and impactful response to address HIV/AIDS. So we started a long planning and consultative process to discuss a merger to form a coalition agency to serve East and South East Asian communities on HIV/AIDS, including the Gay Asian AIDS project, the Toronto Chinese Health Education Committee's AIDS Alert, and the South East Asian Service Centre's Vietnamese AIDS project. On World AIDS Day on the first of December 1994, the three agencies merged to form ACAS, the Asian Community AIDS Services.

Towards More Inclusive Communities

In 1995, the year of the fifteenth anniversary of GAT, we did another CelebrAsian show, which was a fundraiser for our AIDS projects. It brought together a cast of over fifty people and filled the auditorium at the York Quay Theatre in Harbourfront. There were plays and performances, and it was a very galvanizing event for the community. It celebrated the legacy of GAT and

GAAP and marked a key milestone when we took up leadership to build more inclusive, diverse, and supportive Asian communities.

ACAS is more diverse now. Initially, the groups we serviced were Chinese, Vietnamese and Filipino, because those were the three big groups that we had. Since then, we've begun to service more groups, like Koreans, Thais, Japanese and other racialized groups. And our programming has gone way beyond the original target group of "gay Asians" to include other marginalized groups in our communities, such as trans people, youth, sex workers, women at risk, migrant workers, and international students.

The history of gay Asian organizing in Toronto shows that being a real visible organization in the community is critically important. GAT created a safe space to support the growth of the community but mostly stayed within the LGBT communities. In contrast, ACAS sits at the same table as bigger organizations and mainstream service institutions. I think claiming that space has been important. We didn't do that as a political gesture; we did it because we needed to, to survive.

4 | Loud and Proud

The Story of a Brown Callaloo Dyke
Coming Out in 1970s Toronto

LeZlie Lee Kam

LeZlie Lee Kam is an elder who did foundational work and was instrumental in forming and building queer women of colour groups and producing events for this community in Toronto throughout the 1970s, 1980s, and 1990s. LeZlie Lee Kam remains active in Toronto, facilitating workshops and making presentations on the rights of LGBTQ seniors with agencies across the GTA and beyond. The following fictionalized story tells of her "coming out" and early organizing in Toronto and was originally presented as part of the Queer Songbook Orchestra performance night at Buddies in Bad Times Theatre in Toronto in June 2016. The Queer Songbook Orchestra is a music- and arts-based performative archive that chronicles queer histories in Toronto.

This is the story of Maria—a brown, carib, trini, callaloo dyke—and her journey of "coming out" and becoming loud and proud. Maria graduated from York University in 1976. While in school, Maria had been in a very clandestine, loving, and lustful relationship with Sonia for two years. Neither of them had ever used the word *lesbian* to refer to themselves and they had both been dreadfully afraid of the word *dyke*. Maria and Sonia knew these were bad words and thus they did not feel like useful words to describe

themselves or what they felt for each other. They eventually broke up, never settling on a word to describe their love. After much soul-searching, Maria came to the realization that she truly liked girls. In fact, she liked one specific girl. But, how could her love interest be a woman? Maria did a great deal of reading to try to find some answers to this question. She started with *The Well of Loneliness*[1] and other classic books with queer themes. After reading these books, Maria decided that she must indeed be a lesbian. Maria was resourceful and she wanted to find other lesbians. She was ready to celebrate her newfound identity. She set out on a mission to find her people by contacting the Homophile Association of York University. Maria met with a counsellor there. At this appointment, Maria was warned about the potential dangers of coming out. These risks included the possibility of losing her job—her first job, at the Manulife Insurance Company—, losing her housing, or worse.

"What about my family? Can I tell my three brothers, my mother?" asked Maria. She was now very much afraid.

"Do not tell them!" replied the counsellor, emphatically. "Unless you think that they might understand and support you." The counsellor followed this up with the caution: "But you should know that that is very unlikely to happen."

Maria felt confused by this advice. She still had so many questions. She was so conflicted. On the one hand, she finally felt ready to tell the world that she was a lesbian, but on the other, the counsellor had made her scared about how others would react to her news. She had finally discovered herself, and she was ready to explore her desire and love for women. Yet, she was worried about the many potential repercussions. There were so many possible risks and losses: losing her connection to her brothers, losing her job, and even losing her most beloved new apartment. She questioned the benefit of "coming out." "Why bother?" Maria wondered. Deep down, however, Maria knew that in order to explore the possibilities of being a lesbian, she needed to be open about who she was and who she loved.

The visit with the counsellor wasn't a total loss. Maria was introduced to the Homophile Association's peer support network and given a phone number and contact name of a real-live lesbian. Fiona, the counsellor explained, had agreed to introduce Maria to the lesbian community in Toronto. Maria

was excited yet hesitant when she bravely called Fiona. Was her life about to change? Luckily, Fiona was friendly. She told Maria that there were lesbian drop-in programs that night at LOOT (the Lesbian Organization of Toronto) and CHAT (the Community Homophile Association of Toronto). They agreed to meet at LOOT.

"What should I wear?" asked Maria. This was her first meeting with other lesbians, and she had to make sure that she was going to fit in with the others.

"Just wear jeans and a top," said Fiona.

So, in her best jeans and top, off went Maria on the subway to 342 Jarvis Street, just north of Carlton, where the LOOT meeting was about to take place. Maria was nervous about going to the Church-Wellesley village because the newspapers regularly described this neighbourhood as "seedy" and frequented by "ladies of the evening." Maria arrived at the front door, plucked up her courage, and knocked on the door. Fiona greeted her at the door. Finally, Maria had met her first lesbian friend!

As they entered the building, Fiona turned and asked: "Are you from Jamaica?"

"I'm from Trinidad," Maria replied.

"Where is that?" asked Fiona.

"Seven miles off the coast of Venezuela," said Maria. Fiona was still confused. "Does she not know her geography?" Maria thought to herself. Maria began to realize that she had to become an ambassador of Trinidad and educate the new lesbians she was intent on meeting, about her culture and community.

Maria asked about LOOT, and Fiona explained that it was a fairly new group, made up of lesbians who had decided to rent part of the house at 342 Jarvis. LOOT would occupy the first and second floors. The programming included a phone line call-in once a week for women exploring their sexuality. Women could call in and speak with a peer counsellor. There was also a drop-in coffee house every Thursday evening for women to connect and socialize. Maria felt like she was learning a new language: *phone line call-in*, *peer counsellor*, and *drop-in/coffee house* were initially unfamiliar terms. She later learned others that would become part of her new vocabulary: *potlucks* and *women's music*.

Fiona introduced Maria to some of the lesbians who were at the drop-in. Maria was very disappointed because none of them looked like her. All of them were white! "There must be other brown trini lesbians out there," Maria thought. "I have to find them!" Maria was always the optimist, and she was fierce, tenacious, and persistent. Maria decided that she had to become part of this new organization in order to help shape its goals and objectives. She had a hidden agenda, too: meeting new lesbians and enjoying more of those forbidden orgasms she had come to love!

Later that evening Fiona suggested they check out the CHAT drop-in, which was in the basement of a building nearby. Maria was carefully and very subtly surveying the crowd, thinking: "Where are the lesbians? These people look mostly like men." She very shyly asked Fiona her question. "Where are the lesbians, Fiona?"

Fiona laughed. "These are butch and femme lesbians. Some are 'separatists.'"

"Separatists?! All the way from Quebec for a lesbian drop-in?" asked Maria incredulously.

Fiona laughed again. "No.... These are separatists from men," Fiona answered. She then went on to explain that Maria would have to decide if she was butch, femme or a separatist when she officially came out as a lesbian. Maria now faced a major dilemma. She had three brothers, so she could not be a separatist. She certainly did not feel like she fit into the categories of butch or femme based on what they were wearing at the drop-in. She wondered how she was going to find her place in this community.

Later that evening while in the washroom a woman approached Maria. "Hi.... You must be feeling really out of place here."

Maria sighed. "Yes. Can you tell that it's my first time being with other lesbians?" she asked, glad that someone was being nice to her.

"Oh no," the woman replied, "I meant that you are the only *black* here.... You really stand out!"

"I'm from Trinidad, and I'm brown," replied Maria. "How can you not know the difference between black and brown?"

Being from Trinidad, which was then known as the "most cosmopolitan country" in the world, Maria was very used to being in a diverse setting. When Maria started primary school in Trinidad, her father had to complete

a form which asked about race. The choices were white, Black, Chinese, Indian or mixed race. Maria's father had checked off the box for mixed and added *brown*.

The woman replied: "In Canada, there are only whites and blacks. Get used to it!"

Maria was shocked and stunned. "Why does the colour of my skin matter? We are all lesbians here," she thought. She certainly was not expecting this reaction. She had thought that just being a lesbian and sharing similar experiences of coming out would unite them as a group. How wrong this assumption was! She was about to find out exactly how wrong. This was Maria's initiation into the lesbian community of Toronto. She felt sad and angry. However, Maria was not to be deterred.

She was introduced to the bar and club scene where she met three other nonwhite lesbians. They were the only nonwhite lesbians and dykes "out" in the bar scene in 1977. Together they partied and enjoyed the disco scene at Toronto's lesbian bars. These bars included the Cameo, an underground club that was literally underground, causing Maria to question why lesbian bars always seemed to be in the basement! In 1977, lesbians were not welcome or tolerated at the many gay men's bars in the city. The Studio was the only gay bar where gay men and lesbians coexisted peacefully, bonding in solidarity during the many police raids of the establishment. This spot at the corner of Church and Carlton Street was more recently known as the Cellblock/Zippers and was demolished in the fall of 2016 to make way for a new condominium.

Maria had her first personal encounter with the police when they raided LOOT in 1977. This led to Maria's first act of protest as an out dyke, reclaiming the derogatory word that straight people were using against her and her new lesbian friends as a powerful word to describe a lesbian who was politically active. The police stated that they were looking for under-age girls who might be influenced by the older lesbians on the premises. Maria was outraged. She wanted to fight back against this police harassment. The lesbians of LOOT protested against the police raids outside the police station at Dundas Street and McCaul Street, not realizing how much danger they could be in.

Thus began Maria's activism. Over the years she became more assertive about protecting herself from homophobic harassment. Maria decided that

it was in her best interest to start being loud and proud in every aspect of her life. As part of this new understanding, she decided to come out at her workplace. It was 1980. Maria went to the personnel department and put them on notice. "I do my job well and get excellent evaluations, so the fact that I'm a lesbian must not affect my job status," she bravely informed them. Maria even took out an ad in the *Globe & Mail* newspaper trying to find other brown dykes. When she tried to place her ad, she was told that words like "lesbian," "dyke," "gay," and "brown" were not allowed in the paper. As a result, she was left with the wording, "Homosexual female seeking same for socializing and dancing." Not exactly what she had intended, but there it was.

Maria was part of lesbian and dyke communities in Toronto throughout the 1980s. In September 1989, while sitting with some white friends outside The Rose, a lesbian bar on Parliament Street, Maria was targeted by two cops. They brutally physically assaulted her, and when Maria cried out that she could see the number on his badge and that she would report him and his partner, one of the officers stated: "Go ahead, we can find out where you live!" This was terrifying. Maria became even more frightened of cops after that episode and soon found out that many of her dyke friends of colour were being targeted and assaulted by cops on a regular basis. Together, they then strategized to travel in groups of four or more whenever they went out late at night to the lesbian bars to help protect each other from harassment.

As the years went by Maria started to discover more women who looked like her. She was very happy. But Maria was still looking for mixed-race women like herself. She started a group for mixed-race lesbians and lo and behold there were many in Toronto! Once the group started meeting, they decided that they had to make a positive political statement about their struggles as mixed-race lesbians and dykes. Their narratives were later compiled into the anthology *Miscegenation Blues*.[2] The group had decided to do something politically active for the Toronto Pride parade in 1991 and formed the subgroup *Lesbians of Colour*. They loudly and proudly participated in the parade and were joined by many gay men of colour carrying boomboxes and swaying and dancing to the rhythms of soca, reggae, and bhangra music. The people along the parade route cheered loudly as the group marched by. This was the first official QTBIPOC presence in the Toronto Pride parade. At

the end of the parade, Maria was approached by a young brown trini guy named Anthony.

"I know that you are a trini too," he said, "How about organizing something together for the 1992 Pride Parade?" Maria was sceptical because she had not organized with men before.

"Let's join your group with gay men of colour and include other groups of colour in Toronto," Anthony continued.

They then looked at each other and said in unison: "Let's make a carnival jump-up band with soca music!"

So Maria and Anthony joined forces and formed a group of like-minded lesbians, dykes, and gay men of colour. A massive outreach was done across Toronto and outlying areas via community radio stations CKLN 88.1 FM, CIUT 89.5 FM, and CHRY 105.1 FM through community newspapers and other informal networks. They held many meetings at the 519 Church Street Community Centre and eventually the Proud and Visible Coalition was formed. Word had spread about this exciting and unique venture and people came in from New York, Ottawa, and Vancouver to join them at the parade. On Pride Sunday in 1992, Lesbians and Gays of Colour and the newly formed Proud and Visible Coalition met under a banner that proclaimed: "The Proud and Visible Coalition—500 Years of Pride—Celebrating Our Resistance." Behind their little red pickup truck were more than one hundred fifty people of colour dancing, chanting, and proudly living OUT lives.

In 1993, Lesbians and Dykes of Colour reclaimed their space in the parade. The group renamed itself World Majority Lesbians because people of colour were quickly becoming the majority of people in the world. On Pride Sunday 1993, they met under a new banner that proclaimed: "World Majority Lesbians: A REVOLUTION OF COLOUR." They marched loudly and proudly behind their pickup truck waving signs of protest against racism, homophobia and lesbo-phobia and chanting in solidarity with other oppressed groups of colour. The numbers were growing steadily; more than three hundred people of colour marched with them that day. Maria continued organizing Pride events and got the World Majority Lesbians involved in many dyke marches over the years.

They were also starting to take up physical space in lesbian bars. World Majority Lesbians would go together to Fly, Together's, The Rose, Pope Joan's

and other white gay and lesbian spaces. They aimed to make their presence known quietly but not so subtly as dykes and lesbians of colour in Toronto.

By 1999 Maria and other lesbians and dykes of colour decided the time had come to take up space in the gay bar scene on Church Street. Maria started a monthly event, Island Spice, for lesbians and gays of colour and their allies at the Red Spot. She supported other similar events with the Filipina community. These events lasted for a year and were always packed. Maria knew this was the first time that dykes, lesbians, and gay men of colour felt comfortable and safe in the largely white bar scene on Church Street.

World Majority Lesbians decided it was time to do something big for the 1999 Pride Parade. It was the end of an old century and the beginning of a new one. They agreed that their presence in the parade had to be memorable! They knew that they had to make a political statement. They decided on a new name for their float and group: Queer Womyn Colouring the Century. Maria loved this title. It was big and bold! It had always been Maria's dream, begun in the early days of the little red pickup truck float in the 1992 parade, to have a big truck or float in the parade, of the kind the gay men seemed to have. Queer Womyn Colouring the Century requested a subsidy from the Toronto Pride Committee and rented a big truck from J & P Towing.

In the two months prior to the parade, the Toronto Police had started running ads on billboards and posters on the Toronto Transit Commission buses and subways. The ads featured pictures of two Latino men, with the caption "Help Prevent Crime on the TTC!" Community groups and people of colour communities across the city were angry, shocked and appalled by this blatant example of racism and discrimination. The World Majority Lesbians decided to use their truck as a platform of resistance to this outrageous act of oppression. They agreed to rage, rant and resist this racist policing. The big truck would be the site of their resistance. They readied themselves for the parade. The group created a huge sign for one side of the truck that read, "STOP POLICE RACISM—END THE CRIMINALIZATION OF PEOPLES OF COLOUR" in bold capitals. Finally, their truck was ready. The truck and its followers, numbering over six hundred people, were immediately surrounded by the media and numerous photographers. The group was aware of the risk it was taking by putting up their sign of protest on the truck. Maria and Sil, another group member, were appointed

spokeswomen for their group to speak to the press and authorities. While waiting in line to enter the parade, the group was approached by two burly white cops in uniform.

"Who's in charge here?" they shouted. Maria and Sil stepped forward. The cops pointed to the sign.

"TAKE IT DOWN. NOW!" they demanded. Maria and Sil politely refused. The cops then went over to the driver of the truck.

"J & P Towing has a contract with the Police," they told the driver. "Get them to remove the sign, or there will be a penalty to your company," they threatened.

"These lesbians have rented the truck for the day. I can't do anything about what they have put on their signs," replied the driver.

Knowing that there could be further retaliation from the police if they did not remove their sign, Maria and Sil asked the media and other photographers to surround the truck. They needed them as witnesses in case things turned ugly. The two cops stormed off, threatening further action. Two white women, wearing gray pantsuits and looking very official, approached the group and asked for the sign to be taken down. Maria and Sil were called over to deal with the women. The pantsuit-clad women identified themselves as undercover police, stating that their job was to protect their group. They threatened, "It would be in your best interest to remove your provocative sign," adding that it was "degrading to the police of the City of Toronto." The conversation took place beside the truck, and both officers had their hands on their guns under cover of their jackets for the duration.

Maria and Sil again politely refused to remove their banner, while media and onlookers snapped photos. The two undercover cops did not realize that they had been surrounded and were now the subjects of hundreds of pictures. They backed down and allowed them to keep their sign up. World Majority Lesbians had just struck a huge blow for justice!

At long last, the big truck entered the 1999 Pride Parade, proclaiming loudly on its front: "QUEER WOMYN COLOURING THE CENTURY—CELEBRATING PRIDE LOVE STRENGTH UNITY!!" Hundreds of lesbians, dykes, and gay people of colour marched that day. Together, they took up space and made a bold and brave political statement.

5 | Speaking Our Truths, Building Our Futures

Arts-Based Organizing in 2SQTBIPOC
Communities in Toronto

Aemilius "Milo" Ramirez

I first started performing as a drag king/gender performance artist in 2003. Two years later, at twenty years old, I moved out of my family home and moved to Church and Wellesley, the Village in Toronto. At the time, Church Street was one of the few, if not the only area of the city you could find drag kings, sprinkled among the popular regular drag queen shows you'd often catch on the strip. You had to be a particular kind of campy performer to perform at venues like Crews and Tangos, George's Play, or Zelda's, which have all since closed or been bought out by different management. It was very much my belief that if you were not white and you were performing on Church Street, chances were high that you were catering to the mainstream gay, predominantly white audience looking for a laugh, not to mention your performances needed to be able to sell drinks too. More often than not, performances at these shows represented white narratives along with messages of misogyny, transphobia, transmisogyny, ableism, classism, and of course racism for good measure. At that point, as a new performer to the scene, seeing the state of Church Street drag performance culture was painful and heartbreaking; I wanted something different, and I was sure others did too.

Over many years and still, I have seen the racism that happens in those venues: performers in blackface or stereotypical caricatures blatantly

performing. In 2012 there was public criticism of a local drag queen that offensively performed a number portraying a terrorist wearing a burka at Buddies in Bad Times Theatre, a fairly progressive queer theatre.[1] The Art Director at the time, Brendan Healy, made a public apology on Facebook saying that her act was not screened prior to the evening. During Pride of 2013, another local drag queen participated in an event in blackface, and Pride Toronto retracted her contract as the official *TD Drag Queen of Pride* that year after public outcry spread throughout social media. It was actually quite surprising seeing as in the scene on Church Street, something like blackface is so commonplace, and normally nothing is done to rectify or be accountable to the communities these blatant acts of racism affect. Nonetheless, it seems as though, even for *Pride Toronto*, this performer had gone too far. As a trans person of colour, Church Street has always felt devastating to me in big ways. An analogy to describe what a night on Church Street feels like for me would be, if you had a backpack and you could physically collect all the oppressive experiences you encountered or went up against just in that one night in the village, you would leave with your back aching because you had to carry all of that home with you; and you did carry all of it home (see also Ahmad and Dadui, this book).

When you walk down Church Street, you'll find some local businesses, a few community organizations, but mostly there are a lot of franchises, bars, and nightclubs. I'm not sure you can call it a "village" seeing as it really caters predominantly to gay white cis men, people with disposable incomes and respectability politics. Everyone else continues to fight erasure from various angles, from the municipal government to newer residents' associations and local business owners. That's one of the reasons why I began organizing with others, collectively building 2SQTBIPOC performance and cultural interventions, including Colour Me DRAGG and a 2SQTBIPOC walking tour of the village. In the process, I learned a whole lot about the rich and long 2SQTBIPOC history of Toronto.

Walkout!

Crews and Tangos was one of the first venues where I began performing as a drag king. It's the neighbourhood's largest venue, a two-storey gay and lesbian bar promoted as having "something for everyone." At the time in

2005, the majority of their management and staff were white, and I was one of maybe less than a handful of people of colour performing there. My friend was the resident DJ, a person of colour herself, who DJ'ed the drag king nights. One day she called me, with urgency in her voice, saying there had been a staff meeting where management had told her that she was no longer allowed to play hip-hop, reggae, soca, and reggaeton. Upper management stated that these music genres had been bringing in the "wrong clientele." They had, according to my friend, intentionally stayed away from using overtly racist language, and instead stated that "those people don't have the money anyway, and our bar sales are down." After this phone conversation, another friend soon contacted me to let me know that there was a notice on the walls throughout the venue announcing the new policy; that no hip-hop, reggae, soca and reggaeton would be permitted to be played at this club. At that point, I realized it was real, and I was furious; this bar was ready to exclude a large group of their clientele based on race and class. If they were queer or trans meant nothing to them. All they cared about was money and portraying a specific kind of whitewashed image.

A couple of my fellow drag kings and I already had a complicated relationship with Crews and Tangos, because we had wanted to do more politicized performances and were discouraged from doing so. There was tension with the other drag kings who performed there, who were all white. They would make fun of us, talk down to us, and were often incredibly misogynistic. After hearing of the enactment of this racist policy, we decided we would take action and organize a walkout in response. Facebook wasn't as widely used at that time, and so we sent out emails to our networks, letting them know about the new policy and why we believed organizing a walkout was necessary. We also asked them to keep this information as tight within our circles and networks as possible, as we didn't want the management to get wind of our action. The way the drag king nights worked at Crews and Tangos was that one drag king would host the night, and they would be in charge of hiring other drag kings to form a lineup for the show. By chance, I happened to be the host that week. The night came, and tensions were high. The management did end up finding out and yet mentioned nothing to me. Rather, they attempted to intimidate me by being overbearingly present, very security-like. I brought all my friends out, and we did a night of

performances that were all choreographed to hip-hop, soca, and all the music they said would no longer be allowed in the venue; it was powerful. At the end of the night I got on the mic and I told the crowd exactly what enacting this new policy meant, banning genres of music that are connected to BIPOC communities is racist, pushing out clientele based on their income or lack thereof is classist, and we were not going to put up with it. At one point the staff shut off my mic, so I raised my voice to reach the whole room full of people, I jumped off the stage and led everyone out of the venue. There must have been about fifty to sixty of us; we all left with high energy.

That was my first entry into political activism or protest. The word had spread, and there was an article in the LGBT newspaper *Xtra* about the racist policy and the community walkout, and other venue owners had learned about the action. I was living in the Village at the time, and people would stare at me when I walked down the street, in some cases crossing the street to avoid me. Some people stopped speaking to me, under the pretext that I was "reverse racist" towards white people. I'm able to laugh about it now, but at the time it felt pretty scary. Being a twenty-year-old young trans person of colour, I was nervous about what I had just done, but I was also empowered by the fact that I was able to do it, to rise up for something I believed in. Looking back now after having participated in and witnessed other organiz-ing tactics, there are some things I would have done differently, like I would have opened a conversation with the management, made specific demands and followed up on those directly. After the walkout, any evidence of the oppressive policy disappeared, and no public statement was ever made. Within weeks, a lot of the people who had participated in the walkout were back either performing or as an audience/patron. It had a big impact on me personally, though. Out of the energy and empowerment I gained from the walkout, I began organizing Colour Me DRAGG.

Colour Me DRAGG

Colour Me DRAGG (CMD) started as I began to familiarize myself with 2SQTBIPOC community. Towards the end of 2005, I was performing at a regular queer variety/drag/burlesque show called GenderFukt, which involved predominantly white performers and organizers. It was a huge,

often sold-out event, and people would come from out of town to attend. Again, I was one of a handful of people of colour who performed regularly in the show. It was during this time that I began exploring performance using music by Latinx musicians singing in Spanish, and it wasn't too long after that I started feeling like I was being tokenized and exoticized, mostly by the audience but also by fellow performers. People would do things like touch me non-consensually or ask me to speak to them in Spanish. These experiences were far from pleasant, but they added to my already growing desires to find a 2SQTBIPOC community of performers and performance spaces.

I was at a house party one night talking with a new friend about how much I would like to connect with other performers of colour. He shared with me that through organizing with University of Toronto's queer student group LGBTOUT he had developed a relationship with Buddies in Bad Times Theatre, a queer theatre doing a lot of work with youth, and he offered to connect me with Buddies if I ever wanted to organize a show. This got the ball rolling. Again, this was 2005, before Facebook was such a huge platform for communication, so I started a callout for 2SQTBIPOC performers over email and through word of mouth. I managed to find eight performers! At the time, I had decided that it would strictly be a drag show with drag queens and kings. I continued to ask this new friend for guidance because I was nervous, but I essentially produced the show myself working with the other 2SQTBIPOC performers I had recruited.

The show was on the twenty-sixth of February, 2006, a midwinter Sunday night, and it was freezing with snow on the ground. Despite that, we were sold out! I saw the crowd line up, waiting outside the venue to be let in, and I was in shock at how big it was. Again, this was for me the beginning of understanding what 2SQTBIPOC community even was and who was a part of it. I didn't have the language, I just knew that I had this desire to connect with queer performers that weren't white, and not feel isolated, misunderstood, and antagonized. I had never known about this 2SQTBIPOC community that existed in many different ways at different times in the city, its ebb and flow in celebrations and community groups, and discussion groups over the years. All of that was unknown to me until that night; none of it existed for me as a performer yet in 2006.

After the show, I slowly began to bring together a group of collaborators, and we produced CMD shows together for five years, and we progressively realized the importance of maintaining a 2SQTBIPOC space as it grew. We grew in numbers, both in audience and performers. We grew in terms of what we represented, our values around creating an anti-oppressive performance space, and what we aimed for each year. We had dreams of touring, of becoming a festival, lots of big dreams. We were growing together and growing as a community. It started off as a drag show, but it grew into a gender performance community showcase; people performed burlesque, dance, poetry and everything in between. It was a space where people could explore themselves, and complex ideas like racism, ableism, depression/anxiety, chronic illness, transition, and so much more. Many 2SQTBIPOC performers who perform locally now debuted on the stages of CMD; ILL NANA DiverseCity Dance Company, a now notorious troupe in the Toronto 2SQTBIPOC performance and dance scene in Toronto, often reference CMD as one of their starting points, one of the first stages that welcomed them and honoured what they brought as artists, creators, and dancers. We were able to create safer spaces, and that's what will always remain in my memory and my heart as our biggest collective achievement.

A beautiful thing about CMD was the process of how we ran it among ourselves. The process was very intentional in terms of decision making and representation. It quickly became super important to us as organizers that the show opened up how we thought about representation. We had people presenting burlesque, poetry, singing, and so many other styles and practices of performance. We would spend an entire day just organizing the lineup. Another aspect that I brought to the show a couple of times was large-scale group numbers. It was always my dream to be a part of big elaborate numbers (think musicals!). I started building that, and for a few of our shows we did a callout specifically for those who hadn't performed before and would be interested in collectively choreographing a number. I loved collaborating on these performances; collaborative creation added another element of community building we felt strongly about.

When I look back, I realize that CMD was a part of some very pivotal moments in the city for 2SQTBIPOC and community organizing. In 2010, for example, there were very public arguments in local media about politicizing

Pride, and CMD played an active role in that dialogue. That year, both Queers Against Israeli Apartheid (QuAIA) and Blockorama (Blackness Yes!) were organizing in resistance to Pride Toronto. QuAIA had been banned from marching in the parade for being supposedly anti-Semitic, and Blocko was being moved to an insultingly tiny lot despite being an enormous and well-attended Black block party. The majority of our shows were sold out towards the end, and at every show we would raise funds for different community groups locally and abroad. That year we decided that the funds CMD raised would be for both QuAIA and Blocko, in a highly politicized show called "Silence This!" with the running themes being censorship, displacement, and what radical rising up could look like. It also happened to be the year of the G20 Summit in Toronto. The show was to take place on the Saturday of the G20. At the time we didn't understand what that was going to mean. The city was a ghost of itself, over a thousand people arrested that week, whole blocks shut down. I remember making my way to Buddies on the morning of the show for soundcheck, and the whole area was a ghost town. I had turned the corner, and there was a SWAT team marching; the sound of police marching was a truly frightening experience that froze me in my tracks. And yet somehow, in the middle of downtown during all of this, our show was packed. People found ways to make it out, even though it was difficult to get there. Many said they were grateful that CMD was on that day, so that, despite the hatred, police violence, and rampant white supremacy in the street, they could be somewhere with their people, with community, where they felt represented, because we needed each other.

CMD was never just a showcase. In its final year, it was a full-production show. We won $5,000 from a local arts organization, the ArtReach Pitch Contest, which recognized us as outstanding youth community arts group. Buddies had finally offered us their largest performance space in the theatre and honoured us as the headliners for the Queer Pride programming that year. CMD ended in June 2011—I think because we weren't able to create sustainability. It was a huge responsibility and with growth came growing pains; we didn't have the supports in place to process through and salvage what we had, how far we had come. Having been a part of building community in this way for a while, I wanted to know more about 2SQTBIPOC history; soon I would have the chance to do that.

What Kind of Ancestors Do We Want to Be?

In early 2012, I got together with one of my dearest friends Rio Rodriguez and four other young 2SQTBIPOC to talk about the potential of connecting with 2SQTBIPOC elders and people who have been around for a while to learn about local queer and trans history. Some of us had experience with organizing work; some of us were just getting familiar with community organizing and had met through community events like CMD and youth arts groups. Learning about the decades of 2SQTBIPOC history of Toronto began as a personal project that seemed really exciting to all of us. Rio had found out that someone was doing an LGBT history walking tour of Toronto, so a couple of us checked it out. We all had our scepticism, and for the most part, rightfully so. A lot of the history was white, mainstream things that we already knew. It mostly praised the neighbourhood, mentioning how the 519 is enormous and admirable, and that Alexander Wood (a merchant who owned much of the land that now forms the Village and who is now immortalized by a statue in the area) was the forefather of the gay neighbourhood. Meanwhile, we wanted to create our own 2SQTBIPOC walking tour because we knew that gentrification in the Village is a big force, and that there were more complicated things happening in the neighbourhood than that. That's how our research started. We watched a few documentaries together and made research day trips to the Canadian Lesbian and Gay Archives. We connected with some elders and then the walking tour came to be that summer of 2012. We have been hosting tours for youth groups and interested community members ever since.[2]

I feel there is a disconnect between 2SQTBIPOC elders and younger 2SQTBIPOC, a missing gap of 2SQTBIPOC history. When I think of ancestry that I can relate to, I imagine drag kings of colour in the 1980s, 2SQTBIPOC book clubs and discussion groups in the 1990s, large-scale community arts events like Blockorama or Desh Pardesh, and people organizing ethnospecific AIDS support during the AIDS crisis. That's the kind of organizing that I've always been drawn to: organizing that combined community building, advocacy—things that literally save our lives—with arts and culture, a proven effective combination in 2SQTBIPOC communities.

Without being too nostalgic or implying that things were once "better" in the Village (I'm not sure they ever were great for 2SQTBIPOC), there are

some important changes that have happened in the Village to make it even more hostile towards queer folks who are poor, racialized or disabled today, and that's what we wanted to uncover: physical changes and cultural changes, some of which seem deliberate. For example, there used to be a set of outdoor stairs in the Village which were locally known as "The Steps" that was a popular hangout spot. A lot of queer youth connected there; I would meet up with friends there as a teenager. It was removed in 2005, supposedly to limit public space because of loitering and drug use. There is now another Second Cup, not too far from where the original stood, with a patio and very minimal seating; the first Second Cup was wide open, with space for everyone, and it was right on Church and Wellesley. Having a space like that is part of what a village should be. A place where people know they can find each other, and that will support the inclusion and support of everyone. Now only certain kinds of gay people find each other inside Village venues, mostly white gay people with a disposable income that can afford to buy coffee or meals or pricey products, and it's definitely not an accident that it's been built this way. I've heard a lot about the Christopher Street piers in New York, which was a space where Black, brown, and Latinx queer youth could meet and celebrate themselves and each other and the ballroom scene. Since it was a public space, they weren't required to buy, consume, or conform. Though "The Steps" were not specifically or exclusively used by 2SQTBIPOC, I think a great loss was felt once they were removed.

Something important to mention too is that the Village is heavily policed; I'm not sure if it's always been this way, but it's especially evident around the 519 Church Street Community Centre. It's not uncommon to see people harassed for loitering—if they can even find a spot to settle in now that there's less space to sit on at all. There's a set of cement stairs out front said to have been built intentionally during renovations to honour "The Steps"; however, that too has quickly become a heavily patrolled area of the building. The cleaning up of the neighbourhood has always meant the removal of street-involved folks. In 2008, residents in the area of Homewood and Maitland, just east of Church Street, organized a terrible residents' association, whose main goal was to protest the trans women who were working on the street as sex workers. They were calling the police every day and holding resident "protests" against these women, some of whom had been

working in this area for years. Around this time, three trans women had been murdered in that neighbourhood, which prompted the growth of trans activism, such as the *Meal Trans* program at the 519. People who understood that this residents' association was transphobic and discriminatory held a big counter-protest, and people would regularly take shifts in the area to make sure the women working there were ok, and to be there to intervene if the cops got involved. I became aware of all of this and was involved as a performer for a couple of fundraisers that were organized during this time.

In many ways, my work through the walking tours, performing, and curating performance is rooted in trying to create a legacy for 2SQTBIPOC stories. A keynote speaker at a conference I attended once asked the audience: "What kind of ancestor do you want to be?" This resonated in that it made me question what will I be remembered for, and what do I want to build for future generations. I want to pass on 2SQTBIPOC stories and create platforms for them because I believe such stories have liberatory potential. There is important 2SQTBIPOC history here, and we can't let the corporatization of Pride or of the Village fool us into thinking that things are ok now, or that we can easily forget about our history and how it shapes our present in such significant ways.

Building Alternatives for Trans of Colour Community in Toronto

When I began coming out as trans, the trans people who were closest to me were all white. I knew that I desired and still do in ways I have yet to experience, a BIPOC trans and nonbinary community in Toronto. I observe these kinds of communities in New York or the Bay Area, and I've connected with some of these folks like Bklyn Boihood and Brown Boi Project. At the beginning of my career as a performer, Buddies in Bad Times Theatre seemed like the only venue that staged culturally meaningful or political performances. It has its own fair share of problematic baggage, but with the tireless work put in by many 2SQTBIPOC (staff, artists, curators, organizers) over the years and presently, it remains a place where performers feel empowered to be political and radical within performance art and theatre. Since Colour Me DRAGG, other performance spaces have emerged, including Asian Arts Freedom School's Drag Musical and Les Femmes Fatales, a Black-led burlesque troupe and showcase founded by Dainty Smith, a former collaborator

and producer of CMD, just to name a couple among many. One venue close to my heart is Unit 2, a space started by Rosina Kazi and Nicholas Murray of LAL. A DIT (do it together) space for and run by radical 2SQTBIPOC, it has become a mainstay in the community—for artists and performers, for facilitators, a place for community dinners, for fundraisers and so much more. As these intentional and beautiful alternative spaces and initiatives develop, grow, and begin to thrive, I do find myself asking from time to time, pondering: What about the Village? Who belongs in the Village? Specifically for those of us who are non-Black, non-Indigenous to this part of Turtle Island, do we say abandon it altogether and build throughout other areas of the city, and possibly end up recreating the same dynamics, not to mention participating in gentrification?

Fundamentally the question is this: how will we create sustainable alternatives? Folks in politicized queer and trans community often organize around creating anti-oppressive alternatives to spaces/systems, fighting against heterocissexism and racism and the carceral state. But then, you have a situation that comes about such as the organizer of the Trans March in 2013 inviting a police contingent to march, while police violence is enacted on BIPOC trans community so intensely worldwide. These moments remind me of the work to be done. The Trans March, for instance, has never felt like a progressive place to me, and it won't be until it recognizes its white hierarchies in leadership and honours those who have actively been erased from being represented, specifically Black trans and Indigenous Two-Spirit nonbinary, women, and feminized people. At the same time, I still recognize that I am a part of this trans community and I need to continually ask myself what I can do to be a part of shifting and transitioning this community in ways that represent and heal us all.

The truth is, I see 2SQTBIPOC at the forefront of a lot of street-based organizing projects, like Black Lives Matter. I also see us responding when violent things happen, showing up to a protest for someone like Sammy Yatim, who was killed on the streetcar by the Toronto police in 2013, or walking out of a venue with racist policies like we did years ago, or fighting against residents' associations and gentrifying forces that want us pushed out of neighbourhoods where we live, gather, and work. But how do we keep from breaking underneath all this urgency? And, what happens then?

How do we build a different kind of world? In some ways, I've seen how 2SQTBIPOC organizing can break open the possibilities. After fighting back, after building our own cultural spaces, what we need still is to create traces for these legacies we are leaving; sustainability and new worlds can come from having these stories to feed us, from having names and places to call upon to sustain us. Creating our own cultural spaces and leaving our own legacies is an important starting point.

6 Time Capsules

Laureen Blu Waters

350
the number of bones in a human body

Scattered underground
Thousands of silent stories, from a long time ago
And those just recent
Never given the chance to pass information
from Mothers to Daughters, Fathers to Sons
Relatives to relatives

Little children's stolen voices
Lives taken without a choice
Daughters, Aunties, Mothers, Grandmothers
Bodies far from home
Silently lay in unmarked graves

Stories from long time ago
Lost in the dirt
Who will hear their words?

Grass, trees, shrubs, flowers, vines, seeds, they speak for them!
Medicines we harvest and use to heal our sicknesses
Nourished by their bones, deep in mother earth
Roots reaching far below the surface of the untrained eye

These ancestors and family members do not lay silent
They wait for our visits
Calling to us during each season, winter, spring, Summer, fall
Coming back to life, nourishing their children with their wisdom

Their deaths have not been in vain
They remain
Time capsules
Waiting to be discovered by us

2009

Part Two

Cartographies of Violence

7 | Cops Off Campus!

Alexandria Williams

This essay was originally presented as a talk at an event at York University in January 2015, "Resisting White Supremacy, Colonialism and Racism on Campus." The event, which predictably became the subject of contention, was co-organized by the Faculty of Environmental Studies' ACE (Accessibility, Community and Equity) and Equity Committees, as part of the Transforming Violent Environments seminar series that students and faculty from these bodies were collectively co-ordinating that year. Alexandria's talk highlighted student struggles against intersectional violence on campus and the university's own anti-Black responses to sexual assaults on campus, which regularly includes racial profiling of Black students, staff, and faculty, and demonizing the surrounding Jane and Finch community, which the university plays an active role in gentrifying.

I am Black. This is obvious. I also identify as female. I am a hard femme. I have brown eyes and jet black hair. I am five foot seven and a quarter and I wear size ten shoes. I am the daughter of Elizabeth and Eugene Maybury, and I was born and raised on the island of Bermuda. I study theatre here at York University and I have been dancing professionally since I was fourteen. I went to an all-girls private school that had a majority of white students, while my mother worked three jobs putting herself through school. My grandmother's name is Ann Pindar. She was one of the core creators of the Progressive Labour Party in Bermuda that fought to end segregation on

the island. This became the first party to be elected to represent middle- to lower-income families on the island after a sixty-year conservative rule. My father was a member of the Black Panther Party and returned to Bermuda only to see all his work with the party set on fire. His only physical reminders of his membership are a picture and the scars on his body from fighting for what he believed in. My brother received a full scholarship to Atlanta A&T University. He holds the tennis record in Bermuda and was killed on May 9, 2009, while incarcerated in a New Jersey prison. He still is, and will always be, my best friend.

All these stories helped to create the person who stands in front of you. The stories that I am going to share today are from folks who don't usually feel safe in academic spaces, who don't feel safe sharing their stories and who, for the most part, have taken solace in being invisible. Today, I have been asked to talk about the militarization of campus security and the racial profiling that happens at York University. These practices constantly attack Black people and people of colour. I am going to speak from my experience, along with some brief scholarly facts. They are experiences that I have witnessed first-hand—and acted on. It is my hope that we can begin to understand that experience has a certain degree of precedence over theory.

My first real encounter with racial profiling by police was off campus. It was in the nearby neighbourhood that surrounds the university campus. I was driving a car that my mother had rented so that we could cover some ground while she was here visiting from Bermuda. We were coming home at night from Red Lobster (I *love* Red Lobster!), and as soon as we turned the corner from Sheppard Avenue to Sentinel Road, a cop car motioned for us to pull over. As the cops flashed their lights at us, two things flashed through my mind: Where on god's earth did this cop car come from? And what have I done wrong? While I was trying to remain as calm as possible, my mom started to freak out. Neither my mom nor I are Canadian, so whenever we see the police we have an immediate fear of deportation, even if we have done nothing wrong. We know the power that they have over the lives of nonstatus people here.

The officer knocked on the glass and asked me to roll down my window: "Licence and registration, please." "Good evening officer. Why was I pulled over?" "We have been looking for cars that have been trafficking drugs into

the area. You and your car fit the description." I'm really scared now. I don't know why. All of a sudden a drive home from a great meal has turned into a night where I am being accused of trafficking drugs. "You're from Bermuda?" "Yes." "Why are you here?" "I attend York University." "What are you studying?" "Theatre." "Why did you choose Canada?" "They have a great program." "Do you live around here?" "Yes, Sentinel and Finch." "So if you live so close, why did you rent a car?"

I think this would be the perfect time to tell you that my mother is white passing. She has red hair and hazel eyes, and from the time I was a child and through my time in high school she was regularly questioned about her relationship to me. It never made sense to me, until this night. "Well, I am visiting her from Bermuda, I usually rent a car," my mother chimed in. The officer pulled out his flashlight and shined it on my mom. "Oh, I am so sorry! I didn't see you there. How are you this evening? How do you know this person?" "She's my daughter. I usually come up to spend time with her." "I am so sorry for the confusion, madam. Just a standard check, you can never be too sure. Have a great evening."

As the officer handed me back my licence and returned to his car, my mother and I sat in disbelief. It was a key moment in our relationship, where she realized that she had white privilege, and we both realized that I did not. I got out of the car and asked her to drive. I was so shaken, scared, and angry. I didn't know why. I knew that if my white-passing mother hadn't been there with me, things might have ended differently. Wasn't I worthy of a "good night" or a "hello," like she was? And of being addressed respectfully rather than as "this person," even though the cop knew my name?

I wanted to call my dad or my grandmother so they could help me understand what I had just gone through. Surely they would find this a story from a children's book compared to their own novels of experience with racial prejudice. Still, I needed someone to explain this experience to me. I had been taught that history had happened so very long ago, and that we had passed that point.

With this incident, all of the instances of racism, micro-aggression, misogynoir, ableism, and queer-phobia I had lived through rushed through my head. I was angry, confused, and scared, and was becoming jaded. I understood that profiling happened to Black people. But somehow, I did

not understand how it could have happened to me. I mean, my family had fought for equality, right?

I started to read Frantz Fanon, bell hooks and Malcolm, I watched videos of Mandela and Assata, and I began to sit in the York United Black Student Alliance office just to listen to the Black geniuses who hung out there. I dove into Black Tumblr, explored queer spaces in Toronto, and turned to my elders. I felt as if I was starving and I needed to feed myself. I got more and more involved in organizing. I kept reading and talking to others, trying to figure out what being Black meant and trying to understand why was it was so fucking hard. Eventually all of this talking, listening, and reading placed me in a position to become president of YUBSA. I was able to create a positive space for Black folks to relax, de-stress, and basically just feel like they belong at York University. As the second female president of YUBSA, I made it a point in my role to talk openly about cases of misogynoir and queer-phobia in order to make a space where women (including trans-feminine people) and Black folk from queer and trans communities would feel safe on a campus that doesn't really allow them to. This is especially true for Black queer women, who are left to feel invisible.

I want to make clear that I am not saying that the Black community at York University or the Black community at large is queer-phobic. Rather, I am saying that it is especially and inherently unsafe for Black trans and queer folk to feel safe anywhere. Heteronormativity is dependent on the erasure of the identities and lived experiences of Black trans and queer folk and central-izes white lives in all spheres, from the economic to the social and political. York University is no different from the outside world. At York, as in the wider society of which it is a microcosm, there is a need for Black trans and queer folk to have safe spaces.

Meanwhile, nontrans women on York campuses get a constant reminder that this campus is not safe for us and that rape culture is alive and well. Every three weeks or so we get email reminders. To my masculine-of-cen-tre folks: you may know these as security bulletins, but if you identify as a woman you call them reminders. Nothing ever really gets done about the cause of these reminders—other than the random security forums organized by the university or the "No Means No" posters hanging in the women's bathrooms, whose real purpose seems to be to remind you that if you don't

say "No" when you are sexually assaulted, your assailant has the protection of the law and cannot be charged for their indiscretions.

The militarization of campus is paraded under the proactive stance of eliminating rape culture on campus. However, both the definition of sexual assault and the responses to it serve white supremacy more than they serve survivors. They do not include the routine assault of Black trans people— including trans men who have reported being sexually assaulted on campus. These trans men have been forced to live with their traumatic experiences without the help of campus counselling service, as there aren't any counsellors who are trans aware or sensitive enough to help a trans person of colour in a world that refuses to accept trans people's existence. Meanwhile, I literally cannot find any statistics of violent attacks on trans women, and we know that this is not due to lack of incidents. Think about that.

Then there are responses like the following. One week, according to York, there was a "huge spike in sexual assaults and criminal disturbances" on campus. To respond to this "spike," the next day they increased the security presence. As I entered the university, I saw two to five cops on every corner of the campus. It's not like I haven't seen such a reaction before. I was quite aware of the university's demonstrative response to crime on campus: let the cops show their face, have a forum, and then it's back to life as usual. This time, however, there was a certain urgency in the cops' stature. This wasn't the usual performance; they were given a task and they *were* going to enforce it. After my own interactions with them, I immediately felt unsafe. I knew that they were not here to protect me, as I am definitely not part of the demographic of women who need to be protected—and by this I mean white, cis, and straight. I watched them ask Black men and women to empty their pockets and open their bags. I watched them ask them to show their student ID. I heard them say repeatedly: "You do not look like you go to school here."

Here's the greatest feat of white supremacy—even as a radicalized person who just witnessed this with my own eyes, I still could not believe it. Even as I watched the white and brown men walk by without being stopped, I still tried to justify these actions. I still wanted to believe that York was a place where a post-racial reality exists. Two years earlier, I had witnessed the word "Niggas" spray-painted on YUBSA's door on Martin Luther King Jr.'s birthday, and the university's lack of response. I knew that every time

I go into the York General Store they follow me around like a pig smells shit (despite numerous complaints to them), and I knew that racial profiling happens on this campus. I knew that the only time the university will acknowledge Black people or queer people is when it tries to use our faces for its marketing campaigns—when a cameraman shouts "3, 2, 1!" I knew that the curriculum and what we are learning is systematically oppressive towards Black people and people of colour. That it virtually ignores African and Indigenous cultures and histories (which should be mandatory for all students since they are learning on stolen land) or, when it doesn't, packages them for "teaching" (or rather cultural appropriation) by white academics. Even so, I still wanted to believe that they wouldn't be this blatantly obvious with their anti-Black racism.

After witnessing the police searching Black bodies entering campus, I ran to YUBSA to ask my executive committee to come with me to follow these cops around. Our team's conversation had a lot more "The fuck!" and "They won't let us be great" phrases than I can share here. We needed more evidence. We followed the cops for over two hours. Two hours. We saw two cops asking Black men and women to show their student ID—not once or twice but over twenty times—asking them "Do you go to school here, and if so what are you studying?" while white people and other racialized people walked right past. Sometimes these other students stood by and watched.

In response, we planned an action with the help of various student-led and community-led organizations on campus, including the York Centre for Women and Trans People, OPIRG York, the Access Centre, the Black Action Defence Committee, and Justice is Not Colour Blind. We asked men and women in the Black community here on campus to tell us their stories of their interactions with the police by coming into the space and sharing via email or our Facebook page.

They did. We got more stories than we thought we would. Some told of being asked questions by police, while others told of being physically searched. The people who spoke up were different ages, heights and shades— and all were genuinely scared. Scared. On a campus where they were paying big money to "learn," they were again the visible targets. There is no word to describe the feeling of being invisible until you are being hunted. There is nothing to prepare you for that form of hypervisibility.

YUBSA and our allies went to the York security forum on November 27, 2012, to bring the issue of racial profiling to York's administration. We carried the action to Vari Hall. We demonstrated and made some noise. We had to abruptly bring it to an end when I was told by a member of the administration that if I did not move the action outside of Vari Hall, YUBSA would be sanctioned financially. I was told that the sanction of a York community service group could be to the tune of one hundred thousand dollars. I didn't know how true this was, but I could not risk chancing it. We moved the action outside in the blistering cold, held hands, sang, and ended it. This action led to the creation of the group Cops Off Campus, an amalgamation of various service groups who were a part of the initial action against racial profiling on campus. We did some great work together. The coalition has now lost some of its fire after several of its members, myself included, have been individually sanctioned by the university and told to shut up or be kicked out.

Let's fast forward to 2015. Students were greeted in September with an increase in security personnel equipped with new vests and cars. York has created a stronger and a more visible security presence who walk around our campuses and have gone as far as detaining people at an undisclosed location. I have heard of such an incident anecdotally, from witnessing students who tried to get their fellow student out of this "custody." Needless to say, the new security force is getting their direction from the same university that ordered police officers to empty the pockets and search the bodies of young Black students.

York University has played an active role in the policing of Black bodies on this campus and in gentrifying our surrounding neighbourhoods. The militarization of campus is a reflection of the ongoing gentrification of York's surrounding community of Jane and Finch by the university. The *Oxford English Dictionary* describes the act of militarizing in the following way: "To give (something, especially an organization) a military character. To equip or supply a place with soldiers and other military resources." This definition describes precisely the increasing power of York security on campus and their influence on the surrounding community. York is situated in a "priority area"[1] named Jane and Finch, in a city where Black people are carded by the police 252:1 and the population of Black males incarcerated in prison in

Toronto has increased by 90 percent.[2] Forty percent of the Black population lives below the poverty line, and 15 percent of the poor Black community in Toronto lives in Jane and Finch. These communities use the campus to access resources, service groups, emergency services, workshops, and keynote speakers from Black activist communities that would not be accessible otherwise and are currently becoming inaccessible as a result of policing and gentrification. This is reflected in the recent rebranding of the Jane and Finch community as "University Heights." As part of this rebranding, York is participating in the construction of a subway station on campus, which has already raised rent prices and food prices and has forced three Black families on my floor to move out of my building this past year alone. The militarization of the campus is part of an anti-Black capitalist system that protects white cis people whom York deems as "normalized" and hence worthy consumers, and polices and displaces Black folk who are in its way.

Let's consider some statistics.

In the fiscal year of 2011–12—the same year that the security forum brought up the issue of racial profiling—the following issues were reported: four sexual assaults on campus, nineteen cases of general harassment, thirteen cases of robbery, and one case of stolen property. In contrast, in the fiscal year of 2013–14, reports included thirteen cases of sexual assault, twenty-two cases of general harassment, eight cases of robbery, and one case of stolen property. This means that since York has begun to militarize their campus security, so-called crime has increased by more than 50 percent. So what are they really preventing? Who are they protecting?

It is important that we are clear who is most affected by white supremacy on campus and how. On the very day of our action at Vari Hall, and at the exact time, a white man sexually assaulted a woman on our campus. The only response we heard from the university was the reminder—excuse me, the *security bulletin*—released via email to all students. There was no surge of cops on the premises the next day. No one asked the white men on campus to "empty their pockets because they don't look like they belong here." Furthermore, let us remember that it is Black people who are the prime targets here. After the security bulletin incident, white and non-Black racialized people were once again able to walk right past police officers who were profiling Black students.

This is my story. I hope that the memories that I have shared reflect the realities and lived experiences of Black, queer, and disabled folks on campus. The signs of suffocation, isolation, and trauma are visible. Look through the halls of this fine institution: an institution that we fund and where we learn. Look at the security guards who walk the halls with bulletproof vests and gloves. Look at the flags lining Finch Street that read "University Heights" on pristine white fabric. These signs tell us that we who are not white, able-bodied, cisgendered, straight, and privileged are, and will continue to be, a threat to the university's idea of academic normalcy. This is where our vulnerability lies. Above all, it is also where our power lies. And as ancestor Huey Newton stated, "All power to the people."

8 | Migrant Sex Work Justice

A Justice-Based Approach to the Anti-Trafficking Movement

Tings Chak, Chanelle Gallant, Elene Lam, and Kate Zen

On October 11, 2014, Evelyn Bumetay Castillo was murdered. Forty-three years old and a Filipino citizen, Evelyn came to Canada as a temporary foreign worker in January 2013. While caring for a family with three children, Evelyn was also working as an independent sex worker. Evelyn is one of millions of migrants who are displaced each year and seek ways to support their families abroad. Instead of finding justice and dignity, she found precarious work in Canada, where the laws criminalize and illegalize lives and livelihoods.

In July 2004, a sixteen-year-old woman from Grenada who had reported a sexual assault to the Toronto Police was handed over to immigration enforcement. In 2013, Lucia Vega Jimenez took her own life in immigration detention after a public transit officer turned her over to immigration enforcement for failing to pay her bus fare. Simply carrying out one's daily life or trying to access basic services as a nonstatus person means facing the risk of detention and deportation—daily life is a challenge to borders.

Between April 27 and April 29, 2015, uniformed cops showed up unannounced at twenty massage parlours and private residences where, according to Ottawa police Sergeant Jeff LeBlanc, "a lot of foreign nationals were working." They targeted "mainly Asian" businesses to "determine if there was any exploitation." Though no human trafficking was found, eleven women were detained by Canadian Border Services and later deported. Rather than being given help, these migrant workers were treated as criminals and punished by

a joint operation of bylaw enforcement, immigration control, and the police Human Trafficking Section.

The Migrant Sex Worker Project was formed in 2014 to honour the lives of Evelyn, Lucia, and all the unnamed migrants and sex workers. In the following, we discuss how we came together and outline our struggle for permanent immigration status, safety, and dignity for all women and mothers, migrants and sex workers—for all workers.

The Migrant Sex Worker Project

In 2014, three long-time grassroots activists in Toronto who had been working on the intersections between race, migration, and sex work came together to found the Migrant Sex Worker Project (MSWP). The project aimed to deal with problems facing migrants in the sex trade. We saw that migrant sex workers of all genders were constantly being endangered by law enforcement, immigration enforcement, and bylaw enforcement, and harassed, abused, and deported by the state—yet completely abandoned by those who claimed to be protecting their human, legal, or labour rights. We saw that in the migrant justice movements we were involved in, there was often an absence of sex worker voices and leadership, and likewise in sex workers' rights organizing, an invisibilization of migrants and racialized peoples. The last attempts to organize around migrant sex work had taken place over a decade ago, but there was clearly a need and a desire to refocus on the particular needs of migrant sex workers and bring together our movements and struggles. We demanded and continue to demand more than this.

We are a grassroots group of migrants, sex workers, and allies who demand safety and dignity for all sex workers regardless of immigration status. We use a justice-based framework that places sex worker rights on an equal footing with racism, settler colonialism, and border imperialism. We create tools that migrant sex workers use to protect themselves against human rights violations, educate the public about the dangers of anti-trafficking rhetoric that contributes towards criminalization and border enforcement, and advocate to change policies that hurt and exploit migrants in the sex trade.

We came together at a time when the old sex work laws in Canada had been struck down and there was the possibility of creating something new and visionary that supported the lives of migrant sex workers. We saw

the potential of bringing together migrant justice and sex work justice to counter the dominance of anti-trafficking propaganda and policies and their harmful effects.

In 2015, our first year, the Migrant Sex Work Project did culturally relevant outreach and creative arts-based organizing with both documented and undocumented migrant sex workers. This has required persistence and experimentation. The organizing is focused on three areas of work: legal education, public education, and alliance building. Since we began in 2014, we have produced practical guides for migrant sex workers on changes to sex work and immigration regulations, offered support to our sister organization Butterfly, which does direct outreach to hundreds of migrant sex workers in Toronto, presented at dozens of conferences and panels on everything from sexual violence to migrant rights to LGBTQ refugees and forced labour. Currently, we are working to build cross-movement alliances, change municipal policy on sex work, and create a multilingual, easy-to-read comic book that will use real-life experiences to help migrant sex workers protect themselves from abuse in their interactions with enforcement.

We want a strong, effective voice for sex workers, one where sex workers are always at the table where decisions about their lives are being made. We believe that we need to organize as and alongside migrant sex workers, building a range of coalitions, including with migrant labour organizations, anti-incarceration and anti–racial profiling campaigns, and anti-poverty and global justice projects.[1] Doing this work means going beyond "sex positivity" and other politics of sexual freedom and prioritizing the experiences of those who are most marginalized.[2] It means making space for migrant sex workers to take leadership in addressing the issues that most concern their lives. It means that we all understand how various communities are differently impacted by criminalization, colonization, and racism, and that we work to fight them together.

For many sex workers who are not migrants, this means understanding migrant justice concepts and applying them to our work. With a migrant sex work justice framework, we start from the intersections of race, migration, and labour. Starting from the top, with the broader theory, and drilling down, migrant sex work justice means placing sex worker rights on an equal footing with the battles against racism, settler colonialism, and border

imperialism. In our work, we draw much of our framework on migrant justice from the work of groups such as No One Is Illegal in Toronto, a group of immigrants, refugees and allies who fight for the rights of all migrants to live with dignity and respect. We believe in the freedom to move, return, and stay for all migrant peoples, while also being grounded in solidarity with Indigenous sovereignty struggles.

In concrete terms, our demands include:

- repeal of new anti–sex work laws mandated by the passage of C-36, which was introduced in 2014 to effectively recriminalize sex work;
- labour rights and protections for migrant sex workers;
- an immediate moratorium on all detention and deportation of migrant sex workers including undocumented ones; and
- the de-funding of anti-trafficking policing and the redirection of resources to community-led solutions.

Migrants and Sex Work Organizing

Though there is no reliable research on this, we know from experience that migrants comprise a large percentage of sex workers in the United States and Canada, and yet they are largely absent from the North American sex worker rights movement. Facing greater risks of criminalization and deportation, as well as language and cultural barriers, it is no wonder that migrant sex workers face serious obstacles to organizing. At the same time, the lack of representation of migrants in the mainstream sex worker movement has made it easier for sex work prohibitionists to appropriate their experiences within the anti-trafficking movement.[3] Always already assumed to be trafficking victims, migrant sex workers are spoken over by saviours who presume to represent them. Since the inception of a mainstream sex worker movement in the 1970s, anti–sex work feminists have used stereotypes of enslaved migrant workers as a means to dismiss the leaders of this movement as simply "happy hookers" who are out of touch with the realities of the harsher side of the sex trade.[4]

But most migrant sex workers are a lot like other sex workers—they engage in work that is not always "happy" or safe, yet it is nevertheless an economic choice made within a limited range of labour options. While they may often face various forms of exploitation in their workspaces, the vast

majority of migrant sex workers are not victims of human trafficking. The dual criminalization resulting from immigration policies status and anti–sex work laws makes it doubly dangerous for migrant sex workers to be visible. However, their invisibility only serves to highlight the importance of decriminalization, which is necessary to bring their circumstances to light and safely out from the underground, and to offer (by offering) them protection and labour rights regardless of immigration status.

Many sex workers reject the label of victim. They make their own decisions, even if those decisions are often highly constrained because there aren't many other work options. But some within sex worker movements buy into false hierarchies and see racialized migrant sex workers as "the real victims" or inaccurately blame migrants for bringing down wages. Some even support anti-trafficking policies as long as they only target migrant sex workers. Such racism and xenophobia divide and weaken our movement and our power.

Capitalism is the basis of labour exploitation, and restrictive immigration policies deepen that exploitation for poor racialized migrants. But choosing to accept working conditions that are less than ideal does not equate to being trafficked. Migrant sex workers have agency and their work is not trafficking.

We realize the problems with assuming that all migrant sex workers are the victims of trafficking; we witness the harm of anti-trafficking initiatives to migrant sex workers. As an example, in Toronto, the "human trafficking enforcement team" is located within the sex crimes unit.[5] The enforcement team deals only with enforcing sex work laws through stings that keep sex workers on the run from police and without protection. The team has no mandate to deal with the ways that migrant workers in many industries face force and exploitation. This kind of approach to the sex industry is global, and we see it at the highest levels of policy such as with the UN Palermo Protocol, which distinguishes between "sex trafficking" and "labour trafficking."[6] This is to make it very clear that the UN does not consider forced sex work to be a labour issue but a "sex issue," therefore not requiring the typical remedies such as labour protections and decriminalization.

If we make changes that mean migrants in the sex trade are protected and free to make their own decisions, that would mean that many, many more sex workers would get the same freedoms as well, including those who have very different lives. That's because to make things right for migrant sex

workers we have to get rid of so many systems that intersect with their lives. Challenging poverty, racist immigration policies based on colonial borders, the restrictions on sex work, and so on, would mean that we all get closer to collective liberation.

Who Are Migrant Sex Workers?

Migrant sex workers are members of our society, who live, work, play, and struggle in and with our communities. A migrant sex worker is anyone of any gender (including trans women and trans men) who has moved from one place to another, either through formal or informal avenues, and works in the sex industry. Migrant sex workers are undermined at every turn: from the immigration policies that try to keep them out or detain and deport them after armed raids on their workplace, to the anti–sex work laws that push them into working in isolation in the most dangerous parts of the sex industry. Migrant sex workers may be citizens, permanent residents, students, visitors, temporary workers, or nonstatus people. In places where sex work is legalized, there's usually still at least one group of sex workers left to fend for themselves in underground parts of the sex industry: migrants who are undocumented.

Migrant sex workers are frequently poor and working-class women of colour. They often face struggles with immigration, housing, and accessing health services and labour protections. We honour migrant people's ability and freedom to consent to sex work, and we recognize that their consent is relevant![7] We acknowledge that forced labour, though rare, exists in the sex industry and we work to end forced labour in *all* labour sectors.[8] Migrant sex workers across the globe struggle to work in healthy and safe environments without the threat of arrest, detention, or deportation.

Like many countries, Canada has made it illegal to travel to Canada and engage in any sex work, legal or otherwise, such as stripping or webcam work (see operational bulletin 449 by Citizenship and Immigration Canada).[9] This is also happening in an immigration context where there are fewer and fewer "formal" pathways for racialized migrants from the global south to enter Canada with permanent status, resulting in more precarious and illegalized migration. This is why recent research in Canada revealed that 95 percent of migrant women in the sex industry in Toronto would not call police even

"if they experienced violence, harassment, abuse or exploitation."[10] They are smart enough to know that they'd be risking immediate detention, deportation, being outed to their families, and having all of their earnings stolen. Like many racialized people—migrant and not—they also know that involving police means risking physical or sexual abuse by police or prison guards.

Despite the "Sanctuary City" policy passed in Toronto in 2013, making it the first city in the country to declare municipal services (including police services) accessible to all residents regardless of immigration status, undocumented and precarious status migrants continue to face this daily threat of detention and deportation. A recent report launched by No One is Illegal – Toronto entitled *Often Asking, Always Telling*[11] revealed that Toronto Police Service's routine practice of race- and class-based profiling and carding has resulted in one hundred weekly immigration "status checks" on people who are suspected of being undocumented (namely, those who are racialized, low-income, and have an accent). This is in direct violation of the Sanctuary City policy. It is no wonder that migrants, especially those trading or selling sex, prefer their own networks to protect themselves. And as we know, helping sex workers is always criminalized in some way, for example through "pimping" laws or as "living off the avails of prostitution."[12] So migrant sex workers keep doing their own thing, carefully avoiding law enforcement, bypassing racist immigration restrictions, and making a living for themselves in spite of the sticky web of control and punishment they face at every turn.

Conclusion: A Migrant Sex Work Justice Perspective

Given the picture that we have described in this chapter, we don't believe that the anti-trafficking and immigration systems are "broken." We think they are intentional and effective systems that serve the interests of business, government, and nonprofits in wealthy "Western" countries. Central to these interests is the control over the movement of migrants from the global south to the north. The elite in wealthy northern countries use political and economic force to extract resources from the south then militarize the borders to retain control over those resources. This also ensures the availability of an impoverished pool of highly exploitable, disposable temporary workers. "Anti-trafficking" is a way to control the movement and labour of

migrant women in particular. Some anti-traffickers are genuinely well meaning, but they are being used in the service of this larger project of controlling and exploiting migrants and sex workers. As a result, the strategies to resist the anti-trafficking movement cannot be based on "raising awareness" or "reforming a broken system" alone but must address the underlying forces of displacement, criminalization, and illegalization and fight to shift power towards those most directly impacted.

"No one is illegal," the rallying cry of the migrant justice movement, is an assertion that people are not inherently "illegal" but are made illegal by an oppressive, racist, and exploitative immigration system. About three hundred thousand people enter Canada on a temporary basis each year—many more than are given permanent residency. Most undocumented people enter Canada with some sort of immigration status (as a visitor, student, migrant worker, refugee claimant, etc.) and subsequently *lose* that status because of restrictive immigration policies. Undocumented people are not "jumping the queue." There simply is no immigration "queue" for many of us! As it becomes more difficult to enter through "legal" channels, people are pushed underground. And doing sex work certainly doesn't earn you "points" in a "point-based" immigration system based on fake racist and classist notions of meritocracy.

For undocumented people (like the two hundred thousand living in the greater Toronto area) going about daily life is itself a challenge to borders.[13] Enrolling a child in school, accessing a shelter or food bank, or taking public transit without immigration papers can result in detention and deportation. "Anti-trafficking" policies beef up immigration enforcement in our communities and at the borders. We are seeing increased collusion between immigration control and law enforcement here in Toronto. Policies like "Access Without Fear" and resistance to police carding are critical to pushing back on the ways that police racially profile people who look like immigrants, asking for their immigration documents, and then turn them over to immigration officials. This is also illustrated by the prominent raids of sex work establishments like massage parlours or strip clubs that happen under the guise of protecting "public morality" and "public health. These involve municipal officers checking for licensing, or immigration enforcement looking for "trafficking victims" or "illegal migrants."[14]

As permanent residency becomes less and less attainable for most, many migrants, including women and youth sex workers who need or want to leave their homes for another country, are forced to seek out "irregular" methods of migrating, relying on third parties. However, instead of placing blame on the policies of nation states for increasing the vulnerability of migrant women, the government and public response is to criminalize the people who are facilitating migrants' movement into the global north. Today, it is almost impossible to migrate without someone's help—you can't simply get on a plane or walk across a border without documentation (forged or otherwise). For many of the world's migrants, migration is only possible through illegal means. These means are very similar to those used by other forcibly displaced peoples. Indeed, Harriet Tubman could be considered a "human smuggler" for assisting the passage of slaves through the Underground Railroad.

Increasing options for people to migrate keeps power in the migrant's hands. It isn't sex work that makes people of all genders working in sex industry more vulnerable to violence. Rather, as this chapter has amply demonstrated, the migrant sex workers' vulnerability is produced through the criminalization of sex work and migration *and* the lack of access to permanent status.

9 | Queer and Trans Migration and Canadian Border Imperialism

Kusha Dadui

In the dominant story of Canadian nationalism, the country has always been a safe haven for refugees. In the imagined past, the persecuted subjects finding shelter in Canada were Black people escaping from slavery south of the border. The "new underground railroad," however, in terms of LGBTQ organizations such as Iranian Railroad for Queer Refugees and Iranian Queer Organization, is for queer and trans refugees from Iran. In this chapter, I will argue that the history of Canadian immigration, of which the refugee system is a part, is rooted in racism and colonialism.[1] In recent years, this has taken the shape of a homonationalism that includes LGBTQ refugees, particularly those from Iran and other "Muslim countries." This is accomplished at the expense of non-LGBTQ Muslim migrants and on account of the generalization that Islam is a "violent" and "homophobic" religion.[2] However, the queer and trans "safe haven" claim ignores the tremendous barriers that LGBTQ refugees face in accessing life chances in Canada. In fact, as this chapter demonstrates, narratives of queer and trans refugee living in Canada brim with exclusion and discrimination.

A Brief History of Canadian Border Imperialism

Racism has pervaded Canada since the early days of white settlement. Its entrenchment in the Canadian immigration system clearly contradicts the dominant narrative of Canada as benevolent and welcoming to newcomers. Historically, immigration to Canada has followed a White Canada policy.

While this policy was officially repealed in 1967, European settlement continues to be encouraged. People from the global south are allowed to immigrate only very selectively and in ways that benefit the Canadian economy.

Historically, border imperialism was especially pronounced on Canada's west coast, which was the first point of arrival for immigrants from Asia. A well-known example is now widely remembered as the *Komagata Maru* incident.[3] The incident happened in 1914, but its impact resonates well beyond.[4] A group of economic migrants, most of whom were Sikh, had journeyed from Hong Kong to the west coast of Canada. When they reached Vancouver, their ship, the *Komagata Maru*, was denied entry since all its passengers were subject to the Continuous Passage Act of 1908, which "celebrated" its hundredth birthday in 2008. This Act was designed to keep out Asian immigrants. It prohibited any ship from landing if it had stopped in another country on its journey from its point of origin to Canada. When the *Komagata Maru* was on its way to the coast of Vancouver in 1914, the Canadian media reflected the sentiments of white Canadians. Examples include the *Province* newspaper's headline "Boat Loads of Hindus on Way to Vancouver," and other papers' references to the "Hindu invasion" and the "Vancouver troubles."[5]

This and many other xenophobic laws came into effect as a result of a dual system of white settlement and selective inclusion of migrants from the global south, who were from the start designated to remain a cheap migrant labour force for Canada's capitalist economy. Harsha Walia coins the term "border imperialism"[6] to link the facilitation of capital flows and the creation of an exploitable global migrant workforce to the ongoing dispossession and displacement of Indigenous peoples from their lands.

The history of Chinese immigration to Canada clearly illustrates how Canada has always used immigrants as a disposable pool of labour who are undeserving of and disentitled to status, proper health care, and other benefits reserved for citizens. As documented by the Calgary Chinese Cultural Centre,[7] Chinese immigration to Canada began in 1858. It intensified in the 1880s when many Chinese men came to Canada to build the Canadian Pacific Railway. They were paid one dollar a day, two-thirds the wage of a white man doing the same work. At the same time, they were given the most dangerous work, such as handling explosives, tunnelling, and carrying big

rocks. In 1885, the same year that the Canadian Pacific Railway was completed, the Chinese Head Tax legislation was passed. Every Chinese person entering Canada was forced to pay fifty dollars. In 1900, this was raised to one hundred dollars, and in 1903 again to five hundred dollars—the equivalent of two years' wages for Chinese labourers. Unable to stop Chinese immigration, the federal government of Canada passed the Chinese Exclusion Act on July 1, 1923. Since then, many Chinese have observed that date in protest as "Humiliation Day." Each year, people close their businesses and boycott the Canada Day festivities held on the same day.

Another early example of Canadian border racism that illustrates the anti-immigrant sentiments that have governed the Canadian immigration from the start are the "anti-Oriental riots" in Vancouver in 1907, as documented in "The Chinese Experience in BC: 1850–1950."[8] From 1906 to 1907, an "anti-Asiatic parade" was organized by the Asiatic Exclusion League, which ended in a riot, with extensive damage done to property in Chinatown and the Japanese quarter. This is also the year that 901 Sikhs arrived in Vancouver aboard the Canadian Pacific steamer *Monteagle*. Many white residents, feeling that their jobs were threatened, decided to prevent these passengers from entering Canada. They had the official support of the Canadian government. In 1908, the Municipal Elections Act made it illegal for "Hindus" to vote in municipal elections. It also excluded them from becoming lawyers, pharmacists, or accountants.

Anti-Asian mobilizing did not stop there. In 1914, Vancouver's mayor Truman Baxter organized another anti-Asian rally. One of the main speakers was the Conservative Party MP Henry Herbert Stevens, who was a prominent opponent of Asian immigration. In his speech, Baxter said:

> I have no ill-feeling against people coming from Asia personally, but I reaffirm that the national life of Canada will not permit any large degree of immigration from Asia.... I intend to stand up absolutely on all occasions on this one great principle—of a white country and a white British Columbia.[9]

One might argue that this statement is over a century old, but its spirit is very similar to recent pieces of legislation supported by Chris Alexander and

Jason Kenney, who from 2006 to 2015 served as Immigration and Foreign Affairs Ministers in Stephen Harper's Conservative government. Kenney's 2012 Refugee Bill created a racist two-tier system based on nationality. In 2015, Alexander introduced the Barbaric Practices Act, supposedly to prevent "violence against women" and "terrorism" in immigrant communities. The Act targeted Muslims by rendering it illegal to wear the niqab in legal contexts, e.g., while appearing in court to testify or take a citizenship oath, and by making polygamy a ground of exclusion for immigration to Canada. In the same year, Bill C-51 was passed, the racist Anti-Terror Bill that both promotes Islamophobia in mainstream society and further circumscribes citizenship and immigration rights for people of colour in Canada. In promoting the Bill, outgoing Conservative prime minister Stephen Harper announced that "barbaric cultures who force their women to wear Niqab have no place in Canada."[10] While the Harper regime came to an end by the time of the writing of this chapter, it is noteworthy that many liberals, including the new prime minister, Justin Trudeau, voted for both the Barbaric Practices Act and C51. Not surprisingly, in such a climate, it has become increasingly difficult for refugees from Muslim countries to come to Canada.

While Canada prides itself on its progressiveness, current immigration laws are in many ways backward. They increasingly resemble the racist laws of 1914, which gave the government wide powers to arrest and deport immigrants under the War Measures Act. The main difference in the current laws is that the racism that governs them is more covert. In fact, there is a total denial of racism in the current immigration system. Nevertheless, the underlying attitude towards immigrants—as those who are undesirable and must be excluded—has not changed much. On August 13, 2010, 492 Tamil migrants arrived in British Columbia, on the west coast of Canada. The government claimed that all of the passengers were Tamil Tigers and therefore "terrorists." Most of the passengers—even women and children—were arrested and deported. Especially disturbing was the public support for the deportation of these immigrants among the wider population in Vancouver, reflected in mass demonstrations.[11]

Current Canadian immigration law, although less overt, is still profoundly governed by border racism and imperialism, this time under the guise of anti-terrorism and safety. The exploitative principle of the immigration

system is once again coming to the fore in recent changes that have made it much harder for immigrants from the global south to sponsor their family or immigrate to Canada as skilled workers or students. For instance, family reunification now takes longer.[12] This may surprise less if we consider that it was only in the 1960s that immigration policy in Canada was changed to allow immigration from non-European countries. The same racism can still be felt in the ways in which nonwhite immigration is prevented while white immigration is actively encouraged.

That the main interest is the securing of Canada as white is also apparent when we look at the changing state treatment of homosexuality. When homosexuality was criminalized in the late nineteenth century, Punjabis in British Columbia quickly became major targets of criminalization.[13] Then, in the 2000s, when hate crime became an issue in BC, Punjabis and other South Asians were the first to be criminalized as homophobic.[14] As Jin Haritaworn asks in *Queer Lovers and Hateful Others*,[15] why were nonwhite bodies then segregated for being "too queer" if they are now segregated (with the help of both prisons and borders) as "too homophobic"? Is the real interest the protection of queers or the segregation of racialized and colonized peoples from lands that must be kept white?

Indeed, the original seizure of these lands, later secured through borders, occurred not in the name of protecting queers from the excessive "homophobia" of the nonwhite population but in the name of controlling the excessive "queerness" of Indigenous peoples. As Indigenous queer, trans, LGBT and Two-Spirit communities have documented, the harsh sexual and gender violence that has dominated Canada since its birth contrasts with many Indigenous societies pre-contact, where "same-sex" relationships were valued and alternative gender roles respected.[16] In fact, the first to be targeted for extreme violence and murder were often individuals who did not conform to the European gender binary. This throws into question the claim explored in the next section, that Canada is a "safe haven" for LGBTQ refugees escaping oppression.

Queering Borders

The same contradictions that have underlain the colonial practices through which Canada was founded have also shaped the country's border

governance. The nationalist claim to be a "safe haven" for those escaping oppression has a long history in the Canadian nationalist imagination. One of Canada's founding myths is that white Canadians, rather than actively participating and benefiting from the slave trade, rescued Africans escaping from slavery on the Underground Railroad.[17] In common with other Western countries, Canadians see themselves as generous, benevolent, and open to refugees, even though most asylum seekers end up in neighbouring countries in the global south.[18] As I will highlight in this section, the myth of the safe haven is further contradicted by the actual experiences of those who have arrived in Canada as refugees. This has especially been the case for queer and trans refugees.

On June 4, 1969, Canada belatedly signed the Convention Relating to the Status of Refugees—eighteen years after it was adopted by the United Nations. In 1993, the country's Supreme Court concluded in *Canada (Attorney-General) v. Ward, in obiter* that sexual orientation can constitute the basis of claiming refuge as a particular social group. Since then, prosecution based on sexual orientation and gender identity has been added to the list of legitimate grounds.

While this might be celebrated as a gain, it again happened at the expense of intensified racism. In order to demonstrate their legitimacy, refugee claimants must tell stories that conform to culturally racist and classist stereotypes that originate in Western fantasies of nonwhite people's genders and sexualities. I argue that queer and trans refugees are mediating agents who are used to relay Canada's "freedom" and "superiority" over other regions, particularly those identified as Islamic, to the rest of the world. Based on my decade-and-a-half experience as a support worker for trans and queer refugees, most refugee claimants to Canada from the global south, specifically African countries and countries categorized as Muslim, are now LGBTQ refugees. This contrasts with earlier years, when the majority of refugee claims were based on political affiliation.

This queering of the Canadian border regime produces several vital contradictions. It forces queer or trans people who are immigrants or refugees to conform to a nationalist discourse of Canadian superiority for their safety and their ability to stay in the country. In contrast, it positions other, especially Muslim, countries as "barbaric" towards sexually and gender nonconforming

people. This ignores the aftermaths of a colonialism that introduced homophobic and transphobic laws into many global south contexts in the first place. Accordingly, claimants are encouraged to embrace the narrative that they are proud to have made it to a "free" country, and that they can only be free while they are in Canada and away from their community.

However, many queer and trans refugees face racism even (and maybe especially) in spaces that are LGBTQ-centred. Particularly those who do not fit the typical profile of what a queer person looks like to white Canadians are often excluded from LGBTQ communities. As a result, many queer and trans refugees are inhibited from accessing services in supposedly queer- and trans-positive spaces, which causes further isolation.

A key barrier that LGBTQ refugee claimants face is proving that they are queer. For example, one has to demonstrate involvement within the mainstream LGBTQ community in Canada and participate in Pride celebrations to prove that one is queer. For many queer and trans people of colour, these places and events are not necessarily safe, as most Pride events are Western, white, and homonormative. In addition, the refugee process disregards that gender and sexual expressions are culturally varied and do not look identical across diasporic formations, even after a long and ongoing history of racist and colonialist assimilation. Meanwhile, where cultural difference is taken into account, claimants are often forced to perpetuate the idea that their cultures and societies are inherently homophobic and transphobic.

Both my own experience of going through the refugee process and my participation in many refugee hearings suggest that determining one's eligibility to become a convention refugee forces one to undergo a line of questioning that is intrinsically intrusive and traumatizing. Thus, LGBTQ refugee claimants are regularly asked questions to "verify" their sexual orientation and/or gender identity. Such questions include: "Do you have a partner or did you have a partner in your country? Are you active in the LGBTQ community back home? How and by whom do you fear prosecution?" The problem with these questions is not only that it is unsafe to be out in many countries because of government persecution, but also that not everyone experiences sexuality or gender in the same way. Furthermore, the majority of Immigration and Refugee Board (IRB) members who decide on these cases are white, conservative men appointed by the Conservative federal

government. Frequently, these members were appointed precisely because of their deeply xenophobic affiliations and their ignorance about queer and trans bodies. It remains to be seen how this will change under the newly elected Liberal Trudeau government.

Let me elaborate on the stipulation that, in order to be accepted as a convention refugee, a claimant needs to have some involvement in the local LGBTQ community. This is difficult for many newcomers as there is a lot of racism within this community. One illustration is the experiences of many refugee claimants who have attended a support group called "Among Friends" at the 519 Church Street Community Centre. The group meets in the heart of the gay village in the Church and Wellesley area in Toronto. Its stated aim is to support LGBTQ refugees in getting the resources they need and help them build community. At the end of the group, participants receive a letter documenting their involvement in the queer community. However, many newcomers and refugee claimants I have spoken to would not go to this group because they feel they would face racism in the group and at the 519. This includes white queer and trans organizers' constant suspicions that queer and trans refugees are not really queer or trans, but pretend to be so in order to come to Canada. Indeed, organizations such as Iranian Railroad for Queer Refugees or Iranian Queer Organization, who are funded by the Canadian government, are encouraged to police their clients' gender and sexuality by reporting any "frauds."

This policing mirrors the first point of contact that queer and trans refugees typically have with Canada. Often the immigration officer at the border is the first person to whom the claimant has ever declared their gender identity or sexual orientation. This can be emotionally intense given the power relations involved. It is important to examine how race plays out in these scenarios. In order to assess the veracity of their claim to persecution based on gender or sexuality, the claimant is asked questions about the violence and trauma that they have faced from government officials, family, or society. However, claimants from Middle Eastern or African countries are often asked for more details, as these countries are perceived as more homophobic. The homonationalist fantasy of Western supremacy is particularly pronounced when it comes to Muslim countries. It unproblematically coexists with the use of sexual humiliation as torture by Western militaries, of which there has

been little criticism. Clear examples of this are the American soldiers treated Iraqi prisoners in Abu Ghraib and the sexual violence that prisoners faced in Guantanamo Bay.

When the claim is based on gender identity, the understanding of gender identity that is applied by the immigration officials does not take into consideration the claimant's own cultural experiences of gender. At the same time, there is an expectation that the person who is claiming refuge based on gender identity has already started the process of physical transition. However, many trans, genderqueer or gender nonconforming folks might not want to use hormones and have surgery, or they find them very hard to access because they do not have status. This difficulty was exacerbated by the changes made to the Interim Federal Health (IFH) program by the Harper Government in 2012. The IFH program covers health care expenses for refugees who have not yet gone through the hearing process and do not have access to Ontario Health Insurance Program (OHIP) or other health care coverage. However, under the changes made to IFH, extended health care was cut for many refugees. They are no longer entitled to medication, vision (assessment and glasses), dental, or special devices coverage (wheelchairs, prostheses, orthotics, etc.). This is a clear example of not only the xenophobia and transphobia, but also the ableism of the Canadian border regime.

Like many other countries in the global north, Canada thus dehumanizes displaced people and refugees and treats them as burdens. In the case of trans and queer refugees, who have to prove their sexual orientation or gender identity, the process can be very demeaning. As I have argued, it is important to challenge the misconception that Canada is a "safe haven" for LGBTQ refugees. This is clearly reflected in the high suicide rate for refugee trans women in Toronto and other major Canadian cities.[19] Trans women who are refugees have no or limited access to essential life chances such as housing, safe jobs, and health care. Most often they get placed in men's shelters, which is extremely unsafe. Furthermore, they are routinely misgendered by immigration officials or even by members of the Immigration and Refugee Board who are the decision makers. The gender and sexuality policing that racialized Others routinely experience directly contradicts the homonationalist claim that Canada is a "safe haven."

Unfortunately, even those LGBTQ rights and service organizations who invest in refugees have rarely considered how racism and the white saviour complex feed into their work. Newcomer trans folks frequently find it hard to access these organizations since they do not have ID. Many refugees have to escape their former homes abruptly and do not have access to their identification documents when they escape. Furthermore, trans people who have started transitioning often do not have identification that matches their gender presentation.

Another huge problem facing trans and queer immigrants is finding employment. This is despite the fact that, as my experience as a trans program co-ordinator at a major LGBT health centre in Toronto suggests, trans people have the highest level of education in the LGBTQ community.[20] Additionally, queer and trans people who are nonstatus have no access to essential, life-saving services such as Ontario Works or Ontario Disability Support Program (ODSP) that provide financial support to people who face challenges in finding employment. As a result of this difficulty in accessing formal work and benefits, many trans and queer refugees become vulnerable to unsafe and life-threatening work environments.

A Safe Haven?

In this chapter, I have argued that the oppression that queer and trans newcomers and refugees face at the hands of the Canadian state and civil society throws into question the claim that Canada is a safe haven for LGBTQ people. I have shown that, besides being inaccurate when compared to the realities of Canadian border imperialism and racism, this claim itself functions as a method of border fortification. In fact, the myth of Canadian LGBTQ-friendliness has been actively used to exclude immigrants who are constructed as threats to national security and Western values of freedom and democracy. For instance, there are many cases where immigrants and refugees from African countries are denied entry because they are deemed homophobic and therefore a threat to Canadian democratic values.

Far from "rescuing" trans and queer immigrants, Canadian border imperialism systematically inflicts violence on our bodies. I have shown how the attempt to make borders more permissible for the right kind of immigrants and refugees who are "deserving," as many social movements have

attempted, has in fact served to further fortify them. A better starting point might be to question how white Europeans derived the right and legitimacy to control the territory now often referred to as Canada in the first place, and what forms of violence—gendered, sexual, racial, classed, abled, and colonial—continue to be inflicted in the wake of this conquest.

10 | Queer Circuits of Belonging

Asam Ahmad

This essay is a personal testimony that documents navigating homelessness and different LGBTQ community spaces and programs within the GTA in the early to late aughts. It spends some time articulating tensions with the mentoring program set up by Supporting Our Youth (SOY), as well as the creation of QTPOC spaces like AQSAzine. The LGBTQ Family Program, started by SOY in 1998, operated out of the Central Toronto Youth Services offices downtown until SOY moved into the Sherbourne Health Centre in 2004. While this program is often celebrated as an unmitigated success, this essay looks at the role of class and racialization in these mentoring relationships, revealing how they can sometimes produce harm while also providing life-saving tethers for survival. Exploring the culture of white-dominated queer spaces in Toronto via the lived experience of coming out and the fracturing of self and world that followed, this essay maps a personal history as a living and breathing context that still reverberates today.

There is a long silence on the other line. I am seventeen years old, and my new caseworker has just rapidly explained to my dad what he is agreeing to. Because I am not yet legally an adult, she tells him that he must explicitly verbalize that he is disowning me. I'm sure she doesn't use the term "disowned"—such linguistic accuracy would be anathema to social work. But this is what she is asking him to confirm: Are you giving up caring for this

child at this point in his life? My dad doesn't know how to answer. The case-worker is forced to repeat herself several times, and each time I remember hearing a lot of static on the line. Finally, after what seems like an interminable silence, he replies with a single word: "Yes." This is how I become homeless in 2003 in the largest metropolitan centre of Canada.

Because I had intuitively expected this moment long before I decided to come out to my parents, I have already been making arrangements for my landing once out of the familial home. While waiting for space at a halfway home for young men, I crash for a couple of nights at a new friend's place near St. Clair and Warden. She lives in the basement of a townhouse, and the place itself can barely accommodate one person, let alone two. I don't really know this woman, but I am in no position to pick and choose where I lie down to sleep at night. I would never call myself homeless at this time in my life—I have a roof over my head, after all—but for all technical and legal purposes, this is what I am. I breathe a sigh of relief when I am told that a room is available on Elfreda Boulevard, in the halfway home near Warden Station on the outskirts of Scarborough. My room is so small the only bed that fits inside is a single cot on which about only three-quarters of my body fits, but I have never been more grateful to have a room of my own.

Most people think of the homeless as those who are visible on our streets and living in shelters. But I soon learn that as a person living in a halfway home, I am also classified as part of the homeless demographic. The halfway home on Elfreda Boulevard will be my shelter for about five or six months, until I can afford to move out on my own. There is an incredibly high turnover of residents in this space. Every couple of weeks we get a new roommate or an old one leaves. It is never clear what happens to the roommates when they leave; their leaving itself is the finale. Most of the young men I meet here have already been through Canada's juvenile detention system, and many are hardened to existence in ways I am trying hard to resist. There is an assumed solidarity that arises because we are all in the same boat, but our differences and experiences are too varied to facilitate any meaningful friendship or bonding. The only person I really hang out with here is the one other young gay man, Gary, who is the same age as me but far more experienced when it comes to drugs, sex, and homelessness.

As a queer Pakistani Canadian, I am not yet fully aware how the forces of racism, homophobia, Islamophobia and poverty will determine the circuits of my life and the spaces I am allowed to access in this city. Having lost my access to my spiritual practice, as well as my biological family, it is not yet clear to me that queerness alone cannot provide the kinds of kinship and lifelines I am seeking and need to survive.

Queer Belonging(s)

I first meet Jack and Colin[1] while I'm still a sixteen-year-old living in my parents' cramped apartment in Scarborough. On our first meeting I wear a shirt whose sleeves I have cut off to make arm cuffs and a belt that doubles as a chain for my wallet. This outfit compelled a group of Scarborough boys in my parents' building's parking lot to throw stones at my back—but here I don't stand out in an offensive way. In the office of the Central Toronto Youth Services (CTYS) building, on the corner of Church and Wellesley, the housing worker at Supporting Our Youth (SOY) introduces me to my new mentors: Jack, a professor of Fashion & Marketing Design, and Colin, an executive at one of Canada's largest hospitals. Jack and Colin very quickly become "Jack & Colin" in my mind: a singular unit that exists always as one.

I am paired with this older, affluent, stable, professional white gay couple through a program of Supporting Our Youth, a community development project for LGBTQ youth. They become a kind of surrogate parental unit and take me out to fancy dinners when I can't afford to buy coffee (which is most of the time). They teach me how to write cheques, arrange furniture, arrange a charcuterie board, and pay bills. This mentorship project saves my life in so many ways, but it also situates me across jarring (and, at times, abrasive) class lines that sometimes pit different parts of myself against each other.

Jack & Colin love hosting dinner parties. This is one of the first ways we learn to meet each other. I am often invited, and after the first couple of parties, I learn that I am not a normal guest here. Other guests will ask me deeply personal and invasive questions, and while nothing overtly offensive is usually said, I can't help but shake the feeling that I am a topic of some interest and maybe bemusement, even when I am not present. I know on some level that my differences are more pronounced in this setting, but it is not clear to me yet what those differences mean here.

When I graduate from high school, Jack & Colin take me out to a beautiful French restaurant for dinner. The bill is over $200, an amount I rarely have access to at one time. It is one of my most favourite memories of them. They also give me old clothes and cultural artifacts that I cherish because I would not have access to them otherwise. But I am always aware that I am meant to *be someone* they want me to be, that this mentorship is moulding me in particular ways. When I first met them, I appreciate their liberalness and their openness to diversity and other cultures. Later on, as I attend the University of Toronto and try to communicate some of my experiences of alienation and outright hostility as a racialized Muslim man in a heightened Islamophobic context, it becomes clear that their openness to "diversity" only extends so far.

At one of the dinner gatherings at their new condo on Homewood Drive, an executive from TD Bank laughs in my face about how easy university was compared to a full-time job and wonders out loud why students don't do better nowadays. He says this immediately after I share that I have been depressed and not attending classes for the past two months and might have to drop a course. On another evening, a friend of Jack & Colin's tries to pair me up with another guest because we are both Brown. There are very few people of colour at these gatherings, and since everyone is at least middle class, the conversations usually revolve around property, status, and a particular way of appreciating culture. I learn to practise pretentious condescension while learning how to hate myself for doing so. I am told, in so many subtle and not-so-subtle ways, that people from my racial and ethnic communities are too homophobic to provide me with the kinship I need to survive. I am grilled and contradicted when I state I don't want to treat my parents the way they have treated me. What I don't realize until long after the mentoring relationship ends is how alienating these gatherings actually are, and how much they alienate me from my own self. Jack & Colin puff up with pride every time they introduce me to one of their friends, but it takes me a while to realize that this pride is not for who I am but for who they think they are because they are helping someone like me. Jack & Colin are Good White Liberals: they firmly believe in the supremacy of whiteness but would never be able to admit it, even to themselves. They fetishize Black men and occasionally discuss racialized men as different flavours to try. They

think the system works just fine; it just needs to be tinkered with a little bit. Like all good liberals, they have a deep-seated need to think of themselves as Really Good People. Whether or not they've done work to unpack the ways in which they participate in and benefit from systems of oppression is not a question we can ever address.

Like most gay men, Jack & Colin hate fat people. I am fat, and while they don't ever tell me in so many words, they share a lot of anecdotes about their own bodies and the bodies of women in their lives that let me know how *not okay* it is to be fat. I have already internalized the idea that my body is not worth loving the way it is, and these anecdotes confirm and exaggerate my own internal biases. Jack & Colin also love making fun of trans women. But at this time, around 2005, pretty much everyone thinks trans women are a hilarious topic of discussion.

My relations with Jack & Colin are always somewhat superficial. We get along well largely because my politics have not yet been clarified, and I know that, to some extent, I am already pretending to be someone else, someone who makes them feel more comfortable and at ease when interacting with me. And while I desperately need someone in my life with the kinds of supports they can access and offer, this access almost always comes with other costs. I rarely question or interrogate their intense disdain for women's body parts (making fun of women's genitalia seems to be a primary mode of ritualized bonding among gay men). I don't learn to see myself as desirable but rather internalize the idea that my body needs constant re-arranging and re-shifting. And I learn, subtly and insidiously, from them and almost everyone else around me at this time, that people who look like my parents—who look like me, in other words—are not to be trusted.

Jarring Lines

One of the most dissonant experiences I can recall is going to a meeting with a new caseworker at the social services office building in the afternoon and attending a VIP, black tie affair at the the Carlu later the same day. It is hard to articulate the precise nature of the disjunctive experience that moving through these contrasting spaces felt like. To call the social services office a "building" is generous: one could say the SS offices are a building in the same way that a prison is a human cage. Going into a social

service building in this city feels like entering a Kafkaesque nightmare of bureaucracy where almost nothing can ever be recalled by city employees and everything arrives only after it is too late. It is quite rare to have a social worker who genuinely cares about improving your social conditions. Most of the time your worker has already been so broken and demoralized by the inefficacies of the institution they serve that they have pretty much stopped trying in all aspects of their life. Or they think you are already a failure and there is no point in attempting to provide you with resources or information that could improve your living conditions. There are always lots of numbers and waiting lists to sort through, and one can't help but feel, physically at least, like an animal being ushered through the slaughterhouse. The caseworker that day, a middle-aged white woman, takes one look at my hoodie and dishevelled hair and states, without any prompting from or a single question directed at me, that I need to be placed on antidepressants "immediately."

Later that night at the Carlu, which bills itself "Toronto's most significant and unique historical special events venue," the front door staff hesitates only momentarily upon seeing me, their hesitation turning to warm smiles upon hearing Jack has left tickets for me. Later, a waiter apologizes profusely for stepping on my black distressed leather Kenneth Coles (an old pair of Jack's). I remember meeting Jack & Colin's good friend Samantha, who only ever drank ice wine, and her remarking on the terrible clothes being passed off as fashion on stage. The Carlu is a strange place most of the time, being as inaccessible as it is to most of this city's residents. That night, it is decked out in full over-the-top fashion regalia. Finishing my day there after the strange meeting with my caseworker earlier that day is confusing, to say the least.

Jack & Colin introduce me to aspects of this city with which I was completely unfamiliar. Growing up in Scarborough, my experience of Toronto was mostly limited to suburban spaces and plazas. As a teenager, it was a really special event when we got to go to Scarborough Town Centre, Scarborough's biggest mall. Jack & Colin introduce me to the downtown core, especially strips that are newly burgeoning or had up-and-coming restaurants they wanted to try. Having them as mentors means I am being given access to ways of experiencing this city that are fully outside my purview

and abilities as a poor, racialized, and precariously homed young man. It also means being exposed to strains of gay life and gay politics that are fundamentally different from what my life experience had been teaching me. They see the revitalization of Regent Park as an uncontested good—I only see the poor and racialized people being displaced and criminalized in the name of this revitalization. When a local Palestine solidarity group, Queers Against Israeli Apartheid, are banned from marching in the Pride parade for allegedly being "anti-Semitic," Jack & Colin support the ban. I think QuAIA is a legitimate and necessary part of the queer community.

Having Jack & Colin in my life is one of the precursors signalling to me that queerness does not automatically induce organic bonds of kinship. At one of the last Prides we attend together, we are walking down Church Street when their friend Samantha spots us from across the street. She yells: "My two favourite gays and their troubled youth!" and bursts out laughing. Either they don't hear what she said or they are used to hearing her speak in this way, but they both laugh along with her. I don't think it registers in that moment that she is talking about me, or that even in this space, in the middle of the Pride parade in the heart of Canada's largest queer neighbourhood, I could only ever be a "troubled youth" to this woman.

Of course, at this time, Church Street itself was signalling what it thought of troubled youth in its midst. Supporting Our Youth (SOY) still had its offices at Church and Wellesley then. After a gay group session or appointment with my counsellor, I would often walk around the corner from SOY to the Steps on the southwest side of Church Street. The Steps, as they came to be known in the late 1980s, were the physical steps leading up to the Second Cup coffee shop, which became a hangout for many homeless and street-involved youth.[2] Most of these youth were queer, but queerness was not a barometer of belonging. If you were street involved, if we had seen each other at a shelter or a food bank, you would receive a polite nod or a smile to signal that you were "cool" to be there. Because I didn't like to advertise my poverty, I rarely hung out on the Steps, but I would often run into youth I had seen in a gay group or at a club or bar. Sometimes I would run into Gary there. The Steps were meaningful precisely because they existed without an imposed meaning. They functioned in the way they did because of who was using them. In 2005, the Steps were

demolished. It was the final sign that gentrification was full-blown and in effect in this neighbourhood.

Jack & Colin & I stopped speaking a couple of years after that Pride, ostensibly because Jack & Colin decided to break up, but really because we were no longer interested or capable of being in each other's lives. In my last email exchange with Jack, he told me that he supported Palestinians. If I hadn't been so hostile in bringing the issue up in the first place, he said, he would have "gladly" shared his views with me. The last time I saw Jack was while I was walking up Yonge Street with a friend. We made eye contact, but Jack walked right by me as if I didn't exist.

Different Grounds

Coming out in 2004, you couldn't see a Muslim on TV unless they were a terrorist or terrorism was being associated with them somehow. Over the course of almost a decade of being disowned, being away from family, and being completely alienated from my spiritual and religious roots, it became clear to me that I deeply despised Muslims. My associations of Islam stemmed from the dominant stereotype of all Muslims as backward, barbarians, religious fundamentalists, etc. I had assumed that I had never met a Muslim who was anything other than this stereotype.

It was around this time that I met Sadia, one of the founding members of a small grassroots collective of Muslim women and their allies called *AQSAzine*. After being actively encouraged by Sadia to participate as a collective member, I found myself sitting in someone's living room surrounded by a group of astonishing, intimidating, and fiercely brilliant Muslim women. Not all of these women were queer, but the space itself was so queer-centred and queer-focused that it felt like every Muslim I now knew was a queer Muslim. It would be a cliché to say that meeting so many other queer Muslims felt like coming back home to myself, but this is exactly what it felt like. It's almost impossible to communicate the feelings of home and belonging I felt in those spaces after being so alienated from my own self-image for so long.

Through *AQSAzine*, I got to meet many different kinds of Muslims. I was able to meet people who felt like family, for better and for worse. I got

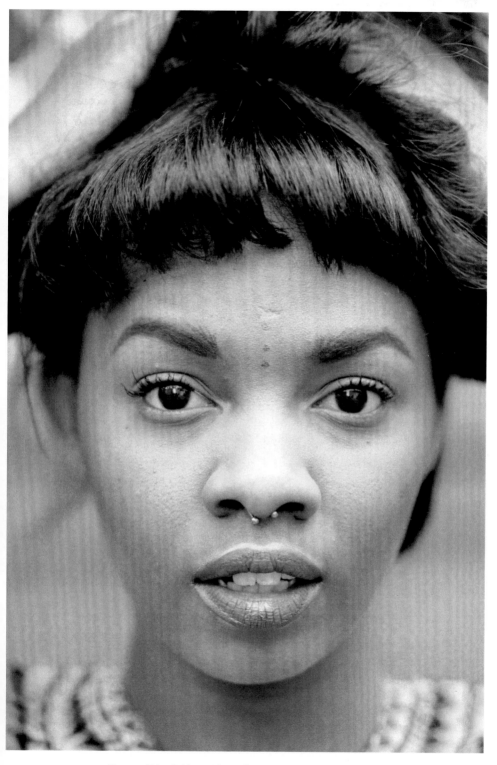

Figure 1. Zahra Siddiqui, *Shi Wisdom*. Reproduced with permission.

Figure 2. Zahra Siddiqui, *Yung Bambii*. Reproduced with permission.

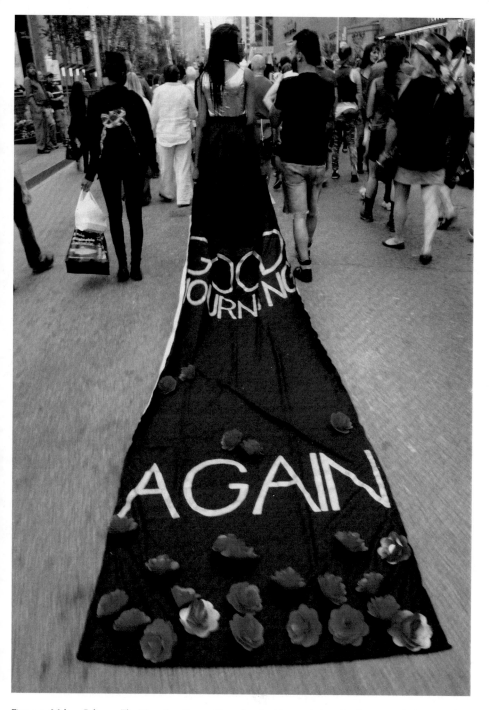

Figure 3. Melissa Palermo, *The Mourning Dress 1*. Reproduced with permission. *In the evening light, Luna Saint Laurent is walking away from the camera, amidst a large group of people, in the street. A long train flows back from her dress, from below a bodice, towards the camera behind her. The train is black and drags on the ground. Near where the train begins to touch the ground behind Luna's feet is written in bold lettering "GOOD MOURNING" and then near the end of the train in the foreground, is written "AGAIN," surrounded by paper roses.*

Figure 4. Melissa Palermo, *The Mourning Dress 2*. Reproduced with permission. *It is dusk, and Luna Saint Laurent, a Black woman with long braids and a bright smile, is standing in the foreground, wearing a dress made of reflective gold on top and the same on the bottom but covered by a layer of black geometric lace. On her feet are combat boots. A long train follows behind her. She is standing on the street, and behind her to her right is a small crowd walking forward, holding flags and large signs. There is also a crowd of people standing on the sidewalk behind her to her left walking and watching the march. Buildings, signs, bright lights, and a cityscape frame the top of the image.*

to support the editorial process, volunteer physical and emotional labour, and help facilitate some important and necessary conversations among the queer and Muslim community in Toronto. At one of the zine launches, I performed a poem about my mom in the main hall of the Art Gallery of Ontario. It's a sad poem, describing how my mom has had to navigate so many different kinds of trauma without having the language to speak to her experiences. Afterward, almost a dozen Muslim women came up to me and told me they felt better about the state of the world simply knowing that people like me existed. It was at once humbling and strangely consoling.

This is not to say everything was perfect in this space. Trans people never felt like they were safe in our collective, and many left abruptly. *AQSAzine* itself had a complicated and tumultuous existence, in my experience at least. The founders decided among themselves not to renew funding for zine publications, meaning one of the primary ways the collective sustained itself was taken away without the collective's input. *AQSAzine* was forced to end soon after, and it was devastating to realize that even queer people who looked like me could still betray me. But *AQSAzine* gave me a way of organizing and meeting other queer people of colour that I had never experienced. I remember breaking fast in a house full of queer Muslims during one Ramadhan, and while it was nothing like breaking fast at home with my biological family, it was spiritually and emotionally nourishing in ways that felt very familiar.

One of the first things I internalized after coming out, not just through interactions with Jack & Colin but via the gay community's self-propagating ideas of what "gay" is and looks like, was the idea that queerness = whiteness and that in order to be queer one had to assume the outfits and affectations of white middle-class gay men. When I first came out, I assumed the gay community would be a welcoming utopia for everyone. I assumed that, because I was "coming out" to a community of individuals who had themselves experienced such long histories of oppression and discrimination, they would be incapable of inflicting oppression, violence, or discrimination on others.

Retrospectively, I can't help but laugh at the naiveté of such a sentiment. There is something strangely comforting in knowing that I was able to come

back to myself in no small measure because of a familiarity and a sense of kinship that I was told would only cause more suffering and pain: the religion I grew up in.

There are so many complicated ways in which and through which queer people find each other, and the idea that one's sexuality is the only thing that can form kinship with others rings hollower and hollower with each passing year.

11 | Collateral

Melisse Watson

Is this the year I give up my windows
Do I have one more year?
Trade in for a basement
A shame, what with the
Beautiful weather we are all all all having

Should I wait?
Mistake the winter for short dark dreadful days
And yet, the only time it rains anymore (remind, remind, remind them)
Trade the whole sky for a burrow
An intricate underground den of clay, soil soundproof
Embossed rivers as they tightly push their way between
A basement and
A hollowed space
One could pretend the day came and went
Maybe even plant something

What if I've waited too long
Prices as high as the condos they're building up up up
Underground full of bodies
No more room, ground level(ed)
Nothing vacant, nothing left to own
Start gentrifying
Criminalizing

Classifying
Detain and deport
That'll get the roaches

Pipelines run our machines cleaner than our water
Our children can't live like this
Res's ignored
Nations dismissed
Resources and rivers scarcely run
Rerouted to replace abundance, with "never enough"
Black folks still enslaved
Land still occupied
Womxn still raped
Still missing, still murdered
Still mental health and still mental illness
History still fictitious
How well we are able or unable to deny the truth
A system built without us is unjust through its frame
A foundation lain with disdain for change
Will never believe the youth
Tell us our best interests; use intimidation, fear
Same system
Shame system
An estranged system

Here
Surviving
Is predetermined
By legacies and legalities
Whether your predecessors were the bought or the patrons
Colonialism always begins with land
To know our future is to listen to where she has been
Her demise still catalyzed by our labour and compliance
Crawl back into her belly from whence we came
Until the sun sets for good

Until the moon pulls the plug, until the sea drains
Swallowing our plastic islands and blanched white reefs
A natural antibody is coming, an abolition of what is left
A liberation of the violence we've conceived, received
A freedom we can believe in

The trees are gone, clean water encased
We wanted cut diamonds in our rings
Instead of clean water in our kids
We won't break out of a perpetual prison and
The pipelines won't leak where the whites live
They'll tamper with the rivers until they lay quiet
The fish no longer breed, lose themselves to the dams
Choose your stock for the waterways
The DOW is doing well these days
Linear notions of forward keep us in place
Reconciliation without reparations is a deception of peace
The oil will rise first from the rest
Our body mass submerged, our denial collapsed
And so I ask
Who here can breathe here and so who here can breathe here, and so who
 here can breathe here, and so who here can breathe here

And still
From here we said the names of the gods that we beloved in
And the ancestors we arose in
The children we gave birth to
Even in a dying world
We all have held elastics and had them fall apart in our hands
We don't expect to lose freedom while preparing to defend
Sometimes we can't imagine our futures
And yet we pull through into the darkness
Over and over again
Over and over again
We have a right to be lost and homesick

We were stolen and displaced
We have a responsibility to our treaties
We shall not walk away
From pregnant cliff nor thirsty oak
My windows remind me that we ache
One month, one day, one moment at a time
We search together for weakness in the concrete
It is together we will witness either
Great anew or a great fall
With some loved ones close and some loved ones far
Oh the distance we have walked

But what if choice is again made for me
A penalty, a purgatory
Floods at the coast, drought to the main
Land storm-torn apart—brick to clay, glass to sand
What once was so giving, simply will not any more
They will have us believe we have one more day
Until the moment that we won't
We believe that we will win, but what if we don't

Me
I'll risk trading in my windows
For a place in the earth
And in the last of all moments
I will welcome the dark

Part Three
Communities of Care and Healing

12 | Toronto Crip City

A Not So Brief, Incomplete Personal History
of Some Disabled QTPOC Cultural Activism
in Toronto, 1997–2015

Leah Lakshmi Piepzna-Samarasinha

Toronto has a rich history of disabled organizing and community making by and for sick, disabled, Crazy, and Deaf queer and trans Black/Indigenous and People of Colour (BIPOC). That organizing has happened in a million ways—from meetings to Facebook fights, from friend-made care collectives to envisioning what accessible sex parties would look like to throwing sick and disabled queer and trans people of colour (SDQTPOC[1]) cultural events.

And this is happening now, and it happened twenty years ago. When I moved to Toronto in the 1990s, I was schooled and healed by local psychiatric survivor organizing and coalition building with disability, poor people's, and First Nations/people of colour movements. On my wall hangs a flyer for a Desh Pardesh–sponsored queer South Asian event on community-based healing offering childcare, free tokens, and a wheelchair accessible space *held in the year 2000*—putting to rest the notion that caring about disability or ableism is a new thing in our communities.

I wanted to begin to write down the stories I remember, inspired by the working-class femme historianship of the writer Joan Nestle, who recorded working-class femme, sex worker and queer and trans histories in her writing, blending her personal experience and community-based research. I

am proud to ground myself in a tradition of grassroots intellectualism and working-class, disabled history.

In working on this article, I realized a couple of things. I realized that I or someone probably needs to write a book about this. I realized that whatever I can record right now will be useful, but clearly the product of one person's experience—a forty-year-old queer AFAB mixed Sri Lankan/Irish/Roma sick and disabled and Crazy mixed-class femme documenting the organizing and cultural moments I have personally experienced because it is what I currently have the capacity to do in this article. I did not include material about stuff coming out of agencies like Across Boundaries (Toronto's long-running and only POC mental health agency, where Andrew Loku hung out) because I have not hung out or been in community there. There are a million more stories I could tell, and want to: the stories of *Camp sis* insisting on ASL and access in their annual Pride shows and the presence of disabled queer women of colour at those shows and organizing collective; *Unapologetic Burlesque's* radically deep access, from ASL to live captioning to greeters welcoming those not already knowing everyone in the community; MADPOC's 20teens' organizing of Crazy identified people of colour, led by queers; GAYASL and ORAD's queer ASL classes that many hearing and Deaf QTBIPOC began taking in 2011, leading to some combating of audism within hearing SDQTPOC and QTPOC communities; Accessexable's work trying to create crip-made accessible sex parties. This is a partial, incomplete history that does not claim to be definitive or the only one. I hope it will be of use.

Bulldozer Community News Service and Psychiatric Survivor Pride Day, 1996–2000

When I moved to Toronto in 1996/1997 as a young, queer, cis, femme, brown, Crazy, soon to be disabled twenty-one-year-old, I did it for a lot of reasons: the vibrant queer people of colour organizing and cultural scene, Sri Lankan community, Desh Pardesh, my lover, the fact that I could afford to rent a one-bedroom apartment with a backyard to grow vegetables, a liveable wage eventually once I got papers. But I also came into a community where disability and being a psychiatric survivor and/or abuse survivor were things that were talked about, organized around, not silences in our radical QT Black and Brown movements and communities.

One of my first activist commitments was writing for, editing, and distributing *Bulldozer Community News Service*, founded in 1980, and formerly known in early incarnations as *Prison News Service* and *Bulldozer*. *Bulldozer Community News Service* was a radical newspaper that defined its constituencies as prisoners and former prisoners, psychiatric survivors, First Nations people, people of colour, and poor people. It was named Bulldozer after the paper's motto: "The only vehicle for prison reform is a bulldozer!"

In its incarnation as *Prison News Service*, the paper had been one of the most important North American prison justice papers in the 1980s and 1990s and had developed a strong analysis linking group homes, psychiatric prisons and criminal prisons as part of the same system—years before radical academics would use the term "carceral systems." White, disabled queer writer Eli Clare would ask in his 1999 book *Exile and Pride*,[2] with wistfulness: What would have happened if the disability and prison justice movements had built alliances in the 1980s, recognizing that prisons and psych institutions and hospitals and nursing homes all lock away people the WSCCAP[3] wants contained? Well, in Three Fires territories, some of us had asked that question, and organized around it, in 1996. We were a super working-class, racially mixed collective of young queer people of colour, older white working-class ex-prisoners, sex workers, current or former drug users, and survivors of abuse and psychiatrization. While we might not have seen ourselves as a disability group, disability, PTSD, and madness were deeply interwoven to the social justice journalism we did.

And we talked, and wrote, about our experiences as survivors of childhood sexual abuse, PTSD, and madness. Jim Campbell, the main editor and longest standing collective member (who funded *Bulldozer/PNS* almost solely on his wages as a city meter reader), was particularly brave and tone setting in talking about recovering his memories of being sexually abused as a child in his white, working-class/farming rural community in Northern Ontario and the connections he drew between childhood sexual abuse and colonization, oppression, and prisons.[4] Issues of *Bulldozer* from 1997 contained unsigned (because we wanted to evade surveillance by CSIS) articles about how to survive going crazy in jail through books, meditation, and herbs, sex work organizing against NIMBY (not in my backyard) restrictions trying to move street-based workers out of areas where they worked, First Nations organizer

Dahkajawaea's recent tour to Toronto, and youth of colour breaking out of a new boot camp-style youth jail.

Parkdale, a now heavily gentrified neighbourhood in Toronto, was, in the 1980s and 1990s, filled with working-class and poor Black and Brown people, and known as "Canada's biggest psychiatric ghetto" (many of whose members were also Black and Brown). With the development of long-lasting injectable and pill-based psychopharmaceuticals in the 1960s and 70s, 999 Queen West, aka Queen Street Mental Health, had moved from locking up all its inmates to releasing them into group homes in the community, where you would get a daily allowance of your ODSP or welfare doled out and your meds monitored (these were still policed places). This was voiced as a humanitarian effort, but it was really a profit-maximizing one. However, de-institutionalization allowed Crazy people to get together, move more freely, organize about our conditions, and talk about whether we were actually crazy the way the psych system had said we were, or whether maybe we were kinda, but we also had survived abuse, residential school, colonization, and migration.

Psychiatric Survivor Pride Day was a locus of psych survivor/madness activism in Toronto in the late 1990s. Founded in 1993 by Lilith Finkler, a queer, working-class Libyan Jewish psych survivor and Parkdale Community Legal Centre's Psychiatric Survivor Community Legal Worker, Parkdale Legal was the free, social justice–focused legal clinic, a lifeline so many in Parkdale depended on for help with immigration, the criminal legal system and the psych system, or all three.[5] Parkdale CLC was one of the only legal clinics in Canada with a specific focus on mental health law. Parkdale Legal was what helped process my immigration paperwork and helped me when my partner got abusive. The waiting room was a hot spot of poor, of colour and Crazy community—you ran into everyone there trying to see a worker. And their community legal workers both provided free legal services to poor folks and did community organizing as part of their paid work. (Imagine that.)

Lilith was a tireless working-class, queer, crazy, femme organizer of colour. She taught me so damn much. One of my strongest memories of Lilith is her hanging out and organizing at the Country Site Cafe, a doughnut shop opposite the Gladstone Hotel where many poor people and/or psychiatric

survivors hung out. (This was all pre-gentrification/white/upper-middle-class invasion and displacement in Parkdale. Poor people lived in the Gladstone, paying rent by the week, and had built a strong poor people's community there.) The doughnut shop's position across from the Gladstone and a ten-minute walk from Queen Street Mental Health and many folks' homes in Parkdale made it a popular hangout for broke psych survivors wanting coffee and a beef patty, and a place to hang out. Lilith would greet every person in the doughnut shop by name, talk with them, hand them a flyer for Psych Survivor Pride Day Organizing Committee's meetings, and sometimes offer free legal advice about forced treatment orders or disability benefits in a corner of the coffee shop. She loved everybody hard, she loved other Crazy people, and she taught me so much by watching her Crazy femme of colour working-class survivor organizing skills.

I went to those meetings as a Crazy, broke, barely making it twenty-two- and twenty-three-year-old queer brown girl. Those meetings were some of the first meetings where I ran into what I and others would name hallmarks of disability justice culture: free food, free tokens, a physically accessible space, organizing happening at the pace and from the needs of the people doing the organizing, and the belief that Crazy people were capable of doing organizing, that we were competent. I walked, with fibro, from my house at Dupont and Dufferin to the clinic at Dufferin and King—about three miles each way—until a horrified Lilith found out and gave me a week's worth of tokens. Not two tokens, but ten. These were like gold to me. Organizing happened crip style, and slow, with breaks when someone lost their shit or needed to throw up or cried. And the organizing happening from our ideas and needs—not being imposed on us from above like much social service "community engagement" projects turned out to be.

And while like in much psych survivor organizing, there were white, cis, straight Crazy dudes who sometimes tried to dominate, in my memory the majority of the participants were Black, Brown and Native women, many of whom were queer. And we were led by Lilith, who was upfront about setting a deeply working-class, POC, queer, Crazy agenda, and who was great at telling a white Crazy dude to stop yelling at a Brown Crazy woman. It was from her queer brown craziness that the idea of a Psychiatric Survivor Pride Day had come—she reasoned, queer people had come up with the idea of

Pride, not shame, and psych survivors were both often queer and had a lot of shame to overcome.

The years I was a part of Psych Survivor Pride Day, we had a day-long conference at the Parkdale Library, a wheelchair accessible community hub, with know your rights (about housing, jobs, dealing with welfare, and dealing with the psych system and forced treatment) and healing spaces, a delicious free lunch that everyone tried to take home, and an unpermitted march down the middle of Queen Street. I remember a whole bunch of crazies, including maybe QT/POC, holding signs and balloons that said NO FORCED TREATMENT and PROUD TO BE CRAZY, marching to a boarding house which had recently caught on fire and killed six psych survivors. The impact of seeing a bunch of nuts being a people, marching with dignity and resistance to mourn our dead, assert our humanity and demand our right to be Crazy without punishment, had a huge impact on those marching and those watching from the sidewalks.

Lilith would leave her job and Peggy Gail Dehal-Ramson, a queer, femme Indo-Caribbean organizer, would take her place, changing the name of Psych Survivor Pride Day to Mad Pride and continuing the tradition of Toronto psych survivor organizing with leadership by queer women of colour.

1997: Edmund Yu Murdered by Toronto Police

Edmund Yu was a broke Chinese immigrant man who was a psych survivor. In February 1997, normative people on the Spadina streetcar complained that he was "acting abnormally." Someone called the police. Edmund pulled out a small hammer he used to crack open nuts, and the police shot him dead.

Organizers in Toronto quickly called out Edmund's murder as both racist and ableist—that the cops murdered him because of the interlocking oppressions he faced as a disabled/Crazy man of colour. Toronto disabled, Crazy and/or POC organizations such as Toronto Coalition Against Racism (TCAR), a group with many queer and trans women of colour organizers, World Majority Lesbians, Psych Survivor Pride Day and others organized a huge protest march that took Queen's Park in 1997. Yu's murder affected a lot of people a lot of different ways but became a focus point for folks to look at ableism and racism in police murder at the same time.

2010–2013: Creating Collective Access Happens at the Allied Media Conference, Some QTPOC Crips Come Home and Talk About It

Creating Collective Access's 2012 promotional blog post:

Creating Collective Access is at the Allied Media Conference again this year! This is our second year and we are growing! We are getting big and juicy! This shit is for real!!!

Are you a crip and/or someone with a chronic illness that is going to be in Detroit this summer for the Allied Media Conference?

We know that for many of us, access is on our minds when it comes to traveling, navigating the city, movement spaces, buildings, sidewalks, public transportation, rides, the air, the bathrooms, the places to stay, the pace, the language, the cost, the crowds, the doors, the people who will be there and so so so much more.

Would you like to be connected to a network of crips and our allies/comrades who are working together to create collective access?

What is collective access? Collective Access is access that we intentionally create collectively, instead of individually.[6]

Most of the time, access is placed on the individual who needs it. It is up to you to figure out your own access, or sometimes, up to you and your care giver, personal attendant (PA) or random friend. Access is rarely weaved into a collective commitment and way of being; it is isolated and relegated to an after thought (much like disabled people).

Access is complex. It is more than just having a ramp or getting disabled folks/crips into the meeting. Access is a constant process that doesn't stop. It is hard and even when you have help, it can be impossible to figure out alone.

We are working to create mutual aid between crips and beyond! We try and work from an anti-capitalist framework. This framework is a big part of what holds us together. Last year, we shared food and resources, we found last-minute housing for each other, some of us fronted money for food and some of us who had long-distance phone plans made phone calls.

Things we are thinking about as possibilities for collective access in Detroit:
*collective eating and food gathering. having a central accessible place where we eat together. This space could also be kid friendly to help provide mutual aid for parents and their children. We may go on joint food runs to the grocery store or to pick up food and bring it back.
*collectivizing rides—pooling transportation for those who need it. helping to co-ordinate rides to and from places.
*sharing information/communication. helping us be in touch to share information (about access, ableism that is happening, workshops, resources, etc.), connect and provide a working network of crips through out the AMC.

The Network: We imagine that there will be pockets of planned access happening. We cannot anticipate or meet everyone's medical or access needs and we are sure that for a lot of you, you have your PAs, folks who you feel comfortable with and trust already lined up. Our hope is to create a network that can connect these access pockets together. We hope we can help each other and share resources: you can't walk long distance, but i can speed in my chair down to the end of the block and get food; i can't read, but you can, so you help me find my workshop in the schedule; you can help make calls to organize the food gathering and eating, while i carry the food up into the room. We hope that together we can create a culture of collective access.

Creating Collective Access (CCA) Detroit was born in 2010 out of three queer disabled Asian Pacific Islander cis women's deep revolutionary desires for kin, and out of our terror of how the hell we were going to survive the Allied Media Conference (AMC) and the 2010 US Social Forum, both held in Detroit, Michigan, as disabled QTPOC. Mia Mingus, Stacey Milbern and I were all working on the Disability Justice track of the AMC; Mia and Stacey were also working on creating DJ workshops and space at the US Social Forum. We were all on five conference calls a week, and we were all silently freaking out about how much these ten days of conference would destroy our bodies. It's a familiar disabled thought pattern: no access to kitchen, not home with our PCAs and beds and strategies, in a super over-stimulating

environment with little sleep, uncertain accessible transportation (Will the wheelchair access van even show up? Are the buses in this city really accessible, or just some of them?) and long walks and waits for food, crowded rooms, scents, and exposures. Until one day, three weeks out, when we were honest with each other during a check-in about how we were feeling. And we started dreaming this wild thing—crip-made access, made by QTPOC sick and disabled queers supporting each other, allowing each other to be cognitively different, a vent user, a cane walker, needing to lie down.

Within three weeks, we put up a blog, spread the word within our networks, and saw people respond from all over North America. Stacey was driving up from Fayetteville, North Carolina with her access van; she brought three folks from the Disabled Young People's Collective and two paid PCAs who agreed to do care work for all of us. We asked to be put in suites together so we could build community. We made a scent-free suite; folks who didn't have MCS used fragrance-free products for the weekend. Patty couldn't travel, so she Skyped in to her presentation. We crammed fourteen people into an access van that was only supposed to hold four.

We committed to moving together. We had all shared an experience of being left behind—too sick to go out, building nonaccessible, too many exposures, not able to move fast enough to keep up with able-bodied people. So we stayed together, moving in a beautiful pack of cripness at the rate of our slowest member. We ate together in the common room. We went around and haltingly talked about our lives. Some people cried because it was the first time they'd been able to talk about disability—because of both ableism and *the whiteness of most disabled spaces.*

We worked on cross-disability solidarity in many marvellous ways. Teukie took Mia's wheelchair and filled it up with takeout because she could walk to the shawarma place and back, bringing it back to the crip suite. Mia used her cis femme traditionally beautiful crip charm to get us access to the fridge and stove on the tenth floor. We gave each other permission to take the conference at crip speed. We had meetings lying down. We facilitated workshops lying on ice packs. We did not apologize or feel ashamed of our disabled QTPOC bodies.

Further, we used our collective power and the AMC's relationship-based model to work with the AMC to build relationships that changed how AMC

made the whole conference more accessible. They put a scent-free space policy in place, mail ordered unscented Dr. Bronner's soap 'cause nobody in Detroit sold it. They emailed workshop presenters beforehand to ask them to integrate access into their space, three months before and a month before and a couple of weeks before.

It wasn't perfect. Two paid PCAs who were nondisabled got really burnt out PCAing for twenty-two people for ten days. But CCA was small and huge. It changed the lives of everyone I know who was in it. We took the memory of it home to our home communities and used it in many ways to build disability justice community and activism.

And Toronto sick and disabled QTPOC folks were at the AMC. Detroit is a four-hour drive or five-hour bus ride from Toronto, and for the first time, in 2010, many Torontonian QTPOC began to attend this grassroots media conference, including SDQTPOC. We brought the experience—both of collective access, and of cross-disability crip space made by and for disabled queer women of colour—back to Toronto, dreaming what could be next. We had small gatherings of sick and disabled QTPOC to talk about our lives, bodies, and experiences of disability and ableism within society and our communities, racism and whiteness within Toronto's disabled community. We talked shit, we gave each other the caring of listening, and we began to envision what building QTPOC community and access in Toronto could look like. As Toronto queers continued to come to AMC, Toronto SDQTPOC participated in CCA from 2010–12. The outcome is hard to pinpoint scientifically, but those years saw a broadening of conversations about disability among SDQTPOC in Toronto.

2012: Sins Invalid Comes to Toronto, Some SDQTPOC Talk

Sins Invalid is a Bay Area, California-based disability justice performance incubator. Founded by Patty Berne and Leroy Moore, two physically disabled Black and Black/Asian, queer and kinky artists and revolutionaries, Sins creates large-scale, all-disabled, broadly accessible performances about sex and desirability in the lives of sick and disabled people, centring queer and trans and/or Black and Brown people. Sins is one of the places many people heard the term "disability justice" for the first time and has been pivotal in using SDQTPOC performance about sex, eugenics, ableism and

resistance as a way of building disability justice community. Cofounder Patty Berne, when I asked her why Sins decided to focus on performance art, said, "I could do a million workshops trying to convince nondisabled people of colour to care about ableism, or white disabled people to care about racism and our lives. Or I could make a three-minute performance that shows them their dreams and nightmares and turns them inside out."[7]

I began performing with Sins in 2009 after watching their 2008 show and crying, coming and having my mind blown and life changed. Since our founding in 2006, our full-scale performances have all occurred in the Bay Area because the cost of accessibly transporting twelve disabled performers and many staff to another part of North America is usually prohibitive. However, beginning in 2010, we began to offer some touring of reduced versions of our shows—two to four performers, plus video—to college campuses and venues throughout North America. We usually offered a performance plus a disability justice workshop, viewing both as an organizing opportunity to share our vision of disability justice—centring people of colour and queer and trans folks and everyone usually marginalized in mainstream white disability organizing.

In 2011, Sins was approached by Syrus Marcus Ware, a queer, Black disabled trans artist, cultural worker, co-organizer of Blockorama and Toronto's Prison Justice Film Festival and youth arts worker at the Art Gallery of Ontario, to bring Sins to Toronto, to perform at the AGO. Knowing Syrus's groundbreaking work in Black disabled queer/trans culture, I was very excited that SDQTPOC and QTPOC communities in Toronto would be able to see a Sins show, live, for free, in a beautiful, accessible theatre.

The organizing process was not without challenges, primarily because of the racism of the rest of the organizing committee. Syrus went on parental leave, and this meant that four out of five of the disability studies academics who organized to bring Sins were white disabled people with a history of being racist to disabled Black and Brown folks in their disability studies programs. They showed their racism in many ways while we planned the show together: claiming they didn't know any disabled QTPOC (despite having kicked out or harassed SDQTPOC in their program into leaving); asking Loree Erickson, a white queer disabled femme porn maker with decent anti-racist politics also on the committee, "You seem to know some disabled

people of colour—can you invite them to join?"; saying to a Sins performer (me) during our disability justice workshop, "We're aware we had a diversity problem—that's why we invited you!"; and choosing to hold the afterparty in a bar that, while being physically accessible, was also a white frat bar adjacent to U of T during Saint Patrick's Day filled with drunk, white, straight able-bodied patrons and thus *inaccessible* to disabled QTPOC because we felt uncomfortable and unsafe. As we prepared to start the show, many Sins artists and SDQTPOC gazed nervously at the audience. White/nondisabled people made up more of it than we would've liked and many sick and disabled QTPOC, living in the immigrant suburbs or outer ring housing, dependent on the undependable Wheel Trans, came late to find the venue at capacity. This could have been prevented by creating priority or reserved seating for SDQTPOC at the show. These are the ways in which racist ableism plays out in micro and macro ways of organizing and cultural production.

However, it wasn't all bad. Disabled QTPOC organized to house Sins artists and pick them up from the airport, hanging out and building connections. Sins artists and Toronto QTPOC artists ditched the party and hung out at a sushi restaurant together after the show. SDQTPOC came to the workshop and the performance in numbers, saying that it was literally a show they had been waiting years to see. And some SDQTPOC artists, namely myself, Syrus Marcus Ware, Eshan Rafi, Arti Mehta, and Nik Red, went out to brunch the Sunday after and, over gluten free crepes, shared stories of racism within white disability studies and our ideas for what a Toronto version of Sins could look like.

2013: Elisha Lim and Loree Erickson Start the "Why Would I Come to a Party Where My Friends Are Barred" Action

On January 17, 2013, Elisha Lim, a nondisabled, mixed-race, Asian genderqueer visual artist, made a public commitment via a Facebook event page to not attend any inaccessible events for one year. This action emerged out of Lim's long-term friendship with Loree Erickson, a Toronto-based white, queer, femme, power-chair-using disabled porn creator and disability activist. "It was really personal," said Lim. "I realized I'd been lying to Loree for a couple years where she'd be like, 'What are you doing this weekend?' and I'd say, 'I don't know.'" The truth Lim wasn't admitting was that they were going

to events that Loree would not be able to go to because they were inaccessible. "I couldn't bear to do it anymore. I decided that I wanted to boycott inaccessible parties just on my own. And then I thought, maybe this is an opportunity to make a public statement."

Lim was amazed at the number of people who joined the Facebook event: 399 in the first week. People from across North America became aware of the action, and the Facebook page became an accessible hotspot for people to debate, collectively pool, and co-create new resources. The page was the first place I saw Toronto's collectively created Google Doc listing accessible performance spaces, started by Toronto queer writer Sarah Pinder. The doc's template was picked up by organizers as far away as Texas who wanted to create a similar resource for their communities.

"The best part about [the action] was the conversations and the fights," said Lim, who faced criticism and backlash from some able-bodied queer and trans people of colour organizers who charged that Lim was hurting low-income QTPOC event planners who wanted to throw parties in inaccessible (but affordable) spaces or inaccessible houses. Lim and other organizers countered by reminding folks that most disabled people are poor too, and by researching and sharing info about affordable, accessible performance spaces, and where to rent a ramp for thirty-five dollars in Toronto (i.e., from Shoppers Drug Mart). The Facebook page for the event became a place where disabled QTPOC, nondisabled QTPOC, and white SDQs came together to argue and debate and learn and change people's minds.

Participants also shared and discussed concrete, crip-made accessibility tools like billie rain's fragrance-free event resources,[8] the blog *Building Radical Accessible Communities Everywhere*[9] about how to make a space that's accessible except for the bathroom (rent a wheelchair-accessible Porta-Potty; take the hinges off the door; find a nearby space with an accessible bathroom that will let folks use it), and DAM 2025's document "Affordable ASL for Community Based Organizations." People drew on, shared, and built on the already-banked brilliance of low-income sick and disabled folks in creating the access we need.

"People fought a lot, and people really stood their ground. I feel like it became more trendy to ask, 'Is this party accessible?' Certain parties [like QPOC, a dance party] moved to accessible spaces because of the action.

[S]paces that maybe weren't as 'cool' became cooler because they were access-ible. There was a cultural shift." Erickson agrees, while noting that many people signed on to the document but few joined Lim in boycotting every inaccessible party. Both feel that the action was a way to use Lim's able-bodied privilege and cultural capital as a popular nondisabled QTPOC artist to raise the profile of accessibility, instead of disabled people always being left with the role of challenging organizers about access and ableism. I agree. I saw this action and the resources it created as touching off a change, where QTPOC performances that were not specifically disabled or led by disabled folks began to provide detailed access info, be held at accessible venues like the Tranzac, Gladstone or Unit 2, and provide ASL or be prepared to face anger when they did not. It was no longer business as usual or ok in the same way for able-bodied QTPOC organizers to "forget" about accessibility.

Lim officially ended the Facebook event a year after it began. "I feel great because I don't lie to Loree anymore," they said. "To this day I don't go to inaccessible parties, which means I often don't go out at all. Sometimes I feel out of touch and lonely. But people with disabilities feel that way all the time."

2013–2015: Crip Your World / PDA: Performance/Disability/Art

Remember that gluten free post-Sins brunch? It didn't stop there. Through emails and texts, many failed and one successful grant application, Leah and Syrus hatched a plan to launch a Toronto-based, QTPOC-majority disability art collective, Performance/Disability/Art (or PDA). Our QTPOC perform-ance show, Crip Your World: An Intergalactic 2QT/POC Sick and Disabled Extravaganza, brought ten sick, disabled, Deaf and Mad video and live dis-ability justice performance artists from Toronto and across North America together for a sold-out show at the 2014 *Mayworks* festival. We planned and carried out a cross-disabled, QT/POC-centred arts retreat for sick, disabled, Mad, and Deaf mid-career artists, The Great Disability Arts Retreat, in Fall 2014. Consisting of eight weeks of workshops where we'd meet, hang out and talk about our work as disabled and Deaf writers and artists, and, well, what it means to be a crip writer or artist in a world where we're so assumed to be unable to create and where there are so many invisibilized and very apparent ableist barriers to our being able to be creators. Our latest show,

PDA Takes Over the Artists' Newsstand, was a case in point: invited to perform in an inaccessible venue (the Artists Newsstand, a takeover of an unused newsstand in the inaccessible Chester subway station), we highlighted its inaccessibility by creating a crip arts march from Broadview, the closest accessible subway station, and by filling the subway station with disabled art, ASL interpretation, many people sitting and taking up space with our scooters, wheelchairs, canes, pain, signing and Madness.

We continue to meet, create, and perform on a crip basis—"as spoons allow" as co-creator Syrus Marcus Ware says. I believe our small, important space has helped other sick and disabled arts spaces populated by QTBIPOC grow. I would like to believe our work makes other SDQTPOC artists feel like they can throw a big show, write a big complicated work. Writing about our arts practice makes me think about many questions about disability justice arts practice. What does it mean to make disabled art space that is richly Black and Brown, poor, cross-abled, with childcare, cheap, and moving at the slow, sick, cancelling, Access-a-ride broke down pace of our bodies? Often, it means not producing at the "hot shot," "ambitious" able-bodied pace of abled arts practice, even abled QTBIPOC practice. Are we seen as less serious because of that? How can we keep insisting on our slow moving, strong and vulnerable SDQTPOC arts practice? This chapter is still being written, and we are excited to keep writing and performing it.

Conclusion

When I was working on booking the Mangos with Chili's 2013 Toronto show, I listened to myself as I explained to my co-director that not only was it simply the right thing to do, we would have to have ASL because people, both hearing and Deaf, folks of colour would be outraged. That the culture had shifted—not at all fully, and not automatically, but through years and decades of cross-disability and Deaf cultural activism—and it was no longer just acceptable business as usual to have queer performances in inaccessible spaces. People who did could expect resistance and a community raising our voices in anger.

And I was rewarded. At the show, there was a line of signing folks right up front, parents holding kids watching burlesque, many wheelchair users with nice wide rows, fragrance-free seating and frag-free soap in the

washroom, an accessible toilet seat brought in by a performer on their lap in the cab to the show, folks who left halfway through because they got too tired, youth and elders.

As disabled QTPOC, there are so many things we don't control. But sometimes, we can control the stage. The Toronto Mangos show was the disabled QTPOC centring movement and community I want to live in and make art for and with. It was the opposite of an inaccessible performance space filled with able-bodied, nonparenting, young white queers. It was a cross-disability, parenting and mixed-class community for three hours where I felt like all my parts could come home, where I was not isolated from other disabled, deaf, chronically ill and/or Crazy folks because of the walls ableism enacts to separate us from each other and forcibly isolate us. That show and that crowd, it was the world to come. Made by sick and disabled QTPOC genius. May there be many future ancestors to come.

13 | Healing Justice

A Conversation

nisha ahuja, Lamia Gibson, Pauline Sok Yin Hwang, and Danielle Smith

In the fall of 2015, a group of Toronto-based practitioners work-ing with a variety of healing modalities met at Six Degrees Community Acupuncture, a healing space on the traditional ter-ritories of the Mississauga of New Credit, Haudenosaunee, and Three Fire Confederacy on Turtle Island (colonially known as Toronto, Ontario, Canada). Others doing similar work, includ-ing Gunjan Chopra, Susanda Yee, and Chiedza Pasipanodya, had planned to be part of the conversation but could not be there on the day. There are many others who have and continue to strive to have similar conversations and dialogues within our communities. We invoke them in this conversation. We thank Shruti Krishnamoorthy for transcribing this roundtable.

nisha ahuja: It's really beautiful that we're gathered today to talk about heal-ing justice, and about offering healing spaces intentionally, to queer and trans people of colour in Toronto. And to talk about how that's come to be, and how we're all doing it. I just want to give love and thanks to the many other people who have been doing work to create healing and wellness in our communities, both locally and in other areas, because we're all connected. Let's start by talking about what is healing justice and how it's come to be a term that we're even talking about. For me, healing justice is a growing

movement of people around Turtle Island who are using this term to talk about collective liberation. Who talk about how our wellness as individual beings is absolutely connected to collective liberation in a broader sense. Healing justice assumes that working on one's own wellness is connected to one's own wholeness, and that healing wounds that have been created through colonization and capitalism, sexism, homophobia and transphobia is actually subverting and transforming some of the deepest harms that our system creates. I'm familiar with the term through a lot of folks who are connected to the *Allied Media Conference* (AMC) and the Healing Justice and Disability Justice tracks which came out of the AMC and the *US Social Forum* in 2012.[1] But I know that this has been happening for centuries, not just on Turtle Island—with Indigenous and non-Indigenous peoples—but also in other places. So that's my own personal connection with it. I don't know if others have thoughts on it.

Lamia Gibson: Healing justice is something that has been happening as I've been doing my work and as I connect with more people who're doing similar work. I haven't really named or defined it until today.

Danielle Smith: Like you said, it's been done since time. But I appreciate healing justice because it's challenging the medical industrial complex and how that functions and how artificial that system can be. It's because the medical industrial complex is so dominant that defining healing justice is an ongoing thing, speaking to whatever needs to be addressed.

Pauline Sok Yin Hwang: I can definitely relate to not necessarily having the words to put on this as an approach to activism or an approach to life. But I guess it's those two words together, "healing" and "justice," that have so many connections for me. As nisha was saying, it's very obvious that there are ways that our bodies completely change in reaction to the trauma that's caused by injustices in the world, to these systems of violence. They get very personalized in the body. So it's an approach that works with the body and also in the context of the greater movements, and then just sees those two pieces working synergistically together. How can you work with one person without supporting them in the web of relationships that they're in, with everyone else and all living things? How can you build movements when you don't look at the individual people in that movement and their well-being, which affects the well-being of our relationships?

na: On the idea of movement building, I think healing justice is recognizing, naming and centralizing that healing—healing modalities and well-being—is in itself radical. Going back to our roots (literally the definition of radical) is in itself movement building. That is in itself justice work. Often, in activist spaces, caring for each other or ourselves and addressing the deep wounds created through systems of oppression are seen as secondary to movement building when actually they can be centralized and can shift and transform our relationships to systems of oppression. Really transform those relationships in a way that creates a lot of individual and collective empowerment. Sometimes I'm wary of using this word, but there is a deep power that we connect to in these processes.

DS: Just listening to you all speak, I'm even thinking about the terms "health" and "healing," and what it is to be healthy for us as various practitioners of something. To think about health, not in the terms of the medical industrial complex, but how "health" is actually so multifaceted, and that's what we're all trying to address. I keep thinking about the different systems of oppression that are at work, and about the connection between individual and collective healing. Bringing it right *here* for us as practitioners, and speaking to my experience of illness this morning, how do we as practitioners in a particular method define healing? What I'm trying to say is that healing can take place in so many different ways. And the term "healer," I've been questioning it a lot.

na: I question it all the time.

DS: Thank you for that, because it's made me think about it a lot more. Status can be given with that title that may not fit. I'm also thinking about individual healing and what it means to work in a particular mode or modality. And what it takes to be able to do that, and what healing looks like to be able to do that, and what self-care looks like. And even complicating the term "self-care," where it is usually left up to the individual to look after oneself. Which I think is reinforced by the medical world, too. Versus the collective notion of interdependence—how we take care of each other. And what all of the facets of that look like in the movement that we're creating or participating in and the things that we're trying to heal. There's a lot in there.

na: Yes! It's a lot! As you're speaking, I'm thinking of what it means to cultivate communities of care. Many of us are individual practitioners or

folks who try to create spaces where people can gather to go on their healing journeys, which is about creating communities where care, health and wellness are centralized. I keep thinking of a circle, like it's centralized, almost like a chain effect, or like a thread that weaves through everyone. I'm also thinking of what you said about the idea of the word healer. We often talk about this. Some people feel really called to use that word for their modalities. And no shade on them. But for me, the idea of facilitating someone's healing journey or sharing a healing modality is more true to what my being does, because I'm more interested in someone connecting to their self-healing, their innate self-healing ability. This is why the idea of healing justice is so powerful in the face of all these systems of oppression. Because when people connect to that essence of themselves, they can't be fucked with in the same way by these systems because you enter into a level of expansiveness of the spirit and the body. Yes, things are going to happen and we'll still be affected by them, but the resilience and the vulnerability that is involved in that resilience is much different.

LG: And that medical model you mentioned functions on the truth that it takes the power away from people and shifts it over to the practitioner, as opposed to returning the power to the person. Not even returning it, just saying that it's there. This makes a space for people to be like: "Oh, I can connect with this in me? Oh, it was always here?" Making that space is a massive tool of resistance against so many systemic oppressions.

[…]

PSYH: I grew up in this city, and it's really hard to separate my own history and my own journey from various healing spaces that have existed here over time. There are many other practitioners who have done a lot of work with queer and trans people of colour activists, even if they don't necessarily identify that way. A lot of times, in the forging of a public movement like healing justice, there's the naming, and then there's who hears about it, and then who publicly participates. And then there are all these other people who do that kind of work and don't really talk about it very much. I can think of Eileen Eng at Spectrum Healing, a naturopath and energy healer who has a clinic on Dupont and a retreat centre in Minden. Eileen has worked with so many people in the community and inspired many of us to work from that juncture of spirituality and physical energy healing. And there was a

yoga practitioner, Nitya Kandath, who was here for many years, who lots of people have practised with, like Sairupa Krishnamurthi, the yoga facilitator, practitioner of shiro-abhyanga (Ayurvedic head massage), and naturopath. Most of these folks are people of colour, some queer. I also keep going back to spaces that are more like community spaces. Like community organizations and art spaces. When I was growing up, there weren't necessarily a lot of explicit "healing justice" spaces, or spaces framed in terms of your physical or mental health. Well, we did have to heal. [Laughs.] But we often did so in spaces that framed it as coming together, being ok, being able to be yourself, and exploring parts of that, and doing it in so many ways. So I guess that's why I'm still struggling with this "healer" or "healing justice" kind of line. I just feel like gazillions of people who are doing community arts stuff or community facilitation stuff are doing healing as well. I remember the *Arrivals Project* that I did with Danielle and Diane Roberts in 2007. That was a community arts project, but it ended up facilitating so much emotional as well as physical healing for many participants. So where is the line?

na: You're so right, Pauline. There are so many queer and trans allies who might not totally know the personal experience of what it is to be queer, trans, or even know the "right words" that might be happening in movement building but are there to support in different ways. Whether it's through artistic exploration or creating gathering spaces or just being a practitioner who is trying to create a sliding scale or free days, or just different accessible ways of being with people. I'm studying Ayurveda right now at the Centre for Ayurveda and Indian Systems of Healing. My teacher, Ismat Ji, Dr. Ismat Nathani, is not queer or trans, but whenever I bring up questions that are specific to communities that I'm connected to in class, she'll always approach it in a way that is open, accessible and without judgment. There are so many people I can think of. Like Zainab Amadahy, a Toronto-based author, screenwriter, community organizer, and educator of African American, Cherokee and European heritage, who is someone who often comes up in our conversations. And folks who aren't here in this circle who would be great additions to this conversation in so many ways.

PSYH: When I was growing up and becoming politicized, a lot of the spaces that in reality were queer and/or trans POC-dominated spaces were not explicitly queer ... and sometimes not explicitly POC. I personally felt more

comfortable in POC-dominated spaces than in strictly queer and trans spaces, because those were often pretty white-dominated. I'm also thinking of a lot of folk organizing in the context of the antiglobalization, antiwar movements such as Colours of Resistance, No One Is Illegal, Freedom School (pre-Asian Arts Freedom School), some of us at Youth Action Network, and other networks that were trying to do antioppression work as part of anticapitalist organizing. It was many, many queer women and trans folks of colour doing a lot of the legwork. It's through that work that today I still have a strong sense of being part of queer and trans communities of colour. A lot of my friendships came out of that time. Though none of these groups were explicitly queer, there was some overlap with folks from groups like Queer Asian Youth, Black Queer Youth. There were writing retreats at Camp SIS, the Indigenous and women of colour run healing arts space in Minden, and lots of events at the Toronto Women's Bookstore which, with all its challenges, was for sure another place where a lot of queer BIPOC hung out and built community. Another thing comes to mind is the project that Lamia and I have been working on to make the Ontario Vipassana Centre more trans and queer accessible.

na: How is that going? What's happening?

PSYH: I think it's going really well!

LG: I think it's going well too. I feel like, for the time that we've been doing it, which is since maybe 2014, there's massive change.

PSYH: It's been rippled all over North America.

DS: Do tell more please.

LG: There's not a lot of tangible change that's rolling out because it's an international organization so the application form cannot be changed yet at an international level. So it's hard to see the change. But the folks who run OVC and what they're communicating through the community of Vipassana Centres is incredible. They're just like, "Give us more! Tell us more! We wanna change things! We wanna make it better!" Such genuine, cis-gendered folks, straight folks, who are like: "I've never thought about this! I'm gonna go learn and come back with like this language." And I'm thinking: "Wow, you really did learn something in there! You're not even pretending." Yeah, it feels very authentic and genuine.

DS: That's exciting.

PSYH: I did some reflecting on the process and just what an example it is of how deep but quiet shifts can happen on the basis of something like, "I'm trying to minimize my ego … I'm trying to actually listen. [Laughs] I'm not trying to be important." It's not showy, it's just part of the spiritual work to listen and not be defensive. I don't see a lot of that kind of work in other spaces around divides of oppression, so it's kind of exciting.

na: It's really interesting to see that happening with regard to trans and queer stuff. I think about my love MeLisa Moore, who's not from Toronto originally, she's based in Baltimore. She's a Black and Indigenous to Turtle Island woman, genderqueer presenting, who has a long history as a meditation/Dharma practitioner and has deeply contributed to my spiritual growth and understandings of the workings of anti-Black racism. In a lot of Dharma spaces or spirit-based spaces that could offer healing through one's own connection to spirit practice, like meditation or Buddhist or Yogic practices—a lot of places that I'm connected to—the amount of racism that is present and anti-Black racism specifically is so intense. In a way that practitioners, or the people who are holding the spaces, are so unreflective of. MeLisa and I have both been talking to different centres. MeLisa, taking the lead on that as a Black woman, and as someone with a long history of experiences in Buddhist and spiritual spaces and with Buddhist teachings, talks about how this is an integral part of even one's meditation practice and working with the ego, which are central principles to her work in community wellness. But there's a different level of resistance that I'm hearing to race than to queer and trans stuff. Which is interesting, because I wonder how the Vipassana people would respond to talking about anti-Black racism that shows up or even racism that brown folks and other people of colour experience in spaces. Which is why it's often queer and trans Black, Indigenous and people of colour who are trying to create these spaces for healing. It's really bringing up for me the need for spaces that centralize queer and trans folks but also racialized queer and trans folks. And that's such a need because so many spaces that are geared towards healing, connecting to one's own self-healing, or meditation or yogic spaces, can be so isolating and non-welcoming, and actually re-triggering. I've experienced more racism and homophobia in spirit-based places that are supposed to be connected to my own ancestral traditions than I have in other places. That's sometimes the most damaging I find. So that's why I keep coming back

to wanting to do this kind of work. How about you, Danielle? You had like a yes response when I asked that question about ancestry.

DS: There are so many things, and so many things that are unknown for me about that. I'm thinking about the work that Pauline and I did, almost a decade ago, and that I continued on working with Diane Roberts and Heather Hermant, what now I'm terming as embodied ancestral research. I like to describe it a little bit as using theatre exercises, like a person would do character study on a character and embody that character to perform it. For lack of a better description, a similar sort of process is done, but it's not to perform your ancestor but to embody your ancestor, to experience your ancestor, and to experience the connection of your present day self with your ancestral self. And that line of how it can work, it's vast … like the potential in that is so overwhelmingly vast. And that connects, too, to the grief that came up, really quickly, when you and I were talking about how we've all come from these different places ancestrally in the world. And even conversations that MeLisa and I had last year with a bunch of other folks about the lack of information that's known about African spiritual traditions. I know they're out there, I know people are practising them, but the accessibility and the knowledge, the general public knowledge about it, is still so limited. And that might be a good thing in the way Black culture's appropriated. I don't know. [Laughs.]

[…]

na: Connecting to ancestors has been integral to my own journey of connecting to self-healing energy or whatever that part of my energetic body is—and also to how I share energy work with others and do work around healing relationships through time energetically. Also, as someone who has an artistic practice that's been really important as well. Actually, in the artistic practice accessing things that were connected to ancestors then translated into how I share healing work with other people or with myself. It translates into the recognition, or maybe the question: If we offer healing to our beings now, in this present moment, does that then offer healing to ancestors past and generations forward? My personal belief is HELL YES! [Laughs.] This is probably getting a bit more into other realms. But in terms of what we now call quantum physics and the idea of how energy and time works, we can actually shift through many things because energy and matter are the same. That's a very brief outline of why I believe it so much. [Laughs.] So I do feel

that ancestral connection and I also feel guidance, even though there's a lot of blurriness around if there were people who shared healing modalities in my ancestral past. I know that the region I come from, a mix of many things were happening: Buddhism, what's called Hinduism, yogic practices from many lineages.... I think of caste, how caste has erased where a lot of the practices of yogic sadhana or practices come from. I know that that was all in the mix along with Sufi stuff, along with Islam.... The region I come from in South Asia has that mix, so I feel that coming through in different ways in the yogic practice I share, in the energy work, and even in the Ayurveda stuff. I feel it present. And I feel like people, whether they're present with it or not in their current day experience, are doing that. They're gifting that to their ancestors as well.

PSYH: I almost want to repeat that, and put it in bold or something: that the healing work that I do today affects the pain of my ancestors. I have definitely felt shifts with the ancestors that I have connected to, through projects like the one that Danielle did. As people who have experienced different kinds of colonialism and imperialism for so long, maybe that's not something everyone thinks is possible, that there are ways to address some of the pain that was inflicted. There are ways, you know, on a societal level, but what happened did affect people's emotional psyches, and we carry that stuff on till today. At least I feel that I have inherited a lot of things [laughs] from the ancestors. So yeah, I just want to underline that we can actually work on that today.

DS: I'd like to call Chiedza back into the circle in a conversation and a discussion that we were a part of recently. I had expressed the concept or the idea born of Indigenous teachings that what we do now affects the next seven generations but what we do now can also affect the past seven generations. Chiedza was talking about having a discussion with her mom, and asking her: "Well, when this happened, how did you deal with it? Like, what did you do?" And her mom is like: "What do you mean how did I deal with it? I went and I got the water, and I cooked food, and I just did what I needed to do. The daily things. Like these questions, don't ask me that. We didn't have the space to be able to examine this," the way that our generation now does. And how it's a privilege to be able to do so and at the same time a responsibility.

na: It's like an opportunity-responsibility—that's how I feel. This is an opportunity, at this present time, even though shit's still going down. For some folks, there's spaciousness. I'm not Black, I don't know what it's like to deal with the kind of anti-Black racism happening now. But even in the face of that, a shift can happen.

[…]

LG: I've got to chime in, as someone who's British and Turkish, so representative ancestrally of colonizers, but also resisting white supremacy in my family, being raised with British people, and the way that white supremacy invisibilizes my experience. I practise medicine that's not of my ancestry: Chinese medicine and Shiatsu, which is Japanese. And then through this work I come around, and I think "Oh there are pieces here where I hope that I can offer healing towards the layers of colonization through acknowledging my existence." And through connecting with Turkishness and then: "Oh! I found out information about cupping traditionally in Turkish culture, cool." But I'm so removed from my Turkish culture that it's like a whole other bag of grief that I'm saying, "Hi, here you are." I am disconnected but also there's this incredible opportunity to maybe carefully, always humbly, or as often as I can be, offer a way to be, "How can we co-exist together? What is my responsibility as a person who is white passing, white privileged, raised British with the mixed race-ness in my existence which gives me so much information?" How do I sit with all of that, all of those truths—'cause I exist? And how do we use that as a transforming tool? How can I be used, maybe, as a transforming tool to help mend these aches that sit historically in all the people's lineages who crossed my path or hear this recording, read this chapter? How can I, with my British ancestry, step up? And be like: "Ok! I'm here." As Maya Angelou said, "If you have the privilege then your responsibility is to share it." How do I use it in ways, and how do I do that with less, with as minimal ego as possible? How do I support Indigenous sovereignty in this conversation? As a person who exists, I need to also acknowledge how much more I need to learn so that I can contribute to a just presence on this land.

na: I really appreciate you naming how white supremacy shows up in your family and also the white passing-ness and privilege that comes with that. And the complications of that, being Turkish mixed.

DS: I can riff off that too, identifying as a Black mixed-race person having light-skinned privilege. Thinking about how that plays out, and contemplating how privilege functions as a means of unawareness. How do we raise awareness—our own and others'—what role do I play in various contexts, and how do I use my privilege to move through different spaces intentionally—as you said, Lamia? To shift and heal relationships among us as individuals as well as collectively?

PSYH: I can definitely relate to what you both said, not with the exact same background, but just in terms of the many ways that I have privilege in the world. And then how that intersects with everything that we've been talking about.

[. . .]

na: Another question that we had on our list of things that we were excited to talk about was about models of holistic medicine practice that balance the sustainability of the practice with accessibility to the communities that we're trying to serve. What does access to healing and healing justice look like in a city like Toronto, where gentrification is happening? In a context of higher rent, fewer state resources, and more people being denied primary health care. What does this mean for the modalities that we share? On the sustainability/accessibility note, I've been talking with practitioners who share different spaces. From free spaces to pay-what-you-can sliding scale, to fixed rate. And it's trying to find a way that people can access it. But because we live in a capitalist system, people have internalized a monetary value of healing. So talking to people all over, from Oakland to the East coast (this part of Turtle Island), it seems people don't benefit as much from the modality that they're engaging with if it's free because unfortunately capitalism has pushed people to undervalue what they haven't given as much monetary exchange for. But then there are other people who know how important these practices are to their well-being. Where it's like, they could throw down two or five dollars and receive immense benefit because that's actually a lot of money for some people. And for some folks, going to a free workshop means they don't even engage with the material in the same way. So it's a tricky balance.

PSYH: It's tricky. Is it possible to inject more conversations about money into our communities? I just feel like class and money are really not talked

about much. My thoughts about this are in the larger context of how we talk about "isms," which I also feel has shifted over the past fifteen years or so. Sometimes it feels like instead of having open, supportive, productive conversations, it's more like "Oh you're supposed to already know this stuff." So if you don't get it, then it's like shunning, or naming and blaming. So yeah, creating spaces where we can actually have honest vulnerable conversations about all the isms, but also very much including class and money. Because I feel like so much is internalized from the capitalist value system.

LG: Totally. I've been doing community acupuncture in this Canadian context since 2007, where we have "free" healthcare. Watching people having to pay for a service—folks who would otherwise not have access to the service. And being a business owner watching people over a course of months, watching the numbers on one side and watching how people relate to the medicine. And then having conversations with people about treatment plans: "Okay, you're here. You're gonna pay for this service. This is how this medicine works. So you need to think about coming here once a week for the next ten weeks. So plan that budget, this is why we have this sliding scale." The empowerment piece around how accessing health care almost gets taken away a little bit more in this system as opposed to our counterparts in the United States. I think about Third Root in Brooklyn, who have a very similar space to us here at Six Degrees, and going down there and talking to them. Our struggle here around people paying for something is so different than what's happening in the United States. Because people there are so used to paying for things, so the success of community acupuncture is way bigger. As opposed to here—I don't know if you find this in your practice—where people are like: "But I don't pay for this. I can't even factor it in." Because here we go to the doctor for free and if you have some benefits then maybe your prescriptions are somewhat paid for. And just inviting people to think differently about their health care, and then having conversations. This is no slight on people. But we pay for lots of other stuff, and we don't prioritize health care in the same way. Back in the day, I used to drink a lot. I would go out and party and blow like sixty dollars in a night, no problem, wouldn't even blink an eye. But come to think about maybe getting a massage for my sore shoulder, I'd be like "Mmmm ..." And there's my own complicated reasons why I was drinking whiskey and not getting a massage. But just even

the thought about the way that capitalism takes that away from us, and the options we're given in this capitalist colonial context. And thinking about my history, I wish that in my growing up the thinking about health had been more prevalent. How this scarcity model that capitalism thrives on is counter to creating functioning, beautiful community and people helping each other out. And thinking of creative ways to make this space more financially accessible, and sustainable for practitioners. Because when Six Degrees started, the rate was twenty to forty dollars and then we shifted to twenty-five to fifty-five dollars, and now we're at thirty to sixty dollars. And the reasons those things happen are about keeping sustainability for the whole place. Because rent goes up, because we moved space, because our rent in this new space is more than in our old space, and wanting to get bigger, to make it more accessible for more people, to have more practitioners, to have more styles and practices of medicine.... But thirty dollars as the minimum—that's a lot of money! You know? "Ok, I think you need to come in once a week for the next five weeks and then we'll reassess and see how you're doing, that's $150 in the next month! And I can't even totally guarantee you that you'll feel completely better, 'cause that's just not how this medicine works, and that's actually not how humans and bodies work a lot of the time." So yeah. It's just a lot of thinking and it's risk taking, and it's like we lose some folks, and some people don't get to access those services any more, and other people do. And hopefully a new something model will come through and there'll be some kind of sponsorship program one day. And then physical accessibility, rents are so frustrating in Toronto.

na: We've talked about how you had tried to put in an elevator into this building and it was exorbitant. Trying to hold our gatherings in physically accessible spaces is so important.

psyh: I'm thinking about what's happening in the city, and also about how big Toronto is and how many parts of the city are not that serviced. About starting a conversation about where we are located, why so many of us need to stay downtown. And if you wanna talk about health care spending and money, how much money goes into this biomedical industrial complex that we just assume is a given? It doesn't have to be ... not everywhere in the world is like that. And we need not only be completely outside of the "mainstream." I know Guelph Community Acupuncture managed to find a

spot in the community health centre there. I think it is more accessible and they are more able to build those connections.

na: I think about ways to counter gentrification—I know it's always been happening, but I feel like in the last five years it's happening quicker—that are really through community circles and community gatherings and organizations. Partnerships, like you said, like joining with either health centres that are already there or just shifting what it means to be in different communities geographically. There are so many folks outside of the city centre downtown that are needing access to these spaces and modalities. So doing that bridging more is something that I really envision in the next decade. And building a web of people that is harder to break, in resistance to gentrification, in a way that can support communities who are more marginalized, including queer and trans folks of colour. But also communities where we might not have the same visibility, because queer and trans folks live within people of colour communities as well.

[...]

DS: Another topic I wish we had got a chance to talk more about is disability justice and how that plays in. We talked about it in little bits and pieces but not specifically around that.

na: Disability justice has been a big influence on healing justice.

DS: And I'm not even sure what I would like to say or hear about it. I think partly because I'm coming from the background that I come from in sports massage therapy ... very, very ableist and elitist. And how I have struggled with a learning disability while in school. And thinking about disability in different ways, and coming from my personal experience of being very very kinesthetic. I think there's so much potential in how healing justice and the terminology and the language around it has been formed out of disability justice. It's a totally different frame from the medical industrial complex, you know? And it's giving back—what we started the conversation with: it's acknowledging that each individual has their own healing capacities and that they're defined in very specific ways that include harm reduction. And that things that mainstream medicine would call a pathology are actually very functional, you know?

LG: Totally, yeah to this.

PSYH: The normalization ...

DS: Exactly, and it's like "cure" or just "dispose of." Like if you're not in that cure model, then something's wrong with you: "Sorry." That's how it's gonna be coming from the mainstream model.

na: It creates the idea of suffering not existing, and pain not existing. And the ultimate place to be is without pain, and the ultimate place to be is without suffering. When is that gonna happen in this living world? So what does it mean not to be afraid of those things, but accept them as part of our journeys, as places of learning and growth and possibility for change and transformation? And also recognize the magic and skill and beauty and wisdom that come from journeying through whatever it might be?

LG: I'm sure the experience of pain and illness has infused revolutionary struggles for thousands of years. Because it's always such a source of strength to come through to live with whatever it is.

PSYH: And to have that as a motivator to create those communities of care, that vision of interdependence, as opposed to "I can be strong. I can be completely 'healed' on my own."

na: Yeah ... which can be helpful for some, but it's definitely not the only way. And we need each other.

LG: I gotta wrap it up because we gotta poke people in ten minutes!

na: Acupuncture begins! [All laugh.] Oh, thank you all so, so much, so much gratitude, and gratitude to all our ancestors and ancestors of this land, and all the cajillions of people that are doing this work in different ways.

All: Thank you!

14 | A Love Letter to These Marvellous Grounds

Living, Loving, and Growing in a City Called Toronto

Shaunga Tagore

I was born to a father who knew ever since he was a little boy growing up in pre-partition Bengal that his life purpose was to take care of his family. I was born to a mother who was terrified of dying during childbirth; who was sure that her bones and exhaustion could not sustain raising another child. Yet her fears dissipated like bubbles popping into the atmosphere once she held my body for the first time. I was named after my great-grandmother who gave up her name, her hair, and her duties of wifehood and motherhood to devote her life to serving God. My parents wanted to honour her memory and bring her name back in the family. Along with her name, I inherited her trauma, resilience, and ability to talk to Spirit. I was born in the sparkle of a Gemini sun just as it was setting on the horizon, and while a full Sagittarius moon was rising.

I was born to be a channel of communication between the past, present, and future, and in the in-between dimensions. I was born to know intimately trauma which isn't mine; to learn that I do not need to hold this trauma in my body in order to honour who gave it to me. I was born in the transition point between death and life. I was born to be a healer; an advocate of change, internal and external. I was born to be a storyteller, and to share my stories with the masses.

I grew up lonely, highly sensitive. I absorbed and internalized my family's pain, unknowingly taking responsibility to heal that which was much bigger than me. My parents spent nearly twenty-five years in rural Manitoba, building their own small plastics manufacturing company alongside my aunt and uncle who had sponsored their immigration from West Bengal, India. I grew up in this town, made up of a large Ukrainian population, a few racialized immigrant families from Africa, Asia and the Caribbean, and a small group of the original peoples, including Cree, Metis, and Anishnabek First Nations. I grew up experiencing the emotional impacts of living with a family struggling with money, survival, twenty-hour work days, and trauma that nobody had names for.

Systemic and interpersonal violence regularly undermined, broke down and violated my sense of self, body and spirit, but I found resilience with a small clan of goofy, weirdo, misfit friends with whom I wrote bad teenage songs, plays and videos, and sang Spice Girls and Savage Garden karaoke in my basement. I found refuge in wild, joyful realms of music, community theatre, imaginary friends and lovers, and real-life animal and grandparent companions. It wouldn't be until adulthood that I would discover how my emotional intensity and creativity, as well as my childhood struggles with mental health, were tied to my ability to see/hear/speak to spirits, ghosts and ancestors. Ultimately, this was about my life path with magic and spirituality, and my journey as an artist, creator, and healer. I was always the little brown girl whose spirit was too big and weird for the space that held her; a shy and quiet firecracker who couldn't wait to break free.

Today I find myself living in a place many know as Toronto, a place more accurately known as traditional Haudenosaunee, Wendat, Anishnabek, and Mississauga of New Credit territory currently occupied and colonized by the Canadian state. September 2015 marked my ten-year anniversary of living, loving, creating, working, and growing on these marvellous grounds. I have spent this decade immersed in the building, breaking down, breaking open, and regenerating of relationships, home, and self. What I've learned, unlearned and am still learning about change, activism, organizing, creation, community, healing, spirituality and magic is astoundingly beautiful. Today I reflect on my journey. I share my story as a gesture of gratitude and love to

myself, the people and communities who have touched my life, and to the land and lives that have held me here.

When I was seventeen, my parents lost their business, which to them was more like losing a child. It was a devastating experience of family betrayal for them at the hands of their business co-owners, my aunt and uncle. During my last year of high school, we were forced to leave our home and relocate to the city of Winnipeg.

The biggest gift I received from moving to Winnipeg was the opportunity to connect with a relatively large Bengali community. For the first time, I learned what the words "internalized racism" meant. For most of my life thus far, the way I had coped with growing up in a small white-dominated town, and with being bullied, ostracized and shamed for who I am, had been to deny and loathe everything that made me who I am. At a young age, I had lost the Bengali language from my tongue; I had learnt to dissociate when my parents spoke anything about their histories or culture. Although I had always needed to be connected to spirituality, assimilating myself into Christianity, the accepted religion of my peers and friends, had been my most available option.

Moving to Winnipeg brought me closer to Bengali cousins, nieces, nephews, uncles, aunties, elders, babies—no blood relations, but family nonetheless. We shared trips to the beach on Lake Winnipeg with chicken curry and bottles of coke in the trunk, and aunties in saris and uncles in suits casually chatting under the trees. I cultivated cherished relationships with young children, elders, and people my own age who I will always refer to as the "kids" of the community, no matter how old we get. We made up jokes in broken "Bang-lish," hung out at Assiniboine Park, and played charades until 4 a.m. We invented cultures on borders that existed just for us. Here in Winnipeg, I found that unspoken sense of home and belonging that you never know how much you've missed until you find it.

My passion as a teenager was theatre, dance, school band, and classical piano. Until the age of seventeen, I was intensely focused on pursuing higher education and a career as a concert pianist. When I moved to Winnipeg, however, much to my confusion, frustration, and sadness, I lost my drive and enthusiasm for the piano. It wasn't until adulthood that I would realize this change in me was a result of the trauma my family experienced while

relocating to Winnipeg: my mom losing her sister, my parents losing their business, all of us losing family and home. This is how trauma gets stuck: I absorbed my family's pain, as I didn't know how to save or heal a family suffering through severe loss and depression.

After I finished high school, I began taking classes at the University of Manitoba. What I really wanted was to take a break from school, since I did not know what kind of career I wanted. However, my parents would not hear of me taking any time off. Resigned and indifferent, I signed up for some classes on feminism, anti-oppression, history, and movements of liberation. This ignited a spark and inspired a curiosity in me. I began to form a ferocious language to my relationship to justice. My anger awoke at all the ways oppression had hurt me and others. I learnt how to articulate, fight for, and dream of the kind of world I wanted to live in.

There is something about finding yourself that always leads to growing more into yourself; sometimes this means growing up and away from the people that mean the most to you. With a growing awareness of how oppression and structures of violence operate in communities, relationships and homes, and within my own self, I began to feel uncomfortable in the womb-like skin of my Bengali community. For example, when young women spoke up about sexual violence, nobody would believe or support them because the perpetrator was a highly respected male doctor in the community. I grew increasingly agitated, anxious and furious at the ways in which patriarchy, transphobia, homophobia, fatphobia, Islamophobia, anti-Black and anti-Indigenous racism were permitted to function freely in this mostly upper-caste Hindu Bengali community. The ways in which cultures of casteism and classism allowed most to only respect certain kinds of professions, labour, bodies and livelihoods. The ways in which "Bengali Pride" could all too easily be interchanged with a false sense of superiority and power over others.

I did not understand or have all the words to describe the depths of what I was feeling at the time. Yet I knew that this kind of community was not the endgame for me. It was not the life or world I wanted. Winnipeg was no longer a place where I could grow. This community could not hold my queerness, my weirdness, or the innovative and eccentric things I wanted to do with my career. It could not help me honour how I want to love and be loved, or the passion in my spirit that wants to break down and break out of

every gender norm, attachment to white superiority and colonial-capitalist violence I saw around me. It could not help me dismantle these things in my self.

One day I was browsing university programs online and made the snap decision to leave home and travel halfway across the country to live on my own. I told everyone I was moving to Toronto to attend York University's Women's Studies program (now Women, Gender and Sexuality Studies). Giggling excitedly under my breath, I announced: "I'm going to find people like me!" Call it naivety, call it the absurd optimism of my Sagittarius moon— I innocently hoped that this program would open all kinds of possibilities for me. I hoped that it would fulfil the dreams of what I've always searched for: Friendship. Falling in love. Belonging. Interdependence. Justice. Reciprocity. Infinity. Peace. Growth. Healing. Community. Home.

York University, and especially its Women and Gender Studies program, has a reputation for being a leader in intersectional, antioppressive revolutionary feminist scholarship. Indeed, I found a lot of this in student activism. During my first few years at York, I organized with the Undergraduate Women's Studies Collective, United South Asians at York, Sexual Assault Survivors' Support line, the Centre for Feminist Research and the YU Free Press. I organized panels, conferences and film festivals, brought in rad queer South Asian speakers from New York City, wrote and performed songs for each year's December 6 memorial of violence against women, marched during Drop Fees rallies, picketed during the CUPE 3903 strike of 2009, listened to and supported folks struggling with suicide, depression, and assault, published Indigenous Feminist, Black Feminist, and Palestinian freedom articles as features editor of the YU Free Press, learned about organizing efforts seeking justice for survivors of the Bhopal disaster, and offered my presence in solidarity with the Tamil community (students and beyond) during their famous hunger strikes, demonstrations, and shutting down of the Gardiner Highway in 2009.

These promises extended to the classroom. When I first started classes at York, I signed up for every anti-racist feminist course I could get my hands on. I was practically drooling with stars in my eyes to be in the same room as fierce and brilliant brown, Black and Indigenous professors who I had previously read about, and in classrooms full of other passionate folks eagerly

raising their hands to debate queer theory. For the first time, I felt like I wasn't the only one trying to discuss what was important to me. In fact, so many people were adding to the conversation that I could hardly get a word in! My dreams of finding people like me seemed to be coming true . . .

If not for that pesky thing I would learn all about during these years: white feminism! White tears, white defensiveness, white guilt, white forgetting, white denial. I learned I could either be the silent, brooding monster, or the angry, aggressive brown woman—and nothing in between. I argued with them, I tried to build and rebuild trust with them, I tried to explain myself and the impact of their actions and words, I spent so much energy trying to convince them that racism is real.

Ultimately the most important thing I learned about white feminism is that I don't have to fight with it. I am not ever obligated to give it an ounce of my precious time and energy. I learned that I don't have to break myself while trying to force them to understand or change. I can just choose myself. I can choose to put my energy into building with my own communities—and if any white feminist is resistant to changing and growing away from their white superiority complex, they are not part of these communities.

At this time I began organizing with United South Asians at York (USAY), a student group with the mandate of bringing together multiple South Asian communities and individuals on campus to promote justice, anti-oppression, and solidarity. *Finally,* I remember thinking, *I've found political brown people, AND they feel like home. I have a community I can joke around and be goofy with, confide in, AND organize for justice with.* I fell in love and fell in love hard with these folks, as friends, lovers, and community. Along with organizing together, our relationships became incredibly intimate (romantically and sexually, in some cases), while we helped each other through suicide attempts, sexual violence, and deep emotional struggles.

From these years, I learned that the ones who are the closest to you are the ones that can hurt you the most. I learned that even though we were drawn to each other so quick, deep, hard and fast, it didn't mean that we would be able to take care of each other at our most vulnerable. It became clear to me how much South Asians in our history and practice have internalized patriarchy, misogyny, homophobia, and gendered violence. I lived with the pain of experiencing the very folks who had always promised they

wouldn't, do this to me in the most horrific ways. I made love and home with these people—but even at home I could be reduced to either the strong, calm brown goddess who saves everyone but isn't allowed to be a real human being, or the homewrecker slut who ruins the peace of communities and families when she speaks up against violence everyone else is ashamed of admitting—with no room for anything else in between.

I kept asking: How could these histories keep repeating themselves? Why can't we change? Why can't the ones I love stop hurting me? Why can't I walk away from the ones I love? By 2009–10 I was spiralling fast and about to crash and burn. My relationships during this time broke me so hard, they broke me open. I couldn't make anyone change around me; I had to change myself. I couldn't remain the same person if I wanted to survive.

I started therapy and started asking different questions about myself. I re-visited my childhood; I looked at the history of everything that made me. I stopped being able to write like an academic and instead I wrote everything I knew in poetry. I wrote my first poetic manuscript, *The Erasable Woman*. I wrote about the feminine as sacred, my body as sacred. I wrote to acknowledge all the different ways queer women and femmes of colour survive structural and interpersonal violence, just to say to them, to myself … *I know you are here.*

Around the same time I had just about had it with academia. I had begun my master's degree at York in women's studies with enthusiasm. But the level of racism, competition, ableism, elitism, and violent appropriation I realized existed in "higher" academic feminist scholarship was downright (and sometimes literally) vomit inducing. There was no room in these spaces to treat each other like human beings with feelings, spirits, disabilities, illnesses or emotional needs and boundaries. Every day my time spent with my women of colour friends felt like a regular support group to vent our rage and convince each other not to drop out. It's no wonder that I could not sustain regular and close friendships with many of these people after grad school was over, because we didn't have a chance to get to know each other outside the realm of crisis.

I often felt like I was too stupid or inadequate to make it through the rest of my program, and my anger built to a fury at the injustice I regularly experienced and witnessed. One day a white queer cis-male professor sent

me an obnoxious email, and instead of writing him back I wrote all my frustration and anger into a poem I titled "A Slam on Feminism in Academia," which was later published in Jessica Yee Danforth's anthology, *Feminism for Real: Deconstructing the Academic Industrial Complex.*[1] To this day I receive emails from folks telling me that they read my poem in this book and that it helped them stay in school, or get through the day, or just feel validated and not so alone.

I often think: What would have happened if I had instead written my brilliant thoughts to this professor, only to have them dismissed and lost in his email inbox? I learned this powerful lesson not to waste my words and magic on fighting with people who don't want to change. I learned that there are times when it feels as if our options are limited, as if the only thing we can do to fight oppression is scream at a blank wall until we burn out and collapse. But in these moments, if we widen our perspective and look in another direction, we will find masses of people who will love and nourish us; who are waiting and needing to receive our brilliance. Sometimes the best thing to do is channel the anger, despair and injustice we feel/face into creative outlets and open our spirits to something new.

In 2010, I finished grad school full of heartbreak, exhaustion, accomplishment, and resilience. I branched out beyond academia to work and train with feminist community organizations like the Toronto Rape Crisis Centre and *Shameless* magazine. Once again, my life would change as I browsed through my emails and saw a class offered through the Toronto Women's Bookstore with Black feminist burlesque icon and performer, Coco La Crème: "Introduction to Burlesque 101 from a Feminist Anti-Racist Perspective."

In the six weeks of completing this course, my love of art, dance, and music was rekindled. For the first time since the trauma I experienced aged seventeen, I returned to my own truth as a performer and storyteller. Burlesque as an art form opened a vibrant and exciting door; it changed my life in more ways than I realized could be possible. It gave me the opportunity to fall in love with my body, creativity, self-expression, stories, and sexuality. It gave me the chance to reclaim ownership over my body, after many experiences with sexual violence and control. In burlesque, I could find joy and play. I could be my own brand of sexy, political, quirky, powerful, and surprising, and I could share that with small and large audiences who wanted

to witness my journey. I had a space to challenge myself creatively, physically, emotionally, and spiritually. I could get to know myself nakedly, unapologetically. Through burlesque, I was able to take care of the wounds I had experienced and rebirth myself as a powerful phoenix on stage.

In 2011, I performed my first burlesque routine at Colour Me Dragg—a community group that from 2006 until 2011 organized drag, burlesque, and cabaret showcases in Toronto by and for people of colour.[2] That same year I revamped my book of poetry, *The Erasable Woman,* into a ten-minute burlesque and musical theatre solo performance piece at Eventual Ashes' inaugural *Arise* program—a multidisciplinary performance program for LGBTQ emerging artists of colour under the mentorship of multidisciplinary theatre/dance artists Gein Wong, Krystal Banzon of New York City, and ILL NANA DiverseCity Dance Company of Toronto, whose crucial community making I will return to in a bit.

During this time I began to work with Asian Arts Freedom School (AAFS), first as a participant, then as the facilitator of my first ever arts-based storytelling workshop in 2010, and eventually as an ongoing facilitator, mentor, co-ordinator and program co-ordinator from 2010–13.[3] AAFS is a radical history and storytelling program for folks of Asian descent (many of whom identify as queer, trans or genderqueer). Queer femme of colour artists and writers Leah Lakshmi Piepzna-Samarasinha and Gein Wong founded the program in 2005. It ran for many years out of a basement in Kensington market before branching out to other locations such as the AccessPoint on Danforth Community Centre, Dufferin Park, and Unit 2 (a community home/space run by LAL, the Toronto band consisting of Rosina Kazi, a queer South Asian woman and Nicholas "Murr" Murray, a Black straight man).

I remember the very first weekend I spent in Toronto in September 2005. My older sister emailed me the call-out for a cool storytelling workshop happening at the University of Toronto's Women and Trans Centre. It was the first "try-out" workshop of AAFS, to see if there was enough interest to apply for government arts funding. At this workshop, I met Gowry, a young Tamil woman scholar and writer I would later work with at the Centre for Feminist Research in 2010. I also met Matthew Chin, a queer Chinese-Jamaican academic and storyteller. I was instantly drawn to Matthew and thought shyly to myself, a lonely new kid in the city: "I want to be his friend!" I wouldn't

see Matthew for another seven years. In 2012 Matthew and I bumped into each other again at an AAFS workshop I was facilitating at Unit 2. We started chatting while I stirred a pot of dahl on the stove for the workshop. From that point on we developed a beautiful relationship, and today he is one of my best friends.

I tell this story to illustrate that, after five years of living in this city, connecting with queer community of colour through these artistic spaces felt like a returning, a safe landing, and a coming home. Maybe I didn't find people who were exactly like me, but I found a moment where *I could be exactly like me.*

My life blew up even wider and fuller in 2012 when I was accepted as a participant in ILL NANA's first ever Right to Dance two-month solo intensive program.[4] ILL NANA is currently made up of three genderqueer people of colour dancers and multidisciplinary artists, Sze-Yang, Jelani and kumari (all of whom I would eventually cultivate meaningful friendships with). They created their Right to Dance program after years of struggling through the mainstream dance scene in Toronto in beyond; after experiences of exploitation, degradation and abuse in supposedly "prestigious" dance training programs. Their dream with Right to Dance was to provide affirming, accessible dance education for all body types and marginalized folks, particularly queer people of colour and others who have experienced barriers accessing dance and performance training.

I had long seen myself on stage performing fantastical dances. As I would listen to music on the subway, I would see the lights, costumes, and audiences cheering. I had taken dance classes as a teenager, but I didn't believe I could be good enough, or worthy enough, to be a professional dancer or performer. I knew there was no room for people like me in the industry. I never thought I would be skilled enough to come up with my own choreography. It was a dream I assumed would always just stay in my head.

ILL NANA's Right to Dance Program literally made my dreams come true. Completing their program was like bursting through a door that I always thought was locked and stepping into a universe full of sparkles, colours, beauty, and stars with all of our names written on them. After the performance showcase, I knew I had begun a new life; one where dance and performance would be a serious, core part of my personal and professional life.

This couldn't have been more true: since 2012, I have choreographed at least twenty different solo dance pieces that I am proud of, performing them at packed venues full of vibrant, cheering queer people of colour. In late 2014, I took the material I had been developing and created my first multi-disciplinary One-Woman-(Burlesque)-Show, also titled *The Erasable Woman,* which I later performed in San Francisco's Queer Astrology Conference and Toronto's Mayworks Festival. I have guest facilitated Right to Dance drop-in classes and mentored other people going through ILL NANA's two-month intensive program, and choreographed a group contemporary piece for the 2014 cohort. I became a collective organizing member of *Making a Stage for Our Stories* (MASFOS), an LGBTTQ2S dance conference and showcase that grew out of ILL NANA's dance education programming which, since 2013, has been organizing a yearly dance showcase and week-long series of dance classes and training offered by queer-identified facilitators. Matthew and I even co-choreographed a dance piece for ILL NANA, which they performed at the 2014 MASFOS showcase at the Palmerston Library Theatre.

It's still unbelievable to think about how much creative growth occurred for me in three short years—I am a different and better person because of the strength and vision of ILL NANA and the spirit of queer people of colour arts-based organizing in this city. My life has been completely changed and uplifted. Off the top of my head, I could point out at least twenty other people who have accessed this programming and would say something similar. I'm sure there are countless others I'm not even aware of. The gifts of being a part of these communities and this journey are invaluable. They taught me that the life I want is possible. It brought me friends and community who I believe truly want the best for one another.

One of the most significant births in my life that came out of this time happened in the fall of 2012. kumari and I teamed up to organize the first Halloween edition of *Unapologetic Burlesque: Queer. Consensual. Anti-Racist. Not Your Average Burlesque!* We were both fed up with the racism, cultural appropriation, and heteronormativity we encountered while trying to do burlesque in the city. We wanted to organize a fun and affirming place for folks to perform, explore burlesque and tell their stories. We organized our first show with the intention of honouring political, radical histories of burlesque, and of creating visions and dreams for the future.[5]

Neither of us could have expected how big this series would get and how it would take on a life of its own. Between 2012 and 2014 we co-organized seven sold-out showcases, a stage at *World Pride*, and several community workshops on character development, costuming and organizing. Hundreds of people got involved in so many different ways: as performers, backstage crew, showcase co-ordinators, accessibility ushers, active listeners, live captioners, ASL interpreters, graphic designers, and as donors of money, time, knowledge, feedback or enthusiasm. Folks with a wide range of identities made the series what it is: Black, Indigenous, people of colour, Two-Spirit, queer, trans, gender nonconforming, living with disabilities, illness, chronic pain or mental health issues, deaf or hard of hearing, cash poor or working class, single mothers, sex workers, fat, mad, and survivors of all kinds of violence.

In the span of two years, I watched performers explode, deconstruct and rebirth the meaning of burlesque. Some of them were seasoned in the field; some were inspired to try out the art form for the first time. Show after show, folks took deeper risks in exploring who they are and bravely, vulnerably shared themselves with hundreds of people. On these stages I witnessed people discover new artistic talents and emotional breakthroughs; explore their relationships to systemic and interpersonal violence, family dynamics and personal relationships; and connect to, reclaim and adore their individual gender and sexual expressions, bodies, resilience, histories and ancestors.

These first few exhilarating years of discovering queer people of colour arts community in Toronto did not happen without struggle and conflict. I lived through break-ups, experiences of sexual harassment, family deaths, and chronic sickness. I left certain community spaces because power dynamics were not taken care of in ways that valued my safety, autonomy, and well-being. Others left certain community spaces because I failed to do my part in taking care of power dynamics that caused them harm. I experienced burnout and exploitation within nonprofit work. I came to terms with the fact that my chronic health issues were serious enough to change my relationship to work and activism. I am still learning how to understand and advocate for my body's and mind's limits and capabilities.

At the beginning of 2013, I decided to become fully self-employed as an astrologer, intuitive counsellor and performance artist. I no longer wanted to be someone who tried to fit "self-care" into my schedule in between doing

everything else I was doing. Rather I wanted everything I did—including my career, relationships, how I spend my time and with whom—to be rooted in intentions of love, joy and what makes me shine. I am still learning how to do this while also prioritizing practicality and financial stability: How to say yes to what I have the capacity to offer, and no to what I don't. How to figure out the difference between the two.

I am unlearning the tendency to martyr myself for other people, especially as an intuitive counsellor and community organizer who often facilitates creation and art space for others. I have learned that it is essential for me to prioritize my own dreams, creative process and healing—because if I'm not then I won't be able to show up for anyone else in solidarity. I am learning not to take too much responsibility for other people's feelings, needs, or healing journeys. Not only is it not my job to save or change them, trying to do so would be denying them their own agency. I am still learning to believe in and trust myself as the best caregiver I will ever have. Together with my friends and co-organizers, I am still learning to prioritize celebration and fun and to acknowledge accomplishments—so that we don't run on scarcity and burnout, and so that we have the space to notice and receive the beauty and abundance of what we are creating. Every day I am committed to learning more about who I am in the world, so that I can challenge and change what I don't want, like or need within me, and strengthen and honour what makes me a better person.

By the end of 2014, I suddenly started to experience paranormal activity. Unknowable forces would shake my bed at night, jolting me awake. Water would start boiling in my apartment when nobody else was around.

It eventually hit me that creating performance work with the intention of healing intergenerational ancestral trauma was much more real than I could have anticipated. Being a part of a community of artists who were diving dangerously and fearlessly into the deepest realms of who we are on stage meant that we were opening portals. We were energetically, collectively and spiritually creating pathways of change, both towards the past and towards the future. What I had done through my creative and performance work was to open a door to a much wider realm of individual and collective consciousness. Furthermore, this is only the tip of the iceberg: I have learned that I have had repressed psychic and clairvoyant powers since I was a child; that I have always been able to communicate with my ancestors. These powers

have always informed my struggles with mental health and vicarious trauma, as well as my creativity and genius.

My spiritual journey has not been an easy one. The year 2015 started with a difficult breakup which was complicated by the fact that I could feel my ancestors (not to mention my ex-partner's ancestors) involved throughout the whole ordeal. It wasn't just my grief I felt in my body, but also the grief, loss, displacement, hopes, struggles, opinions, devastation and fury of so many others' experiences with colonization, family violence, abandonment and betrayal. I literally had a chorus of voices in my head, as well as a plethora of stories, desires, and life journeys full of sadness, survival, and unrequited love that weren't my own.

I describe 2015 as the hardest year I have ever been through since breaking down / breaking open in 2010. The difference between the two is that in 2015 *I* was different. The life I had created for myself was different. I was able to respond to the situation with a stronger version of myself. My growing belief in myself as a creator, healer, and maker of magic held me. For every moment I thought I was losing it, I found a deeper and stronger moment of discovering myself and what I'm capable of.

This was only possible because of the community who reached back to me when I reached out. At the beginning of my break-up I felt devastated from the loss of family, friendship and support system that came with this one relationship—as if this loss meant I was cut off from family, friendship and support altogether. But the Universe would not let me linger in this untrue belief. I was in a rough place but also fiercely committed to looking at the roots of my underlying pain. I connected with many Black, Indigenous and people of colour queer and trans healers, locally and internationally, who lit up my life and who I might not have ever known if I hadn't been heartbroken. I deepened and expanded my relationships with existing friends and community members by figuring out our relationship to magic and healing together. I met and worked with acupuncturists, sound healers, clairvoyants, diviners, herbalists, artists, teachers, astrologers, and writers.

There are many more peers, friends and magic makers than I can name, but I'd like to acknowledge my gratitude of some of those folks and what they have shared with me here: Dr. Gee Love, Leah Lakshmi Piepzna-Samarasinha, nisha ahuja, Six Degrees Community Acupuncture, Brown Girls Yoga,

Karishma of Pranasacral, Jade Fair, Chani Nicholas, Jessica Lanyadoo, Elokin of ShootingStar Botanicals, Oakland's Sustaining Ourselves Locally (SOL), Gunjan Chopra, Jelani Ade-Lam, Sze-Yang Ade-Lam, kumari giles, Anabel Khoo, Chase Lo, Mel G. Campbell … The list goes on!

One short year contained an incredible amount of learning and discoveries. This was the year I learned how to create boundaries with ghosts, ancestors, and family. I learned how to cast spells and transform my relationship to my own trauma. I learned how connected I am to the cosmos; that I could have conversations with my childhood self, grandmothers, and spirits I'd never met before, whenever I wanted. In 2015 I learned to believe in my power to femm-i-fest my intentions of true love, interdependence and sustainable community into tangible realities. I learned how to shed old emotional patterns that I had been clinging on to energetically. I learned to own my gifts as a healer and clairvoyant—to take myself seriously no matter how many others sat with skepticism or disbelief. I came to terms with my psychic abilities; parts of myself that I previously thought were negative aspects of my mental health, I began to understand as beautiful gifts. I learned that no matter how weird or off-the-wall I am, I am not alone. There is actually an abundance of people around me who do believe what I believe, and whose own spiritual powers have awoken and grown during this time as well. On the whole, this time helped me grow into a stronger version of myself: a more empowered, confident, accountable, loving, and visionary person.

In summer 2015, I had the opportunity to organize a two-week fundraiser to promote the work of a healer I had met earlier that year. The fundraiser aimed to create a local space for QTBIPOC to experience this healer's spiritual work, and also to come together as a community and explore our relationship to magic, ancestors, and clairvoyance. I took on the work of organizing this fundraiser because I felt strongly about the importance of creating a local space where activists, community organizers, artists, caregivers and various marginalized queer and trans folks of colour could centre our self-care and healing as an essential part of what it takes to show up fully for our work and relationships, both individual and collective. I was most excited to cultivate a spiritual and healing space for us to access, nurture and strengthen the most powerful version of ourselves, and the most impactful contribution we can make for our communities, movements, and futures.

The two-week fundraiser was a complete success. In many of my conversations with the people who participated, we spoke about how incredible it was for each of us to receive spiritual guidance specific to our own journeys, but also to act as *witnesses* for each other's healing journeys. It was groundbreaking to be a part of this kind of collective release and transformation. I couldn't say in the moment what the larger impact of the fundraiser was to be, but it was clear to everyone involved that something had irrevocably shifted in this city.

This fundraiser offered me a beautiful clarity of the lessons I have been learning over the last ten years: When you move with love, spirit, and intention, what you work for will manifest. What you create collectively will manifest. What you pray for will manifest. The question then becomes: Are we ready to receive what we are collectively creating with one another? One of the saddest things can be when you pray to the universe for something you need and then realize you are not ready to receive it, or even notice that it's there once it is offered to you.

Are we preparing ourselves, internally, for the revolutions we are fighting for externally? What is in the way of our belief? Can we transform the traumas that hinder us from knowing ourselves and keep us stuck in the same place? Can we deal with the parts of ourselves and our histories that have caused harm or used power over others, enough to believe we are not bound to those histories? Can we share, change, move and grow towards freedom and let that freedom run through every secret vein in our bodies? Can we do it collectively?

On my tenth anniversary of living in this marvellous city, I believe that the answer is yes. I am once again at a beginning point, infused with new hope. I don't know what challenges await from this point forward. I don't know what mistakes I'll make and what I'll continue to learn. But for once in my life, I know that I don't need to leave home to honour my growth. I don't have to search for new grounds to be who I am or get what I need. For once I know that everything that I've always searched for can be found right here: Friendship. Falling in love. Belonging. Interdependence. Justice. Reciprocity. Infinity. Peace. Growth. Healing. Community. Home.

September 2015

15 Race, Faith, and the Queering of Spirituality in Toronto

Reflections from Sunset Service

David Lewis-Peart

We are the children of the sunset; the misfits who instead of fit are finding way. Gatekeepers, Truth seekers, travellers of the road less, warriors bearing no sword or vest but rather Love and a single message: There is only ONE.

Can you envision a spiritual community where those most at the margins—queer, youth and young adults, people of colour—are not only welcomed, but rather at the helm of it? One community in Toronto, Sunset Service, attempted to create just that. Sunset Service Toronto Fellowship is an inclusive, interspiritual arts-based ministry begun in 2012. A registered nonprofit since 2014, the ministry's mission has been to engage, educate and equip community for their relationship with themselves, one another and God through the use of the arts. Sunset Service has focused on a message of radical inclusivity, most especially to communities which have historically been excluded from mainstream religious community as a result of such things as race, sexuality, gender identity, spiritual tradition, religious interpretation, and even nonbelief.

It is often suggested that faith, alongside topics such as politics, sex and sexuality, is an area of conversation best left in the private realm. For those of us who exist in the margins, however, our very identities not only brush

up against these seemingly contradictory domains; they are intimately inter-woven with them. As queer, racialized people of faith, our various intersec-tions are rarely, if ever, given public place to be honoured and to coexist beyond the confines of our own embodied personhood. The message which is conveyed, implicitly through society's silence, and more explicitly through the violences which in turn silence us, is that our very being is undesirable, controversial, and if not outright ended, to be relegated to hidden places.

A number of important voices, from within the queer community and from those who are allied, have purposefully challenged these relegations to the hidden and helped resituate Black and racialized queer people as integral members of communities both present and past whose contributions matter. These voices have bellowed from pulpits of all kinds: the halls of academia, church buildings, the pages of novels and essays; James Baldwin, Octavia Butler, Alice Walker to name a few. Each in some way has spoken to and made way for the place of spirituality. The space that we created as Black, queer artists stepped into and attempted to build off of those guideposts.

As an arts-based ministry with a clear agenda of inclusion, Sunset Service Toronto has also been influenced by the transgressive placemaking work of Archbishop Carl Bean, founder of the Unity Fellowship Church Movement in the United States—a predominantly African-American, LGBT-inclusive denomination active in social justice. Another inspiration is El-Farouk Khaki, a human rights lawyer and co-ordinating imam of Masjid el-Tawhid—Toronto Unity Mosque, which is the first of many radically inclusive Mosque plants modelled after Masjid el-Tawhid throughout Canada.

These individuals stand in place for the countless number of queer people of colour who have existed at the intersections of multiple identi-ties and spoken to the possibility contained in this location of faith, race, and queer identity, making room for others to come. Their voices—named and unnamed, past and present—have not only informed Sunset Service Toronto and its work; they are the foundation upon which it has been built. This is a reflection on how it came to be.

For the past four years, Sunset Service Toronto and the committed efforts of those connected to this spiritual community have actively and energetic-ally contested ideas of exclusion by carving out space for queer, racialized people of faith to acknowledge the Divinity that cuts through each and every

layer of our multiplicities as people. The ministry is rooted in the philosoph-
ical teachings of what was coined by Rankow as Prophetic New Thought,
which emphasizes social transformation through the "practical application
of spiritual principles to directly address the violence, injustice and suffering
that exist in the world."[1] The concept that the spiritual meets the material in
quite important ways and that any work done must be inspired (or in spirit)
but must also have real impact for our lives in the world is also acknowledged
in the oft-quoted saying "as within, so without" by Hermes Trismegistus, the
purported author of the Hermetic Corpus. This practical understanding of
spiritual communities as sites of transformative and embodied practice tries
to marry our seeking after "God," or rather a better understanding of the All,
with collective strategies for bettering ourselves physically, emotionally and
mentally throughout our experiences in a sometimes hostile world.

Our emphasis on embodiment or the tangible expression of principles
and ideals in the world in practice and through people has set Sunset Service
Toronto apart in critical ways. This has taken such shape as our support of
the social justice work done in Black and POC communities, our ministry
exploring all parts of identity including the sexual, the intergenerational and
interfaith relationship building and wisdom sharing, attending to Indigen-
ous knowledge systems and tradition, and utilizing music and other arts as a
means of sacred storytelling.

The narrative style of this essay mirrors this emphasis on storytelling. By
telling the story of Sunset Service Toronto, I hope to capture the movement
of ideas that came together at this point in time to create not quite a church,
but rather a family. This essay is an autoethnographic account of my experi-
ence of Sunset Service and my part in its creation. It reads excerpts from
Sunset Service's opening invocation poem alongside select quotations pro-
vided by community members through emailed feedback, thus enabling me
to capture multiple perspectives on the development of this spiritual com-
munity, the foundational practices which underlie our fellowship, and the
impacts that this space has had on its participants. It must be noted that the
choice to use a self-reflexive and more performative writing approach is an
intentional one, but one which has limits. Though in some part co-creatively
developed, this essay does not attempt to represent the entirety of the many
stories that have been a part of building this community. It reflects only a

snapshot limited to one lens—my own, viewed from one vantage point, and at one place in time, in what I hope to be an ever-evolving event.

We, the Children

> It is the family that I have chosen. It's been a safe haven for both wor-
> ship and prayer; a safe space to truly be oneself and leave the stigmas
> and societal norms that keep us bound, at the door.
> – Choir member, participant, Jerome Grant

Nearly one hundred bodies, mostly black and brown, filled up the small second-floor space made to fit eighty people, standing.

Smoke from an earlier smudge mixed itself with the smoke from a lone incense stick, sat on a small altar at the room's front. Smells lingered in the air amidst the rising heat from the people crowded atop the old Glad Day bookstore's space, whose windows looked out onto the busy Yonge Street intersection, overlooking both a community mosque and a sex store nearby. The crowd gathered together on this cold November evening had come for Sunset Service, an interfaith gathering led by a couple of young ministers, held each quarter precisely at sunset.

This particular night was about grief, and in recognition of all those who felt themselves teetering on the edge. Participants were asked to bring whatever weight they were walking with: grief, loss, a breakdown, break up, or whatever challenge they felt needed to be set down. The service opened more than a few minutes late, with a prayerful intention by one of the elder women from Sunset Service's Wisdom Council, a collection of women span-ning religious traditions whose role it was to hold the space in prayer during the intimate service. The Wisdom Council elders were joined this night by a few counsellors from the local community, who had come to provide sup-port to those who might require professional grief support.

The people in the room—some seated in the rows of chairs lining the space, others leaned up against walls or sitting on the floor—were intro-duced to the first speaker. She was a young theology graduate who spoke to the room of her experiences as a bi-racial child in a Jewish household and her relationship with her white maternal grandfather. Tears welling up in

her eyes she shared her memories, both painful and joyful, about the man she loved and had recently lost. With articulate precision, she outlined the uncomfortable roller-coaster ride of her grief, and her experience of holding two truths at the same time; grieving for this man whom she loved as well as her sorrow recalling some of her earliest memories of racial prejudice and discrimination from him. The room hung heavy with her poignant reflection, citing text from the Torah intermittently. She ended her talk with a beautiful Hebrew prayer. In silence, the members of the GLAD Voices Choir rose from their seats to replace her at the front of the room. Offering throaty harmonies in layered a capella, they sang hymns in an African dialect unfamiliar to most and yet, on some other level—deeper and ancestral—familiar.

Not even midway through their closing song, the choir was interrupted by a wail, a grief-filled sound reverberating through the room. The sobs grew louder as the choir finished, and the four elder women, each holding their corner in prayer, searched the crowd, descending upon the source of the sound.

In the second to last row a young gentleman sat, head in hands, tears streaming down his face. The man was helped to his feet by one of the elder women, dressed in white, her head wrapped high. It was now clear who he was. The neatly presented man was in fact one of the counsellors brought in to offer grief support.

Assisted to the front of the room, he shared that the evening of this service was nearly one year, to the day, since the death of his father. He detailed to the rapt audience that he and his father had been close, maintaining the strength of that relationship even after his migration to Toronto for school. Despite this—tears still streaming down his face—there had been a secret he had been unable to broach in his near-weekly phone calls back home to his father. Through sobs and a very slight accent that hinted at his Caribbean home, the young man disclosed that his years spent studying and achieving had obscured his one withheld truth: that he was gay. All eyes in the room stayed fixed on him, as his tears lessened and his voice grew more earnest, ushering listeners along to the most difficult part of his story.

Soon after he had gathered enough courage and resolved to speak to his father about his sexuality, he received a phone call from home. The call informed him that his father had suddenly and tragically passed away.

The young counsellor described for the room the scene at his father's funeral a year before, where he stood with penned letter in hand at the mouth of the gravesite. As the pallbearers and undertakers took turns throwing dirt onto the closed casket, he slipped the letter containing his final confession to his beloved parent alongside the cut flowers and final throws of dirt.

There was a pregnant pause as the man found his way back to his seat. Then, like felled dominoes, person by person descended into an outpouring of vocalized grief. For near fifteen minutes the room of Black and brown folk, queer folk and people of all stripes and types laid bare in testimony. One person had also lost a parent; another, two. Someone spoke about losing their faith and somebody else about having lost their job. Many cried on the shoulders of people who had been strangers just moments before. Others sat quietly, heads bowed. A few fell into incoherent murmurings and began speaking in tongues. Some just upped and left altogether. Afterward, when the room had spent itself, there was left behind a distinctly peaceful energy.

At the close of the evening, comforting hands found rest on backs and shoulders, and laughter replaced what just an hour before had been tears.

This place was an idea whose time had finally come.

Misfits, Finding Way

Here in this space, whether silently or vibrantly, people were connected and connecting. They were reaching in and reaching out through our work to find something far greater than this fellowship and what we call the One.

– Co-founder, minister, Chiedza Pasipanodya

We were just two kids, barely out of our teens and desperately in search of connection. Chiedza, I would often say, was the feather to my brick. Our energies, though distinct, complemented each other in our friendship and later, in our pastoral collaboration. Though unique, our particular ways of interfacing with the world connected in many important places, one of which was faith. Chiedza, born and raised for a time in Zimbabwe, had attended a Catholic convent school and been an Anglican altar girl well into her teens.

The artist she was and is loved the aesthetic and the ritual of Catholicism. There was an order, a routine, and each action housed within it some larger meaning and history.

Although I had been raised in a more Evangelical home, my upbringing included exposure to an eclectic array of denominations which reflected my mother's own journey with her Christian faith. I was christened in a Baptist church but, for a significant part of my childhood, also attended the Pentecostal storefront more rooted in the expressive tradition, common among families like my own, that originated from the Caribbean. Like Chiedza, my experience of church was also about rituals. I was clear, however, that even within the ritual, there was a value in the "out of order" or the spontaneous, which lent itself to an even truer, unrehearsed encounter with Spirit. For me, church was not just an intellectual endeavour for God, but an embodied experience you could literally feel in the tips of your toes. As such, church was also about the unexpected, the mystery.

Though no longer affiliated with the faith communities we grew up in, Chiedza and I remained open and curious about Spirit. We each had spent the greater part of our late teens and early twenties taking every class, every workshop, and sitting at the feet of a myriad of teachers from a range of traditions. Jointly, through both formal and informal study, Chiedza and I engaged instruction in a variety of modalities, including Science of Mind (also known as Religious Science), Christian Metaphysics, the Landmark Forum, the teachings contained in A Course in Miracles, Akan and Yoruba traditional practices, Reiki, Hypnosis, Vipassana Meditation, and Neurolinguistics.

The empowering message contained in the New Thought tradition had resonated with me since I was first introduced to these philosophical teachings as a wayward teenager. Chiedza found connection in the indigenous traditions and teachings with links to Africa, the continent of her birth.

Friends long before Sunset Service had been envisioned, Chiedza and I would often find ourselves in conversation about God. Late night discussions would pendulum between high-level theoretical contemplations— "Who is God?"—to more practical explorations of Spirit and its meaning in our daily lives—"Where is God?" We would laugh at the seeming contradiction between how our very full Saturday evenings would turn into Sunday

mornings. Many a weekend we could be found trading nightclub dance floors for church pews, sometimes with next to no sleep in between the two.

Underneath the amusement of this, however, was a lot of deeply seated guilt and shame. There was little chance we would have come out from the religious environments we had been reared in completely unscathed. Catholic guilt and Protestant condemnation spurred our journey inward, and spurred us even closer towards Spirit.

As we got older and our studies deepened, we began to see that there were very real links between what we were learning—"There is no separation"—what we were personally questioning—"What if all of who we are, wherever we are, were welcome?"—and what, in time, we would be called to do.

We had both come to learn that if God was in, as, and through, then right where we were, God was too. For us, this meant that God encompassed the Black, the queer, the incomplete, the searching, the sexual. We instinctively understood that the sacred and the secular, the Saturday and the Sunday expressions of ourselves were important although difficult to marry within existing frameworks available to us as our ministry's invocation poem states, "misfits who instead of fit are finding way."

Not fitting incited in us a desire to know (and share) that despite who we were, how we were, or the choices we've made, Spirit's presence in us was constant and unwavering. We recognized that our seeming contradictions within many religious expectations were our opening. We were faced with a personal choice: either expand the script or let the script become our spiritual crypt.

In Toronto, there are few thought leaders and spiritual spaces who acknowledge the specific needs of young people, particularly those of us racialized folk holding multiple, marginal identities. The questions we pondered (and sometimes struggled with personally) would eventually become the call that we felt urged to respond to publicly.

No Vests

Spirituality without motive. I always felt you went to church to avoid going to hell, or you did yoga to get enlightened. Sunset Service allowed me to give myself space and permission to get closer to the idea of seeing

myself whole and complete, now. Instead of faith as a tool, a means to an end, or getting caught up in the performance. There is no doing or performing in order to connect with something bigger than myself.
– Participant, minister in training, Kelisha [Othrr] M. Peart

Chiedza and I had already been speaking and presenting throughout the city on the idea of progressive spirituality, following our ordination as New Thought–Metaphysical Ministers. Our first and only workshop at the time, entitled Sex, Sin, and the Sacred, had received some positive attention resulting in our invitation to a number of spaces. We were contacted by Blockorama and Blackness Yes! to participate in their *Back to Our Roots* event in advance of Pride 2012. The invitation had been to sit on an interfaith panel and discuss being queer, of colour and of faith. Chiedza and I floated the names of individuals we thought could be a part—a pool that at the time was quite small. The panel suggestion was quickly dismissed, and in its place we pitched the idea to hold a service. Chiedza and I went about co-ordinating what would become our Pride service, taking inspiration from another event I had the opportunity to be a part of in 2009, *Les Blues–The Gospel Show*. *Les Blues* was a collective founded in 2008 by Elisha Lim, Brescia Nember Reed, Amai Kuda and Leroi Brown, and had been over a year old when *The Gospel Show* debuted. *The Gospel Show* was conceptualized by performer and columnist Dainty Smith and curated by artist, activist, and educator Kim Katrin Milan. I contributed to the event alongside a number of other folks including Kyisha Williams, Robin Fraser, Leelee Davis, and Kalmplex Seen. It was during this performance that it really hit home for me the power of, and possibility in, queering faith. Three years later, Sunset Service in many ways would take its cues from the lessons I first learned there.

Our very first service was held in the ballroom of the community centre, the 519, and attended by one hundred and fifty people. What would later be known as Sunset Service—our ministry and movement—began as just a factual statement of the time our service was held: at sunset. This inaugural "Sunset" service included guest speakers Kim Katrin Milan, queer activist Lali Mohamed, human rights lawyer and co-ordinating imam El-Farouk Khaki, and a host of other faith and community leaders sharing their stories of spirituality and community.

Performances by local artists—musicians, dancers, and spoken word artists—were interwoven with the guest presentations and bookended by group prayer and meditation. A great deal of intentionality was given to make sure individuals on the agenda adequately represented the communities we ourselves reflected: racialized, queer, youth and young adults. Our theological positioning as New Thought ministers made it a nonconflict to meaningfully include individuals from seemingly disparate traditions. Our nondogmatic understanding of God as an everywhere present and equally distributed Intelligence that no group has exclusive access to made it natural for us to be able to share platform and build bridges. It was important for us to demonstrate, rather than just speak to, a possibility of marginalized folks being radically included and at the helm of faith communities of all kinds.

Immediately following service, requests flooded in for us to host a weekly service. Overwhelmed, we meditated on what next to do. The truth was, we were somewhat doubtful. Perhaps the success of our gathering was a one-off. We were relatively inexperienced and unknown. Both of us were still in school, Chiedza pursuing curatorial studies at OCAD University and me completing a graduate degree in environmental studies at York University. We lacked finances and a regular space. At the time, we were not supported or endorsed by any of the mainstream, more established progressive church communities.

Despite these seeming disadvantages, we recognized that the strong feedback and our inner prompting for a spiritual community of peers was evidence enough. It was time for us to build what it was we ourselves needed. We decided that the manageable commitment we could make was to host a quarterly interfaith service: Sunset Service.

Keepers, Seeking Truth

Chiedza has a strong, composed, and loving presence. She gives passage readings from books like *In Search of Our Mothers' Gardens* by Alice Walker, which add some appreciated literary depth to gatherings. David is wonderful at giving sermons that are both engaging and humorous.... He calls people to action by telling them to use love, faith, and their own spiritual awareness to assist in bringing more potency and

awareness into their lives. He isn't afraid to talk about his struggles both past and present. The musical director James Japheth Bailey is another charismatic presence with a beautiful voice. He is just a sample of the young musical talent that regularly performs. I'm not someone that normally sings or claps, but they will make you want to sing and clap, trust me!

 – Participant, Sarah Cram

The quarterly services would come to be known informally as our "revivals" because of their emphasis on performative and artistic aspects. Each service would revolve around a theme that we based on something we were seeing in our lives and in the communities we were part of. Themes have included grief and loss, suicide and mental health in communities of colour, healthy relationships, violence, homophobia, anti-Black racism and the notion of All Black Lives Matter. Over time a committed collection of volunteers emerged, and with their support, we continued to hold these gatherings with next to no outside funding support.

Artists, guest presenters, and performers were drawn from the pools of Toronto's young talent connected to us through our social circles outside of the ministry. Music would grow to be a staple component of our revivals. My nephew James Bailey, an occasional Sunset Service attendee and guest performer, came on board in the second year of the ministry as a lead vocalist. This peripheral role eventually transitioned into a leadership role for James. He helped to form a dynamic choir of young adults from the local community. Together, they perform original gospel inspired music, written by James.

Dynamism and emphasis on community have been the foundational features creating impact for Sunset Service Toronto. The energy of the people who have shown up and given of themselves each week and every quarter year has fuelled the ministry's singular mission: to remind people of the Divinity within. Five years, ten "revival" services, two spiritual-arts installations, thirty intimate gatherings, three baby blessings, fifteen weddings, and one funeral later, Sunset Service is still led by this one mission. It further follows our ministry's five organizing principles: relevance, reverence, relationship, integrity, and celebration. These will be explained in the remainder of this essay.

Relevance: We Work Towards Being Impactful and Responsible

> As a community [Sunset Service] is different because it has a very
> practical streak. It encourages people from various faiths to draw from
> whatever spirituality they believe in in order to become more account-
> able human beings, towards each other and themselves. Sunset Service
> doesn't sugar coat about the challenges of life, or ask that you leave those
> problems at the door. They actually encourage the opposite. If you want
> to cry, then cry it out. If you want to ponder what blocks are holding
> you back, then ponder. In my personal experience, this is where true
> healing comes from.
>
> – Choir member, participant, Diona Chattrisse Dolabaille

Church and spiritual community that doesn't line up with the real lived
experience, joys and challenges of people's lives is in the end meaningless.
Sunset Service began because it was the kind of community Chiedza and I
required at the time. It also happened to be the kind of community others
needed. Relevance for us has meant being responsive to exactly what emerges
for us and for community members at a given time. For example, after a time
Sunset Service acknowledged that for some, the ways in which the monthly
gatherings and ecstatic or revival type quarterly services were being oriented
around a group process didn't meet the needs of folks who benefit from
more introspective and individual processing. In 2015, after securing fund-
ing which allowed for more expansive programming and staff, and striking
a formal relationship with the organization Sketch, which opened a whole
new space for us at Artscape in the west end of the city, a weekly meditation
sit entitled Grey Hour was begun. The program, conceptualized by Sunset
Service team member Othrr M. Peart reformats more traditional, regimented
meditation practice with a freeform style that uses soundscapes curated from
contemporary artists and nontraditional sources to create a contemplative
space for reflection. Think meditation for millennials; no rules and expecta-
tions other than to be okay in the spaces, the unknown, the gaps, and the
grey. The freeform format mirrors the Quaker notion of "silent worship" but
with a twist. The program has been a great success. Relevance for us has thus
meant constantly being willing to ask, "What is needed for us, and from us,

now?" As the saying goes, anything that is not growing, evolving, and adapting—including spiritual and/or religious community—is dead.

Reverence: We Strive to Display a Deep Respect for All Things

The ministry's teachings of love and gratitude, use of sacred readings, prayers, meditation, libation—paying respect to those gone before us and calling out their names. These services filled us with hope and quietness to the noise. I feel as if a weight has been lifted, a cleansing.
– Wisdom Council member, First Nations Elder,
Patti Phipps-Walker

Sunset Service has always reflected an eclectic mix of spiritual practices and traditions that speaks to our location in one of the most multicultural cities in the world. With our training in the more inclusive philosophy contained within Metaphysical–New Thought, Chiedza and I were able to cultivate in our community an appreciation for the wisdom that each of the world's traditions brings to the table; namely, the importance of reverence or respect. Respect for us has evidenced itself in our continued acknowledgement of the awesomeness of the land we worship on and its original caretakers, the planet we're a part of, the people who have gone before us, and of course the worth and value of one another and those ancestors who have paved the way. What fundamentalists often forget in their calls of blasphemy and heresy is that reverence isn't simply about a God thing, but rather about a people thing. If "God"—whether you understand this concept as a force, an entity, or an underlying intelligence—is the unseen, manifested through the seen, Its creations, then honouring God or Spirit is done best through honouring all that have come from God; each other and this world.

Relationship: We Value the Connection between All Things

Sunset Service has been an interfaith safe place to share and listen, a place to connect with Creator, a place where you are never alone and where I feel welcomed and comfortable.
– Attendee, Dominique Gilles

The idea of relationship was a big one to get my mind around early into my personal spiritual journey, if you'd call it that. So much of what I had learned as a youth, and that many of us learn, is how much we are distinct, separate and apart from God, each other and the planet. Religion and its institutions seem hell-bent on reminding people at every turn that they are trapped in skin and full of sin. Upon founding Sunset Service, Chiedza and I were clear that there had to be a space where the focus was not on differences, but on the similarities. Our shared experience of humanity, of birth and death, confusion, chaos, joy and triumph linked us more than the seeming differences of tribe and nation. I was once told by a spiritual elder that the same thing that makes up the stars in the sky, and my cat and dog at home, make me up. This was echoed in the teachings I was exposed to in my teens when introduced to New Thought philosophy. Ernest Holmes, author of *Science of Mind*, called this the "One Stuff" from which all forms were effects.[2] And while Sunset Service doesn't cling to any particular teacher or teaching to validate this fundamental truth, it remains the same; we are all in this together. As the ancient Ghanaian Adinkra symbol, Nkonsonkonson, references: "Together we are linked in life and death."[3]

Integrity: We Care About the Alignment of Our Words and Actions

Sunset Service is what I believe many other places of worship aspire to be: a safe and welcoming environment where both newcomers and old-timers feel welcome, and where there is enough trust and grace for people to ask difficult questions and come up with different answers in an atmosphere of complete respect.

– Participant, Karl Shay

Making Sunset Service a community that lives out what it teaches has been important to Chiedza and me. We make clear that we're imperfect people, and that we do not believe in any one "perfect" process. This applies to the community we have gathered as well. Sunset Service is not a one-stop shop ministry—far from it. We do not claim to contain any clear-cut answers or easy-to-follow steps for finding God. That said, we do strive: to learn, to grow, and to challenge ourselves and our notions of who we are within our

work in the world. Integrity for us and for this ministry that is Sunset Service has been to stay true to what we know for sure—that we are all in relationship and deserve each other's gentleness and respect just for being here, and that our actions, individually and as members of this community, should reflect that underlying idea and ideal.

Celebration: We Act in a Spirit of Praise for Life

From the prayer and spoken word, song and dance, arts and activism, volunteers and congregation, they've been phenomenal. I was filled with emotion and light after first hearing the invocation song from the choir.
 – Wisdom Council member, First Nations Elder,
 Patti Phipps-Walker

Anyone who has attended one of our ecstatic revival quarterly services, full of music and dance and laughter, has noted how powerful it was for them to be in a place that honoured each person's path, but that did so without it being a solely heady or intellectual endeavour. Celebration these last five years has been such an integral part of what I believe has kept us going as a ministry, through some challenging times in Sunset Service, in our personal lives as its founders, and in the world as a whole. Politically, socially, and religiously, this world seems to be careening ever faster backward to ill-serving ideas of exclusivity, rigidity, fear, and violence. These five years have shown us that spirituality can be fun. They have explored possibilities for being in spiritual community that are less about regulation of behaviour and beliefs, and create space for exploration and inquiry.

They are ultimately about celebration. If all our core values were to be whittled down for sake of ease, they could all be captured by this idea of celebration. Celebration is about reverence, it requires relationship, it is a whole-self experience aligning the head, the heart, and oftentimes the hands and feet, and it is responsive to what is needed in each moment. Celebration is life, for everyone, and that at the core should be what spiritual and religious community must make space for.

Indeed, what if spiritual community could be envisioned if those most at the margins—queer, youth and young adults, people of colour—were not

only invited into, but rather leading the charge of, that community building? Chiedza and I have discovered that absolutely anything is possible. That it is possible to challenge, push against cultural norms and religious traditions, and respond to what it is that is needed, now. It is possible to show respect for what exists, give space to "what is," while looking forward to "what isn't quite yet." It is possible to choose: choose to dialogue, debate and re-evaluate notions of spirituality and God and, in the words of Walt Whitman, "dismiss whatever insults your own soul."[4]

Change is the one overriding Law and spiritual principle in operation in an Intelligent Universe. Change happens with or without our consent, and so our role is not only to be open to, but also to be able to welcome change in from the gate. That is the true meaning of gatekeepers.

Those of us who exist at the margins have been afforded a beautiful advantage in our exclusion: We have front row seats to the "yet to come." Individually and communally, from our location in the marginal places, we have been first to both recognize and respond to what (and who), like us, lies beyond the "what is."

And not too distant from this place,
we the children will remember
that every road wandered, no matter how far or winding,
finds home,
And You.

16 | Creating Community and Creating Family

Our QTBIPOC Parenting Group

Audrey Dwyer

The moment was heavy like mud. I stood there listening to one white couple share that their families were really excited for them to start making babies. I felt a knot in my chest. I heard another white couple explain that their parents were urging them to have kids. There was a tremor inside. When I heard a white person reveal that they believed a baby would bring their family back into their lives, that they had hoped a new baby would bring their mother back into their lives ... that's when the tears started streaming down my face. Hearing the word "mother" left me breathless. I was reminded of when my mother had accepted my queerness and then within weeks rejected me for being queer. I had never imagined creating a family without my mother's support, guidance, and storytelling. I had been feeling quite isolated since hearing her firmly state, "I don't accept your lifestyle." As the tears fell and my shoulders shook, my partner took my hand. I felt small and vulnerable—suddenly, like dust, caught up by a great wind and carried off some place else. I felt weak. I heard myself think, "Oh God, I am alone and I don't know what to do."

In the spring of 2014, a friend of mine sent me an email from Toronto's LGBTQ Parenting Network advertising their upcoming suite of programming because she knew I was curious about creating a family. I discovered that the Queer and Trans Family Planning Weekend Intensive was happening at the Sherbourne Health Centre in late November 2014. The LGBTQ Parenting Network is a program of the Sherbourne Health Centre, a health centre located in the heart of downtown Toronto that runs parenting courses in conjunction with the Queer Parenting Programs at the 519 Church Street Community Centre.[1] It provides services such as health care and mentorship to lesbian, gay, bisexual, trans, two-spirited, intersex, queer or questioning individuals—of all ages. It also helps those who are homeless or under-housed and newcomers to Canada. The LGBTQ Parenting Network offers numerous parenting classes each year. These include: Transmasculine People Considering Pregnancy, Dykes Planning Tykes and Daddies and Papas 2B. There are fertility groups one can join and queer positive prenatal classes one can attend. I decided to check it out, signing up for the weekend intensive.

As my partner and I drove to Sherbourne for our first evening session, I suddenly remembered that I hadn't come up with any questions in advance! I didn't do any prep. Would my desire to have kids be enough? I had no clue what to expect—a few games and some information probably . . . Snacks? We arrived there early (check). The chairs were in a circle (cool). My chosen fam was there (phenomenal, so thankful for these folk). I had my partner beside me (wow, we're doing this, we're sitting here, THIS IS SO EXCITING!). And there were snacks—veggies and hummus and crackers (with and without gluten, thanks!). We did a bunch of activities to help us all get to know each other. We did exercises that helped us identify what we wanted as parents, and where we were on our journey. They held info sessions that were curated around the varied deep, emotional and political concerns that came up on the journey to parenthood, sessions about bodies and about different ways to have young people in our lives. It turned out that simply desiring to have kids or being curious about it was enough for this intensive!

After I shed those tears within the first hour, I began grieving. I had an ache in my chest as I listened to the instructor, and to the other parents-to-be. I tried hiding my tears but I couldn't. As the weekend workshop progressed, more and more information came down the pipe, and I became

increasingly overwhelmed. Even though some of the weekend course content was informed by our requests and co-created based on what we needed as a group, there didn't seem to be enough time to address the complicated feelings that came up for all of us. Questions fired in my head: I may have to adopt my own child in order to have my partner's name on the birth certificate? This process is going to cost how much? How am I going to do this without my biological family? I didn't retain a single thing. By the time the weekend was over, I was convinced that I couldn't do it—I'd never be able to make the family that I had wanted. I knew one thing though: I needed to let the grief of my old plans pass. That message was huge.

Within a few days, I became more grounded. I discovered that the trigger around my mom had to do with feeling so desperate to have her in my life that I'd use my newborn child as a tool to bring her back to me. The idea was shocking. I questioned myself: I'd never do that . . . Would I? After more soul searching, I knew that I wouldn't have that answer until I got to that moment, and that judging myself, based on my missing her, wasn't productive. So, instead, I asked myself, "What do you need?"

A place that felt familiar . . . like home.
A place to learn about creating family more slowly and thoroughly.
Time to let the information settle, time to hear my heart speak.
My people. People who shared the same politics, people who I could learn from, who shared the same worries. Like, how do you raise a child queerly, what does queerness and child rearing mean, how do colonization and creating families on stolen land intersect?
I need to listen to people who look like me and live like me.
I need to create a community and foster closeness within that community.
I need to fill my heart with all of the beautiful and varied stories of resilience, fierceness, grace, and tenderness that come from queer and trans folk of colour.

Within a very short amount of time, my partner and I connected over brunch with two others who had taken the course that weekend. We began to chat about what went right and what could have been better. We really

loved that there was a panel with numerous queer parents and their lovely children! And yet, we wanted to be in a space that dealt with the politics of raising a family—not simply how to get it done, how to deal with the legal system and the technicalities and options for different families to survive. The course was informative in a generalized way, but we wanted a place that spoke to our specific needs and our unique struggles. After my experience with the intensive, I realized that we needed a space where we could bawl or rage if we needed to. As we compared experiences, we realized that we wanted to create something that served us specifically. We talked about our connections to our bodies, the future, and, of course, we talked about babies. We talked about morning times, about brunch and about sharing stories over warm food that was homemade. And that was how the QTBIPOC Parenting Group began—from need, from specificity and from a collective vision.

It didn't take very long for folk to gather—the trans folk, the folk of colour, the folk with questions, the folk with answers, the folk who had young people in their families, the genderqueer folk, the single folk, the coupled folk, the poly folk, the open relationship folk, the political folk, the folk who wanted kids, the folk who wanted to adopt, to bear children, to co-parent . . . A bunch of us came up and came through.

We connected with others who had taken the LGBTQ Parenting Network course and invited folks that we knew were going to take the course. We also connected with a few folks who had never taken the course before but had expressed interest. In total, there were around fifteen of us. We all gathered at one of our houses for brunch. We sat in a circle, on couches, on chairs, and on the floor. We ate fresh fruit and gluten free pancakes and bacon. We filled our bellies and shared.

> Can we all introduce ourselves one more time and talk about how we identify?
> Can we all mention why we want to have kids, and when—if you're thinking of having them?
> Can we all mention where we're at in the process, please?

Our introductions were long and generous. It was such a blessing to hear about where people were at in their lives. It was so amazing to listen to

friends (new and old) share their hopes and dreams around family creation. It was such a gift! I fell in love with all of the participants, and I wanted to make sure everyone's needs were met. We acknowledged that each of us was growing and figuring out what we wanted. We knew that we couldn't take our friendships for granted and that we needed to re-meet each other at each visit. These introductions became a beautiful, intimate ritual. We ended up getting to know each other on a completely different level, despite the fact that many of us were close friends.

We talked about adoption and what that would look like for some of us. We talked about how we wanted to be in kids' lives—as aunties and as uncles. We talked about when we wanted to have kids, why we wanted to have them, if we actually did want them in the first place. We asked ourselves these questions again and again—with an eagerness for getting to know each other deeper and deeper.

As we shared our dreams, worries and vulnerabilities, we recognized that QTBIPOC parenting was extremely different from white parenting. In Canada, fertility options and sperm from nonwhite donors were going to be hard to find and hard to afford. We knew we'd be facing transphobia and homophobia in our medical system because of heteronormativity. Legally, registering more than two parents isn't permitted, so differently configured families are denied their rights to create family. We knew that we wouldn't meet the normative expectations and criteria of family that Children's Aid looks for in adoption. We might be excluded from that process entirely. We knew that despite Toronto's "growing inclusiveness" we'd still face obstacles due to the numerous oppressions POC face on a daily basis. Some of us had families that accepted our queerness, some of us didn't. And creating family while queer—even in the best imaginable scenarios—can still have its troubles. The list goes on and on.

Due to colonization and white supremacy, we queers have so much to push against. We try to work through all of these obstacles while building community and nourishing people. We take care of each other's emotional states through active listening, warmth, and in ways that are nonformal and heart-based. It's great to have technical (conception? legal? adoption? medical?) information but we wanted to deal with more emotionally rooted, challenging issues in a way that respected and took care of our humanity

with dignity. Building community is an intentional thing, and our group is rooted in intention. The conversations are created with a bit of structure and the environment is one where people can meet and grow closer to each other.

As a group, those of us who attended the Weekend Intensive shared the info we learned in the course—to revisit it and see what stuck. We shared what we experienced throughout the intensive, and we were so thankful that many of us had the chance to take it with one another. We were thankful for each other's presence because it wasn't the easiest space to be in. I don't think we anticipated all of the worry that came from getting the technical information about creating family, how expensive things could become, the legal system, and birth certificates. Despite the fact that we had so many POC in our session, none of the facilitators could speak to our situation because they weren't POC. For example, the information we received about pregnancy stages was helpful, but we were facing extremely different scenarios.

We knew that we wanted a similar intensive to the one we had attended, but instead of being held in a clinical environment, ours would be offered in an intimate setting and we would tailor our course content to each participant's needs and ensure that *all* questions would be addressed. We spent a great deal of time going around in a circle asking each other what we wanted to know. We made lists. We wanted to have sessions where our specific questions would be answered—no matter how personal those questions may be. We wanted to talk through our fears and where we were at present. We had questions about how to connect with our children, how to connect with extended family, how to raise children, how to move past the parenting we experienced, how to hold on to what we thought worked.

We wanted to know everything.

Let's talk about our connection to colonization and how we're populating this land.
How did you tell your parents that you were going to have a kid?
Let's talk about crip babies and crip parenting.
Where did you get your sperm from?
How do you deal with triggers around survivorship while parenting?
Can you tell us any stories where the known donor system worked?
How do you deal with isolation?

How do you raise your child queerly? What does that mean to you?
Would you be willing to share anything regarding post-
partum depression?
What do we take from how we were parented and is it possible to shift?
How do you raise kids in community?
How did you afford sperm? How do you afford raising a family?
How do you deal with white supremacy and navigating white
queer communities?
How do you set boundaries with your bio fam?

We wanted to hear about the joys and the celebrations of creating a family with queer parents and we also wanted the guts, the hard moments, and the realities. We wanted mentorship from queer and trans folk of colour. We all had an abundance of questions and we all wanted to listen.

The thing about queer and trans parents of colour is that they are unique and strong, vibrant and loving, resilient, beautiful, bad-ass, and inspirational. They are direct and hilarious. And they are at the forefront of creating new and distinct families rooted in love and care.

We spent weeks developing how to give back to our invited guests because we valued their life experiences. We wanted our connection to them to be heart-based and filled with as much generosity as possible. We decided that we would ask the invitees what they needed because we had plenty to offer: babysitting, legal aid, bicycle repair, someone to wash your clothes and your dishes, someone to hold your baby (yes please!), a drive here or there, someone to paint your bedroom, your bathroom, your kitchen. How could we honour your time and your life experience and display our gratitude for sharing your personal stories with us? I approached my workplace to ask for donations so I could give the invited guests personalized gifts for them and their children. And they said yes!

We decided that an informal brunch at home was the best way to achieve a chill vibe and foster intimacy. The invitees could bring their children if they wanted or their partners or come alone. And they could talk about whatever they wanted. We were aware of the fact that some of our questions were going to be very personal. We wanted to be bold with our questions so that we could take care of ourselves. We also wanted to respect others' boundaries,

so we made sure to assure and reassure them that they didn't have to answer our questions. They were encouraged to let us know their boundaries weeks ahead of brunch.

The brunches would happen once a month on a Sunday. We'd all bring food, the meal would be cooked up fresh, and we'd all eat together—scrambled eggs and scrambled tofu, pancakes (gluten free), bacon, croissants, toast (gluten free), cheese, grapes, strawberries, oranges, coffee, tea, juice and ice cream (with dairy and dairy free). There was an abundance of food—always too much! And we were all pretty thankful that we were able to share this way. It was a privilege to have this food, this opportunity to meet as a group and to have access to this kind of learning.

We created a list of POC in the community who have children. Some were new parents, some were co-parents, some had teenaged or adult children. All were queer and are people of colour. And it was freaking amazing, thrilling and life altering! One of us who knew the guest personally would call them or meet with them in person and let them know about our group. Later, that person would send them a detailed email we had created as a group.

There are certain things that never change no matter how many brunches we have. I always feel excited and nervous when the guests arrive. I want to hug them and hide from them. I come with questions and I am afraid to ask them because I'm afraid that they are too personal, they reveal too much of my fears and insecurities … so I summon up my bravery each and every time. Some of them are reasonable and some are so ridiculous that I judge myself … but ask anyway. There are no wrong questions in our group.

For instance, one of my fears around creating family was bringing a child into the world while living in the second floor of a house. My parents owned their bungalow. I've always rented.

What if they fall down the stairs, though? Don't you think I should live in a bungalow like my parents did?

The response was:

Sure … you could always just have kids and trust that no matter what happens to them, you did your best, you're a great mom, people will

judge you the same way and your kids will hurt themselves and be okay and there are stairs everywhere and calm yourself it will be fine just do it. Kids fall down stairs.

The end.

As soon as our guests arrive, we eat and introduce ourselves. We thank them profusely. And then we jump right in!

Things usually start off with our guests sharing how it all began for them: where they were at in their lives when they thought about creating family, their health, whether or not they were in a relationship, how they were living …

I will always remember the heartwarming and hilarious story of mood changes and demands that a guest shared. It was basically about their partner being sent out to get some food for them while they were pregnant. Their partner may have taken a little while to get back—they had had a coffee, they had shopped for nutritious food instead of jars of pickles and boxes of waffles, and there was a blizzard outside that prevented them from getting back ASAP. The anger that the waiting partner displayed towards the dear loved one that was simply caring for their family had us all laughing until our bellies ached. Theirs was a beautiful story about emotional ups and downs, practising patience and, well … being aware of the fact that creating a baby may make you do things you don't usually do.

Our guests are so kind, warm, informative, generous, and enthusiastic. "Just do it! Don't wait! Go for it!" Each beautiful one offers these generous words of encouragement. But what I find reassuring and profound about each guest is that at the end of the chat they a) don't want to leave, and b) they want to come back—either to mentor or to listen to other parents speak. When I saw this happen over and over again, it confirmed the need for spaces such as the one we created. It showed me how necessary this space was. Each of them announced that if any of us had any other questions or needed help, support or community, they would be that for us in a heartbeat. What a gift! They say things like, "Okay, I don't want to tell you the bad stuff." Then we say, "No, no! Tell us everything we need to know, everything, tell us everything!"

Some of our guests shared stories of co-parenting, of wanting bigger families and of not wanting them at all. Some shared stories about troubled pregnancies, connections to their biological families, their relationships with

their bodies, and taking hormones. Each of them speaks boldly of their profound love for their children—and that touches our hearts the most. The stories they share are so personal and we honour their sharing, so much so that we've promised not to share the details with those outside the group.

As mentioned earlier, we introduce ourselves at the brunches, even though we may already know the guest. We also talk about how this group came to be. One of the most amazing stories I heard was from Syrus Marcus Ware. He told us how he, his partner Nik and a few others had created TransFathers 2B, the first parenting course for trans guys in the country. They, too, had felt that something was missing in the gendered course offerings and wanted to create something that would celebrate trans people's bodies and journeys to parenting. They began planning in 2005 and the first course happened in 2007. It was sixteen weeks long and approximately ten people enrolled. I was amazed! Our queer community is so powerful, and the lineage of what we create is so strong and impactful. We get things done!

After our guests leave, we chat about what we learned, how we feel and what we need next. (I, personally, want to move in with each guest, follow them around and learn everything I possibly can.) Our collective goal is to have all our learning needs met and we work towards that by checking in and double-checking in. By that I mean we are continually asking each other how things are going, what needs need to be met for the next session, and what did and didn't work. We do our best to make sure that we're inviting people who can help us answer all of our questions—no matter what role we play as parents.

At this point, we've had a few brunches and some of us are taking the steps needed to create little ones. Some of us always were. I feel grounded and informed. I also know that I have a stronger community that is only growing more and more each day.

My biggest fear is that the group itself will become too big and that the intimacy we are building will be lost. But the more I talk about it with folk and the more I listen, the more I learn that queer people of colour are desiring this kind of mentorship, story sharing and connection building. So, it is my goal to create a larger group for a weekend or a weeklong intensive where folk can have their needs met in a way that leaves them feeling seen, inspired, and grounded.

There are so many cherished moments for each of us. When parents share about how special it felt for them to be invited to speak, we learned that while parenting can bring so much joy to your life, you might also feel alone—even if you're partnered. You're not going to be at all of Toronto's queer events, you may lose a few friends or all of your friends. You may gain a completely different family. I remember discovering that being part of community is about making space for those who want to be there, but for certain reasons can't. I can always offer to babysit when I notice my friends with babies haven't been on the scene lately. I also learned that while I'm so focused on the family I want to create, it is terribly important and mandatory for me to keep my eye out for what others need and how I can help. I consider us so lucky because our group has offered us opportunities to create lasting relationships with our invited guests, thus expanding the Toronto QTBIPOC network. We have become more aware and more knowledgeable about the process of creating family, we've become closer, and we've become more confident and stronger in our beliefs and choices around family planning.

In retrospect, the Queer and Trans Family Planning Intensive Weekend was a great place for me to start. I was able to shed some of the deep-rooted issues that were stopping me from making the moves I needed to complete my dreams. I needed to grieve. I needed to discover—in real time—what I needed to let go of. I don't even have names for all the things I let go of. I just believe that the letting go happened. I needed to weep away the past and the rejections and the conditional love. I needed to allow room for new questions, new visions and new imaginings—and hey, maybe some new worries and concerns. What are the boundaries I need around a little one and my family? What if I never connect with my family again—what would that look like? Would I be okay? Today, my answer to that is a very firm "Yes."

I'm so thankful that that Weekend Intensive launched me into the process of developing a different kind of resilience. I know I'm going to need that if I'm to raise a family. I'm thankful for the information I've gained about my body. I will always cherish the time that I was surrounded by so many members of my chosen fam as I learned about babies! Discovering that my partner and I were on the same page, having not discussed certain things, brought me so much joy and relief! And just experiencing the weekend while sitting beside them makes me feel strong and connected. That

weekend launched me into deepening my community, into education, into dream building and I truly feel confident that I'm moving towards creating the family I've always wanted with support and insight. Who knows … I may take the Weekend Intensive again, because the technical information was so valuable.

When I think about our Parenting Group, the fact that our guests want to stay longer or that they find it hard to leave the group is the biggest gift to me. I feel so thankful that they share their stories and that they help us to achieve our own goals and to dream bigger and bigger and bigger.

In terms of community building and information that affects me directly, in terms of intimacy and familiarity, and in terms of being surrounded by chosen fam and people that I love deeply, I'm so grateful for our grace and our spirit to make things work as a team. I'm so thankful for the Parenting Group that we've all put so much time and energy into creating. I know that we aren't the only people creating community like this and asking questions like this. We're clearly not the first, and I know that we're not the last. I hope that groups like this happen all over the world.

17 | *The Mourning Dress*

Creating Spaces of Healing for Black Freedom

Nadijah Robinson, with Amalia M. Duncan-Raphael

It is 2015. It is 2015, and at this moment in time, I can't help but note that pain and grief are ever-present. We have not yet distilled a ritual for communal healing; we do not yet have this technology. We do not yet have the appropriate technologies to help us maintain our humanity and to protect our lives from those who seek to harm us. I never considered that in 2015 I might be living through a slow genocide.

Right now, a Black person is being killed by police or a vigilante's racist lethal violence. I can almost be sure it is happening, and if I am wrong I am not far off. Soon, there may be a BREAKING NEWS article showing a young, black-skinned individual's image, selfie-style or otherwise inappropriate for newsmedia. There might be gruesome video footage released. The body count will push higher. This rhythm of death and grief continues without end in sight, and I know my people are in pain. Every twenty-eight hours a Black person is killed by police officers, security guards, or vigilantes.[1] Although this figure applies to American deaths, the experience of lethal anti-Black violence is a globalized experience. There is no place on Earth that does not put into practice the hate of the darkest skinned people. And in the media, we across the world see when the US denies an experimental medication to thousands of West Africans suffering and dying from Ebola and criminalizes them instead. We see when African immigrants in Israel are systematically sterilized without their consent. We learn, though from fewer sources, when the twentieth Black trans woman is killed in the US

by August of 2015; this death surpassing the total count of US trans women reported murdered for all of 2014.[2] Social media has for many of us become a portal to near-constant death. We are pushed into consecutive and unending periods of mourning by paying witness to the deaths and violence that our communities are subject to.

When Black lives of transgender women are not deemed grievable, this is an added layer of dehumanization that is especially visited upon the bodies of Black trans women and their communities. It is a collective loss when any Black person's presence and life is taken from this world. It is an injustice when Black trans women live in fear for their lives. As Amalia M. Duncan-Raphael, who co-conceptualized this chapter, puts it:

> The moment I decided to come out as a Transgender woman to my parents, I knew they would immediately be concerned about my safety. It wasn't something I had to heavily Google about, it was always on my Facebook News Feed on a day to day basis. [One's] life safety based on the colour of their skin or their gender preference isn't something we should be concerned with. Unfortunately, I live in a world where being a Black Transgender woman puts me at risk. I was also born with Sickle Cell disease, so I knew their worry would be even more intense. I was even worried myself.

I belong to a queer and trans(-masculine) community of primarily Black and Indigenous people and people of colour in Toronto, which has been and continues to be exclusive of trans women and trans feminine people. Many have been trying to address the underlying transmisogyny in our gatherings, friendships, and community practices. Creating and facilitating spaces that centre trans women's voices, experiences, and presence is one of the ways that I have seen us working towards being accountable to those we have excluded. Acknowledging and uplifting Black trans women's humanity within queer and trans spaces, developing trust, and sharing in moments of grief and healing together is where I chose to focus my energy through a project called *The Mourning Dress*.

I myself am a Black queer cis woman, and I have privilege and relative power of my identities in relation to Black trans women. The way that I

came to create *The Mourning Dress*, a performative object and performance in dedication to Black trans women, which featured Amalia M. Duncan-Raphael, was through what I saw as a shared experience of mourning. In the winter of 2014, in the midst of a fog of pain and grief, I felt a strong desire to create a space for healing for Black people. I knew that while Black people generally were collectively mourning for Black people who were being killed and whose murders were subsequently justified in the media, Black trans women and trans women of colour were experiencing a similar pain. Except the collectivity of their mourning was not affirmed and shared on the same scale. While we were all moving through the thickness of grief, some of our dead were deemed less grievable. I knew that we needed to begin a process of healing that gave more than empty platitudes of unity and togetherness. I knew that I personally needed to express the pain, rage, and grief in ways that would help to heal my people and myself, and in ways that would begin to build trust and intertwine the survival of Black cis and trans people.

After being invited by Suzanne Carte at the Art Gallery of York University (AGYU) to create an art project for Pride 2015 alongside York student organizations, I began trying to find a way to materialize this desire into a space for queer and trans Black people to mourn, centring Black trans women, amidst the self-congratulatory celebration that is Toronto Pride. In February 2015, Toronto's Sumaya Dalmar, a young Somali trans woman, was killed in Toronto, and the news was spread by her communities through social media. I kept with me this recent murder of Sumaya Dalmar and the collective grief and outrage of her Toronto Somali and queer and trans extended family.

Working with York presented the challenge of working with many stakeholders. As a common aspect of my artistic practice, I conducted interviews to touch base with people involved in the project and make sure that the artistic outcomes would be as relevant as possible to their realities and concerns. I conducted interviews with representatives of York University's various student and faculty groups that would have a stake in Pride at York and in Toronto more broadly. Knowing that this is a celebration and a series of events that York students primarily create for themselves, and that my presence as an invited artist is that of an outsider coming in to create an art project that would in many ways shape their experience of Pride this year, I wanted to make sure we could find common footing on which to begin. I

asked many questions about the interviewees' perceptions, desires and concerns about Pride and about queer and trans life at York University in general, and ran my initial ideas past them. I got valuable feedback from them, much of it supportive, along with the warning that many people touching on the topic of Black trans women's deaths are more concerned by their deaths than their quality of life while living. This is true, and while I reflected on this, I came to the understanding that what I wanted to create had nothing to do with morbidly glorifying the deaths of Black trans women, and that I needed to make sure that my project did not convey that sense in the least. Furthermore, I knew that mourning is as much about honouring the dead as is it about allowing the living to process their grief. Prioritizing a process of healing is very much a practice of self and communal care. It was the feeling of collective healing that I wanted to convey and provide through this project.

That healing, to me, required a space to grieve collectively. The mourning dress, a recognizable symbol of mourning, would turn our contingent in the Pride parades and marches into a brief mourning procession, punctuated by paper rose tokens, glitter libations, and a reading of the names of trans women of colour killed in the last year. Creating a rupture in the general tone of Pride, as corporate and branded a celebration it has become, Amalia M. Duncan-Raphael wore the dress and walked in the Trans March with myself and two contingents, of trans people and cis supporters, from York University (see insert, Figures 3 and 4). As the rally came to an end and the crowd of trans people and their cis supporters began to march, I attached the long train onto Amalia, who was already wearing the rest of the mourning dress. The dress, gold and sleeveless with pleats at the waist, spread outward by a tulle petticoat underneath. A black geometric-patterned lace fell over the skirt of the dress, ending a couple of inches below the gold fabric underneath, below Amalia's knees. I attached the long black train, which tied around Amalia's waist and unfurled around eight feet behind her, reading at the top, in large gold metallic lettering

<div align="center">

GOOD

MOURNING

</div>

and, at the end of the train, surrounded by red paper roses, the word

<div align="center">

AGAIN

</div>

As I spread out the train behind her, taking up more and more space in the crowd, people moved around it. Immediately, people began taking photos and talking to each other in quieter voices. There was an emotional thickness around us, like the frequency of the crowd around us had suddenly shifted. I felt humbled, Amalia felt inspired. The air was still, full, and welling. I felt like crying. This moment extended for the duration of the march.

People began asking Amalia questions and then asking for photos. Behind us, the York students decided among themselves to protect the train, preventing people from stepping on it, and staying behind the dress, allowing Black and trans people to lead the way. Dozens of people would approach to ask questions, to vocally thank us for this presence in the march, and to give wordless gestures of thanks for the dress. We gave out red paper roses to many people who acknowledged Amalia and the dress. One person approached mid-way through the march and gave both Amalia and I a hug, expressing their gratitude for the space the dress took up in an otherwise empty-feeling march. We walked together for a while.

The Trans March in Toronto has a contentious history. Since 2009, it has been independently led and organized by trans community members, with annual attempts in recent years by Pride Toronto Inc. to sabotage and then co-opt it. This particular Trans March had Pride Toronto branding and Pride Toronto volunteers marshalling. The event had the celebratory air of having arrived, and the sense of the event's belonging to the trans community that I had felt in previous years was not there. Generally, Pride events are overt celebrations, increasingly centring the presence of corporate sponsors, police, and other institutions that otherwise play little to no role in generating well-being in queer and trans communities. The week of festivities centres primarily around the interests and desires of moneyed white cisgender gay men, while marginalizing or tokenizing the presence of Black and Indigenous people and people of colour.[3]

Amalia M. Duncan-Raphael had the following to say about her participation in the project:

Wearing the dress that Nadijah Robinson designed for the Trans [March] was truly cathartic. I felt like in doing this with her I was raising awareness and bringing some attention to all of the deaths that have

taken place so far. It was also something that made me proud, it gave me the courage to keep my head up and also to be strong not only for myself and those who have suffered but also the generations to come. This would be the moment in which I came to terms with who I truly am and realize my full potential. This was a project that created a memory of strength and power for me. I hope it's something people can see and be encouraged by to respect and stand with us.

Strength and power. In my body of work I often represent sadness and a sense of hopelessness with an edge of fantastical hope and possibility. I use the raw materials of emotional distress and transform them through the alchemical process of artmaking into the more empowering feelings of potential. My work is frequently conceived during moments of intensely felt despondency. What comes to me are simple ideas, as solutions, as ways out of the low place of depression. These ideas are often improbable, fantastical, magical twists on a nonfictional story. If Black people are being terrorized by a constant sense of grief and hopelessness, my mind will propose: "What if we could perform a ritual that would heal us all?" My work then, is to make these improbable images seem tangible and real, like possibilities to consider, because as metaphors they offer more that we can use in real life than as simple fodder for fantasies.

In the context of Pride, an overarchingly bright, colourful, festive celebration, this project's success lies in its ability to both blend and subvert. In order to contrast the triumphant tone of Pride with a simultaneously complementary visual, the dress, both sombre and celebratory, gracious and flashy, re-inserts what we as struggling communities have been feeling—grief. Black queer and trans people are in the midst of a slow genocide, and we are in desperate need of spaces that affirm this reality and let us feel the depth and weight of our loss reflected in each other. Space for grief, affirming our humanity and the full spectrum of our emotional lives, can be our technology for survival. Creating space for grief can be a new ritual we practise with each other for the purpose of healing.

Acknowledgements

The editorial team would like to thank Ghaida for her wonderful leadership in the final months of this book. We are also very grateful to Gabriela (Rio) Rodriguez for their invaluable editorial input into many of the contributions. Alvis Choi held down the rest of our collective while we were finishing the book and created a beautiful blog with many complementary entries (marvellousgrounds.com).

We are grateful to our contributors, for bearing with us during a lengthy editing process, to Amanda Crocker, for her helpful feedback and guidance, and to our anonymous peer reviewers, for taking the time to read and write such encouraging and constructive reviews.

Jin would like to thank the rest of the team for sharing their considerable professional, activist, and artistic experiences, and for all the work they have done in the amazing communities that this book is for and about. Jin also sends deep gratitude to their care collective for making it possible to continue on this project after becoming a parent.

Ghaida would like to thank her partner, family, and teammates on this project. She is eternally grateful to those who paved the way for this archive and form its backbone.

Syrus would like to thank his team for the chance to collaborate on this project. He is forever thankful for his daughter, twin, and grandparents for supporting his efforts, always. Syrus is also thankful for the beautiful community of QTBIPOCS who have shaped this city in which he lives, works, and plays.

This book was made possible through an Early Researcher Award and a SSHRC IDG, and with support from the Centre for Feminist Research and the Faculty of Environmental Studies at York University.

Notes

Introduction

1 David Churchill, "Personal Ad Politics: Race, Sexuality and Power at *The Body Politic*," *Left History* 8, no. 2 (2003): 114–34.

2 See Paola Bacchetta, "Dyketactics! Notes towards an Un-silencing," in *Smash the Church, Smash the State! The Early Years of Gay Liberation*, ed. T. A. Mecca (San Francisco: City Light Books, 2009), 218–31.

3 A version of this vignette is featured in Jin Haritaworn, Ghaida Moussa, and Syrus Marcus Ware, "Marvellous Grounds: QTBIPOC Counter-Archiving against Imperfect Erasures," in *Any Other Way: How Toronto Got Queer*, ed. Stephanie Chambers et al. (Toronto: Coach House Books, 2017), 219–23. See also chapters by Ware et al., Robinson, and Williams in this book.

4 As editors and contributors, we have different relationships to the ongoing realities of settler colonialism, antiblackness and border imperialism that shape how histories on Turtle Island are currently archived, including as settlers of colour and as those who are in privileged position vis-a-vis Black and Indigenous peoples. These differences are reflected in shifting and changing identities and coalitions, which are entered and discarded in acts of linguistic self-determination. The acronym QTBIPOC (queer and trans Black, Indigenous and people of colour) used in this introduction and by several of our authors highlights these complexities. We honour the importance of linguistic self-determination for those who generally remain the object rather than the subject of discourse in academic, artistic, activist and other contexts.

5 Achille Mbembe, "The Power of the Archive and Its Limits," in *Refiguring the Archive*, ed. Carolyn Hamilton (New York: Springer, 2002), 19–27.

6 Edward Said, *Culture and Imperialism* (New York: Vintage, 1993).

7 See *Canadian Lesbian and Gay Archives* at clga.ca.

8 Jacques Derrida, *Archive Fever: A Freudian Impression* (Chicago: University of Chicago Press, 1996).

9 For more on this, see Gabriela "Rio" Rodriguez, "Mapping QTBIPOC Toronto" (major portfolio, York University, 2016).

10 Sunera Thobani, "Prologue," in *Queer Necropolitics*, ed. Jin Haritaworn et al. (London: Routledge, 2014), xv–xviiii.

11 Jin Haritaworn, *Queer Lovers and Hateful Others: Regenerating Violent Times and Places* (London: Pluto Press, 2015).

12 *xtraonline*, "Ontario Premier Kathleen Wynne's Historic Speech at World Pride," *xtra* (2014), youtube.com/watch?v=b_IXd4NMfzk.

13 See also Fatima El-Tayeb, "Time Travelers and Queer Heterotopias: Narratives from the Muslim Underground," *Germanic Review: Literature, Culture, Theory* 88, no. 3 (2013): 305–19.

14 Karl Marx, *On Colonialism and Modernization*, ed. Shlomo Avineri (New York: Doubleday, 1968).

15 Sara Ahmed, *Strange Encounters: Embodied Others in Post-Coloniality* (London: Routledge, 2000).

16 Reina Gossett, "Naming Ourselves, Sharing Our Stories," *Reina Gossett Blog* (March 16, 2013), www.reinagossett.com.

17 Sherene Razack, "When Place Becomes Race," in *Race, Space, and the Law: Unmapping a White Settler Society*, ed. Sherene Razack (Toronto: Between the Lines, 2002), 5.

18 Glen Sean Coulthard, *Red Skin, White Masks: Rejecting the Colonial Politics of Recognition*, (Minneapolis: University of Minnesota Press, 2014); Cedric Robinson, *Black Marxism: The Making of the Black Radical Tradition* (Chapel Hill: University of North Carolina Press, 1983).

19 See chapters by Ahmed, Chak et al., Dadui, Robinson, Ware et al., and Williams in this book.

20 Paola Bacchetta, Fatima El-Tayeb, and Jin Haritaworn, "Queer of Colour Formations and Translocal Spaces in Europe," *Environment and Planning D: Society and Space* 33, no. 5 (2015), 775.

21 Jacqui M. Alexander, *Pedagogies of Crossing: Meditations on Feminism, Sexual Politics, Memory, and the Sacred* (Durham: Duke University Press, 2005), 190.

22 Diana Taylor, *The Archive and the Repertoire: Performing Cultural Memory in the Americas* (Durham: Duke University Press, 2003).

23 See Nguyen in Carolyn Dinshaw et al., "Theorizing Queer Temporalities: A Roundtable Discussion," *GLQ* 13, no. 2 (2007): 177–95.

24 Avery Gordon, *Ghostly Matters: Haunting and the Sociological Imagination* (Minneapolis: University of Minnesota Press, 2008).

25 See chapters by Fung and Li in this book.

26 For example, see Ramirez, in this book, and Leah Lakshmi Piepzna-Samarasinha, "Dreaming with Our Ancestors: The Asian Arts Freedom School 2004–2007," *Marvellous Grounds* 2 (forthcoming).

27 Robin D. G. Kelley, *Freedom Dreams: The Black Radical Imagination* (Boston: Beacon Press, 2002), 170.

28 Razack, "When Place Becomes Race."

29 José Muñoz, "Cruising the Toilet: LeRoi Jones/Amiri Baraka, Radical Black Traditions, and Queer Futurity," *GLQ* 13, no. 2 (2007): 353–67.

30 Elizabeth Povinelli, "The Child in the Broom Closet: States of Killing and Letting Die," *South Atlantic Quarterly* 107, no. 3 (2008): 509–30.

31 Mbembe, "The Power of the Archive and Its Limits," 21.

32 Our reflections and collection of works on QTBIPOC mapping can be found at marvellousgrounds.com, as well as in Jin Haritaworn, Ghaida Moussa, and Syrus Marcus

Ware, eds., *Queering Urban Justice: Queer of Colour Formations in Toronto* (Toronto: University of Toronto Press, 2018).

33 See SAVAC (South Asian Visual Arts Centre), "Not a Place on the Map: The Desh Pardesh Project," *SAVAC* (n.d.), savac.net/collection/desh-pardesh.

34 See also Mona Oikawa, Dionne Falconer, and Ann Dexter, eds., *Resist: Essays against a Homophobic Culture* (Toronto: Women's Press, 1994); Natasha Omise'eke Tinsley, "Black Atlantic, Queer Atlantic-Queer Imaginings of the Middle Passage," *GLQ* 14, nos. 2–3 (2008): 191–215; and Rinaldo Walcott, "Black Men in Frocks: Sexing Race in a Gay Ghetto (Toronto)," in *Claiming Space: Racialization in Canadian Cities*, ed. Cheryl Teelucksingh (Waterloo, ON: Wilfrid Laurier University Press, 2006), 121–33.

35 See Christina Hanhardt, *Safe Space: Gay Neighborhood History and the Politics of Violence* (Durham: Duke University Press, 2013); Martin Manalansan, "Race, Violence, and Neoliberal Spatial Politics in the Global City," *Social Text* 23, nos. 3–4 (2005): 141–55.

36 See also Debbie Douglas et al., eds., *Má-ka: Diasporic Juks: Contemporary Writing by Queers of African Descent* (Toronto: Sister Vision Press, 1997); Makeda Silvera, ed., *Piece of My Heart: A Lesbian of Colour Anthology* (Toronto: Sister Vision, 1991).

37 See also Tim McCaskell, *Queer Progress: From Homophobia to Homonationalism* (Toronto: Between the Lines, 2016).

38 Sunera Thobani, *Exalted Subjects: Studies in the Making of Race and Nation in Canada* (Toronto: University of Toronto Press, 2007).

39 Native Youth Sexual Health Network, Families of Sisters in Spirit and No More Silence, "Supporting the Resurgence of Community-based Responses to Violence, Native Youth Sexual Health Network" (2014), nativeyouthsexualhealth.com.

40 See also Dwyer, this book.

41 Amandeep Kaur, Rio Rodriguez, and Syrus Marcus Ware, "Interview with Syrus Marcus Ware on Church Street Mural Project," *Marvellous Grounds* 1 (2016), marvellousgrounds.com.

1 Organizing on the Corner

1 We thank Shannon Holness for transcribing this chapter.

2 This festival is formally known as *Counting Past 2: Performance-Film-Video-Spoken Word with Transsexual Nerve!*

3 *Red Lips, Cages for Black Girls*, directed by Kyisha Williams (Toronto: Charles Street Video, 2010).

4 Maggie's is a radical Toronto-based organization by and for sex workers. It is discussed in more detail in this chapter, but to find out more, visit their website at maggiestoronto.ca.

5 Kyle Scanlon was a long-time white trans man activist in Toronto who created ground-breaking programs for trans people at the 519 Church Street Community Centre and helped to create *Primed: A Back Pocket Guide for Trans Men and the Men Who Dig Em*, the first sexual health resource for trans gay men internationally. See Broden Giambrone et al., *Primed: The Back Pocket Guide for Trans Guys and the Guys Who Dig Em* (Toronto: AIDS Committee of Toronto, 2006).

6 *Madame Lauraine's Transsexual Touch*, directed by Monica Forrester, Viviane Namaste, and Mirha-Soleil Ross (Montreal: PVC Productions, 2000).

7 Christina Strang and Monica Forrester, *The Happy Transsexual Hooker* (Toronto: The 519 Church Street Community Centre, 2000).

2 It Was a Heterotopia

1 We thank Kelly Lui for transcribing this interview.

2 Gerald Chan, "Out of the Shadows," *Asianadian* 2, no. 1 (1979): 10–12.

3 *Orientations: Lesbian and Gay Asians*, directed by Richard Fung (Toronto: Richard Fung, 1984).

4 *Re:orientations*, directed by Richard Fung (Toronto: Richard Fung, 2016).

5 For more on the *Asian Arts Freedom School*, see Leah Lakshmi Piepzna-Samarasinha, "Dreaming With Our Ancestors: The Asian Arts Freedom School, 2004–2007," *Marvellous Grounds* 2 (2017), marvellousgrounds.com.

6 *Chinese Characters*, directed by Richard Fung (Toronto: Fungus Production, 1986).

7 *Forbidden Love: The Unashamed Stories of Lesbian Love*, directed by Lynne Fernie and Aerlyn Weissman (Montreal: National Film Board of Canada, 1992).

3 Power in Community

1 We thank Guillermo Martinez de Velasco for transcribing the interview with Alan Li, conducted by Jin Haritaworn with Rio Rodriguez that formed the basis of this chapter.

2 *Orientations: Lesbian and Gay Asians*, directed by Richard Fung (Toronto: Fungus Production, 1984).

3 Gay Asians Toronto, *CelebrAsian: Shared Lives. An Oral History of Asians* (Toronto: Gay Asians Toronto, 1996).

4 *Fighting Chance*, directed by Richard Fung (Toronto: Fungus Production, 1990).

4 Loud and Proud

1 Radclyffe Hall, *The Well of Loneliness* (London: Wordsworth Editions, 2005).

2 Carol Camper, *Miscegenation Blues: Voices of Mixed-Race Women* (Toronto: Sister Vision, 1994).

5 Speaking Our Truths, Building Our Futures

1 See also Rahim Thawer, "Defending Uncritical Art Has Consequences," *Marvellous Grounds* 2 (2017), marvellousgrounds.com.

2 See also Gabriela "Rio" Rodriguez, "Mapping 2SQTBIPOC Toronto" (master's major portfolio, York University, 2016).

7 Cops Off Campus!

1 The City of Toronto defines "priority neighbourhoods" (also known as neighbourhoods where Black people and people of colour live) as those that are "falling below the Neighbourhood Equity Score and requiring special attention."

2 Jim Rankin and Patty Winsa, "Known to Police: Toronto Police Stop and Document Black and Brown People Far More than Whites," *The Star* (Toronto), March 9, 2012.

8 Migrant Sex Work Justice

1 Some of the Toronto-based organizations that we have worked in solidarity with include Butterfly, STRUT, No One is Illegal – Toronto, and Maggie's: The Toronto Sex Workers Action Project.

2 See Audacia Ray, "Why the Sex Positive Movement Is Bad for Sex Workers," *Feministe*, April 20, 2012, feministe.us.

3 For example, in the largest sex work online magazine *Tits and Sass*, there has not been a single news item addressing migrant sex workers since the magazine was founded in 2011.

4 Kamala Kempadoo and Darja Davydova, eds., *From Bleeding Hearts to Critical Thinking: Exploring the Issue of Human Trafficking* (Toronto: Centre for Feminist Research, 2012).

5 torontopolice.on.ca/sexcrimes/htet.php.

6 UN General Assembly, "Protocol to Prevent, Suppress and Punish Trafficking in Persons, Especially Women and Children, Supplementing the United Nations Convention Against Transnational Organized Crime," GA res 55 (2000), ohchr.org.

7 This point may seem obvious, but it is quite vociferously debated. If there is any abuse in a sex work context, the UN views consent as "irrelevant." What constitutes abuse is defined by authorities, not sex workers. In many cases, typical conditions for working-class jobs have been defined as abusive and therefore as evidence of trafficking, nullifying the sex worker's consent.

8 Employment sectors that face high rates of exploitation, force, and abuse of migrants include agriculture, food processing, live-in caregiving, and restaurant/service industry work. For example, see CBC News, "B.C. Man Guilty of Trafficking Nanny Gets 18 Months," *CBC News* (British Columbia), October 15, 2013.

9 See Citizenship and Immigration Canada, "Operational Bulletin 449: Work Permit Applications for Temporary Foreign Workers for Businesses in Sectors Where There Are Reasonable Grounds to Suspect a Risk of Sexual Exploitation of Some Workers," *CIC* (2012), cic.gc.ca. This bulletin is only one part of the extensive series of policies barring even legal sex work for migrants to Canada, ostensibly for their own "protection."

10 Kimberly Mackenzie and Alison Clancey, "(Im)migrant Sex Workers, Myths and Misconceptions: Realities of the (Anti)-Trafficked," *Swan Vancouver* (2015), swanvancouver.ca, 17.

11 No One Is Illegal – Toronto, "Often Asking—Always Telling: The Toronto Police Service and the Sanctuary City Policy," *Rabble*, November 2015, rabble.ca.

12 For the current Canadian legislation, where managing sex work is criminalized, see "Protection of Communities and Exploited Persons Act," *Justice Laws Website* (2014), laws-lois.justice.gc.ca.

13 Nicholas Keung, "Undocumented Immigrants: Toronto May Be a 'Sanctuary City,' But Agencies Still Ask about Status," *The Star* (Toronto), August 8, 2013.

14 See Frédérique Chabot, "RAW Groups Upset over Massage Parlour Raids," *CBC News* (Ottawa), May 11, 2015; Metro News, "Deportation of Migrant Women Increases Victimization, Says Sex Workers' Group," *Metro News* (Toronto), May 11, 2015.

9 Queer and Trans Migration and Canadian Border Imperialism

1 For an excellent overview of Canadian border imperialism, see Harsha Walia, *Undoing Border Imperialism* (Oakland: AK Press, 2013).

2 There is now a growing literature on homonationalism and gay imperialism, e.g., Jin Haritaworn, *Queer Lovers and Hateful Others: Regenerating Violent Times and Places* (London: Pluto, 2015); Jasbir Puar, *Terrorist Assemblages: Homonationalism in Queer Times* (Durham: Duke University Press, 2007); Yasmin Nair, "How to Make Prisons Disappear: Queer Migrants, the Shackles of Love and the Invisibility of the Prison Industrial Complex," in *Captive Genders: Trans Embodiment and the Prison Industrial Complex*, ed. Eric A. Stanley and Nat Smith (Oakland: AK Press, 2015), 123–39; SUSPECT, "Where Now? From Pride Scandal to Transnational Movement," *Bully Bloggers*, June 26, 2010, bullybloggers.wordpress.com.

3 Much of the following information is drawn from activist publications such as No One Is Illegal – Vancouver, "Commemorating 100 years of the Komagata Maru," *Rabble*, May 23, 2014, rabble.ca.

4 Another excellent source on the *Komagata Maru* incident that this chapter draws on is the following documentary, which is available on youtube.com: *Brown Canada: A Continuous Journey*, directed by Ali Kazimi (Toronto, 2004).

5 Michael Bird, "Behind the Komagata Maru's Fight to Open Canada's Border," *Globe & Mail*, May 24, 2014; Khalsa Diwan Society, "Continuous Journey," *Khalsa Diwan Society* (2004), kdsross.com.

6 Walia, *Undoing Border Imperialism*.

7 Calgary Chinese Cultural Centre, "A History of Exclusion," *Calgary Chinese Cultural Centre*, 2004, culturalcentre.ca.

8 "The Chinese Experience in BC: 1850–1950. Immigration: 1907 Riots," The University of British Columbia Library (n.d.), library.ubc.ca.

9 Chuck Davis, "Komagata Maru," *The History of Metropolitan Vancouver* (n.d.), vancouverhistory.ca.

10 Faisal Kutty, "How Harper Sows Fear of Muslims in Pursuit of Votes," *Huffington Post* (Canada), September 9, 2015.

11 CBC News, "Tamil Migrants: 'We Are Not Terrorists,'" *CBC News*, August 16, 2010.

12 Citizenship and Immigration Canada, "Sponsor Your Parents and Grandparents," *CIC* (n.d.), cic.gc.ca.

13 Gordon Brent Ingram, "Returning to the Scene of the Crime: Uses of Trial Dossiers on Consensual Male Homosexuality for Urban Research, With Examples from Twentieth-Century British Columbia," *GLQ: A Journal of Gay and Lesbian Studies* 10, no. 1 (2003): 77–110.

14 Fatima Jaffer, "Homonationalist Discourse, Queer Organizing and the Media," *Ideas* (2012), ideas-idees.ca.

15 Haritaworn, *Queer Lovers and Hateful Others.*

16 For further information on Two-Spirit identities, see *Two Spirit People*, directed by Michel Beauchemin, Lori Levy, and Gretchen Vogel (San Francisco: Frameline, 1991).

17 Katherine McKittrick, *Demonic Grounds: Black Women and the Cartographies of Struggle* (Minneapolis: University of Minnesota Press, 2006). On "benevolence" as a value of Canadian nationalism, see Sherene Razack, *Dark Threats and White Knights: The Somalia Affair, Peacekeeping, and the New Imperialism* (Toronto: University of Toronto Press, 2004).

18 According to the UN High Commissioner for Refugees, the top six host countries in 2014 were Turkey, Pakistan, Lebanon, Iran, Ethiopia, and Jordan. See United Nations High Commissioner for Refugees, "UNHCR Global Trends: Forced Displacement in 2014," *UNHCR* (2014), unhcr.org/556725e69, 2.

19 Nooshin Khobzi Rotondi, "Depression in Male-to-Female Transgender Ontarians: Results from the Trans PULSE Project," *Canadian Journal of Community Mental Health* 34, no. 1 (2012): 31–44.

20 See also research done by Trans Pulse at transpulseproject.ca.

10 Queer Circuits of Belonging

1 All names and some personal details have been changed for privacy reasons.

2 See also Ramirez, in this collection, and Rio Rodriguez, "Mapping Collective History," *Marvellous Grounds 1*, September 15, 2016, marvellousgrounds.com.

12 Toronto Crip City

1 I first saw the term Sick and Disabled Queer and Trans People of Color in use in the SDQTPOC Facebook group, founded by sick and disabled QTPOC in 2011.

2 Eli Clare, *Exile and Pride* (Cambridge: South End Press, 1999).

3 white supremacist capitalist colonialist ableist patriarchy.

4 For more information about Jim, an obituary is available at kersplebedeb.com/posts/jim-campbell-remembered/. It includes a reprint of "Fifteen Years of *Bulldozer* and More: The Personal, the Political, and a Few of the Connections", from *Prison News Service*, 1995," and links to other articles about Jim and PNS.

5 For an academic article about Psych Survivor Day, see Lilith Finkler, "Psychiatric Survivor Pride Day: Community Organizing with Psychiatric Survivors," in "Special Issue on Parkdale Community Legal Services," *Osgoode Hall Law Journal* 35, nos. 3/4 (Fall/Winter 1997): 763–72.

6 For detailed articles, posts and info about CCA see creatingcollectiveaccess.wordpress.com.

7 Patty Berne, personal conversation (2013).

8 billie rain, "Multiple Chemical Sensitivities (MCS) Accessibility Basics," *Dual Power Productions* (2011), dualpowerproductions.com.

9 Building Radical Accessible Communities Everywhere, "So If the Bathroom in a Space You Throw Events in Isn't Wheelchair Accessible, What Are You Going to Do?" *Radical Access Mapping Project* (2013), radicalaccessiblecommunities.wordpress.com.

13 Healing Justice

1 For a history of some of these spaces, see "Healing Justice Practice Space—Our Legacy," *Just Healing* (n.d.), justhealing.wordpress.com.

14 A Love Letter to These Marvellous Grounds

1 Shaunga Tagore, "A Slam on Feminism in Academia," in *Feminism for Real: Deconstructing the Academic Industrial Complex*, ed. Jessica Yee (Ottawa: Canadian Centre for Policy Alternatives, 2011), 37–42.

2 See Ramirez, this book.

3 See Leah Lakshmi Piepzna-Samarasinha, "Dreaming With Our Ancestors: The Asian Arts Freedom School, 2004–2007," *Marvellous Grounds* 2 (2017), marvellousgrounds.com.

4 See more about ILL NANA's programming at illnanadcdc.com.

5 See more about Unapologetic Burlesque at unapologeticburlesque.weebly.com.

15 Race, Faith, and the Queering of Spirituality in Toronto

1 Liza Rankow, *Nearer than Breathing: Toward a Theology of Unification* (Cincinnati: Union Institute and University, 2004), 22.

2 Ernest Holmes, *The Science of Mind: A Philosophy, A Faith, A Way of Life* (New York: Penguin Putnam, 1926).

3 www.stlawu.edu/gallery/education/f/09textiles/adinkra_symbols.pdf.

4 Walt Whitman, *Walt Whitman's Leaves of Grass: The First (1855) Edition* (New York: Penguin Books, 2005), 14.

16 Creating Community and Creating Family

1 See also Ahmad, this book.

17 The Mourning Dress

1 Arlene Eisen, "Operation Ghetto Storm: 2012 Annual Report on the Extrajudicial Killings of 313 Black People by Police, Security Guards and Vigilantes," *Malcom X Grassroots Movement* (2012), mxgm.org.

2 Mitch Kellaway and Sunnivie Brydum, "These Are the Trans Women Killed So Far in the U.S. in 2015," *The Advocate*, July 27, 2015.

3 See also Ahmad, this book.

Contributors

Asam Ahmad is a poor, working-class writer, poet, and community organizer. His writing tackles issues of power, race, queerness, masculinity, and trauma. His writing and poetry have appeared in *CounterPunch*, *Black Girl Dangerous*, *Briarpatch*, *Youngist* and *Colorlines*. His first book of essays is forthcoming from Between the Lines. He lives in Tkaronto.

nisha ahuja is an actor, physical theatre creator, writer, singer/songwriter, and art, wellness, and justice educator/facilitator. She is dedicated to dissolving the boundaries between art, traditional/ancient medicines, spirituality, and politics. nisha shares Attmic Energy Medicine, Reiki, Holistic Yogic sessions, and Ayurveda wellness counselling and therapies. She has performed and created classical, contemporary, and original work across Canada, the United States, the Netherlands, and India, including with Canada's National Arts Centre's 40th Anniversary Resident Acting Company. She is a published playwright. Her publications include *Cycle of a Sari* (*Refractions: Solo*, Playwright Canada Press), *Un-Settling* (*Canadian Theatre Review*) and *30 People Watching* (Sense Publishers). Her artist residencies include Buddies in Bad Times, Canadian Stage, Cahoots Theatre, Tejal Shah's The Balacao (Goa, India) and Pattio Taller (Puerto Rico).

Tings Chak is an activist and artist, trained in architecture, whose work draws inspiration from and contributes to the migrant justice and internationalist working-class movements of which she is a part. Her graphic novel, *Undocumented: The Architecture of Migrant Detention* (2017), explores the role of architecture in the control of migrant bodies and the politics of visual representation. She is currently based in South Africa, contributing to popular political education projects and crafting designs towards a socialist future. tingschak.com. IG: @thingswithouttheh

Kusha Dadui works at Sherbourne Health Centre as the trans program co-ordinator. He is a trans masculine person of colour from Iran who came to Canada as a political refugee with his family about twenty years ago. He has presented his work on queer migration and homonationalism in the asylum system at various major conferences, including American Studies Association and Rainbow Health Ontario, alongside key thinkers and activists such as Sherene Razack, Pamela Palmater, and Yusra K. Ali. He is on the advisory boards of the Ontario Centre for Agencies Serving Immigrants and Outburst. Kusha has been involved in the LGBTQ community for fifteen years, including in numerous campaigns to support queer and trans refugees and newcomers.

Audrey Dwyer is a queer artist of Jamaican descent. Her acting work includes *One Thing Leads to Another*, which was produced by Young People's Theatre. She won Outstanding New Play and Outstanding Ensemble at the Dora Mavor Moore Awards in 2016. She was in the Royal Manitoba Theatre Centre's *Good People*, *thirsty* at the National Arts Centre,

Mirvish Productions and Studio 180's *Clybourne Park* and *The Overwhelming*, and has starred in Obsidian Theatre's *Black Medea*. Her play *Calpurnia*, for which she won the Cayle Chernin Award for Theatre, is on "The 49," a list of groundbreaking plays written by Women of Colour. Audrey directed the world premiere of *Calpurnia* at Buddies in Bad Times in 2018 to critical acclaim. It was co-produced by Sulong Theatre and Nightwood Theatre. Playwrights Canada Press will publish *Calpurnia* in 2019. She was nominated for a Dora Mavor Moore Award for Outstanding Direction for *The Apology*, which was about polyamory and Mary Shelley. She has been nominated twice for the Pauline McGibbon Award for Directing. She was the Associate Artistic Director of Nightwood Theatre. She graduated from the National Theatre School in 2001.

Monica Forrester is a transgendered woman of colour born and raised in Toronto. She has been a part of the LGBTTQ community for twenty years and has advocated for awareness and visibility of trans women in Canadian society. For the past ten years, she has been working with the 519 Church Street Community Centre to help low-income women sex workers and to bring more visibility to agencies that trans women access. She produces a bi-monthly zine called *Trans Pride Toronto*, which fosters a connection for trans-identified people within the community and abroad. Forrester has been an important educator within the Fred Victor Centre, an important resource for people who provide housing, such as landlords and nonprofit housing organizations, as well as a supportive touch-point in the lives of many transgendered and transsexual women who are seeking housing. She believes in her work in advocating for the trans community because gaining acceptance, tolerance, and equality is very important to this community that has a lot to offer in mainstream society.

Richard Fung is a Toronto-based video artist and cultural critic. He is a professor in the Faculty of Art at OCAD University. His work touches on subjects ranging from the role of the Asian male in gay pornography to colonialism, immigration, racism, homophobia, AIDS, and his own family history. His tapes, which include *My Mother's Place* (1990), *Sea in the Blood* (2000), *Dal Puri Diaspora* (2012) and *Re:Orientations* (2016), have been widely screened and collected internationally. His essays have been published in many journals and anthologies, and he is the co-author with Monika Kin Gagnon of *13: Conversations on Art and Cultural Race Politics* (2002). Richard's honours include the 2015 Kessler Award for substantial contribution to LGBTQ studies and the 2000 Bell Canada Award for lifetime achievement in video art.

Chanelle Gallant is a writer, trainer, and long-time organizer in sex work and racial justice movements. She is the co-founder of the Migrant Sex Workers Project, and her writing has appeared in *MTV news,* the *Walrus,* the *Rumpus, spread Magazine,* and various anthologies. She lives in Toronto on the traditional territories of the Mississauga of New Credit First Nation, Huron-Wendat and Haudenesaunee Confederacy, and is working on her first book, an exploration of sex as labour. Find her at @femmeifest or chanellegallant.com

Lamia Gibson is one of the owners of Six Degrees, a community acupuncture clinic that offers Traditional Chinese Medicine to incredible individuals and stunning communities.

They love working with fellow justice seekers and helping them restore balance in their lives through food and movement, following the principle that everyone deserves good health care, and that universal Qi is constantly flowing and is best moved or nourished when our whole self is welcomed into the healing. Being trans, mixed (British/Turkish), a parent, and a griever, they are aware of the deep need for us all to be seen and heard, especially when accessing health care.

Jin Haritaworn is associate professor of Gender, Race, and Environment at York University in Toronto, Canada. They have authored multiple publications, including two books, several articles (in journals such as *GLQ*, *Sexualities* and *Society & Space*), and six co-edited collections, which are read and taught on both sides of the Atlantic. Their latest book *Queer Lovers and Hateful Others: Regenerating Violent Times and Places* (Chicago University Press, 2015), on queer Berlin, addresses both academic and nonacademic readerships interested in queer of colour spaces and communities. Jin has keynoted in several established fields on both sides of the Atlantic, including gender, sexuality, and transgender studies, critical race and ethnic studies, and urban studies, and has made foundational contributions to several debates, including on gentrification, homonationalism, intersectionality, queer space, and transnational sexuality studies.

Pauline Sok Yin Hwang is a community organizer and Chinese medicine practitioner who focuses on care for caregivers and changemakers using herbs, nutrition, self-care coaching, acupuncture, massage, meditation, and workshop facilitation. She works from an anti-oppressive, queer- and trans-positive, trauma-informed, whole-person-centred, facilitative approach, supporting people to listen to and transform their relationship with their body, mind, and spirit. She organizes events making connections among social and environmental injustice, systemic oppression, trauma, interpersonal violence, anxiety, depression, burnout, and other physical health experiences. She is a budding researcher in traditional Chinese medicine who connects individuals to their environments and re-balances "patient-provider" power by freely sharing information and resources for people to understand and manage their own health.

LeZlie Lee Kam identifies as a world majority, Brown, Trini, Carib, callaloo, differently-abled, queer DYKE Elder. She advocates for Indigenous and queer people of colour. She currently volunteers for Bridgepoint Active Healthcare, participated in the Youth/Elders Project and currently in the Youth/Elders Initiative at Buddies, and is a member of the Senior Pride Network, community co-chair of NSAC for EGALE, a volunteer trainer with the 519, and a long-time volunteer for ImagineNATIVE. She sits on the Ministry of Seniors Affairs Liaison Committee, the Aging Without Violence Advisory Committee for OAITH and the Ministry of Community and Social Services, PCAT for MOHLTC, the VHA CCAC, and LGBTQ advisory committees. She lives her life from an intergenerational/anti-oppression perspective which "colours" her view of the world. She enjoys soca, dim sum, coconut water, and a hot "lime" anytime.

Elene Lam (LLB, LLM, BSW, MSW) is founder and director of Butterfly (Asian and Migrant Sex Workers Support Network in Canada) and co-director of the Migrant Sex Workers Project in Toronto. She has been involved in sex work, gender, migrant, and labour

movements for almost twenty years. She is earning a PhD in social work at McMaster University. She is also a trainer on gender equality, sexual health, and human rights.

Alan Li (MD) is an immigrant from Hong Kong, a Toronto-based physician, a community organizer, and a human rights activist. Since the early 1980s, he has been the driving force behind Gay Asians Toronto. He is the founder of the Asian Community AIDS Services, the multicultural Coalition against Homophobia, and the Committee for Accessible AIDS Treatment. In 1986, he co-founded the 10% Club, the first registered gay community organization in Hong Kong. He was the first openly gay National President of the Chinese Canadian National Council, an advocacy organization with thirty chapters across Canada. As a physician, he has served many people with HIV/AIDS at Casey House Hospice as well as many marginalized populations at Regent Park Community Health Centre.

David Lewis-Peart is an alumnus of York University whose graduate work focused on community interventions, evaluation, and sexual minority Black youth. A trained human services counsellor, David has worked in frontline social services for a decade, receiving the TD Canada LGBT Youthline Award for Outstanding Achievement in Social Services, a commemoration at Toronto Tourism's Northern Lights: African-Canadian Stories Exhibit, and a "Vital People" award by the Toronto Community Foundation. In 2012 David presented at the inaugural TEDx Conference at OCAD University on his concept of the prophetic performance for those living in the peripheries. David is an ordained minister and student of *A Course in Miracles* and was the co-ordinating minister of Sunset Service Toronto Fellowship, a spiritual-arts community he co-founded in 2012. An emerging writer, David has contributed to such publications as *Huffington Post Canada*, *Black Girl Dangerous*, and *ByBlacks.com*.

Ghaida Moussa is a doctoral candidate in the Social and Political Thought program at York University, where she interrogates how gendered, racial, and neoliberal regimes of knowledge inform our understanding of chronic unidentified illness. She was awarded the 2010 Lambda Foundation for Excellence Award for her master's work at the University of Ottawa on queer Palestinian resistance to oppressive national, colonial, and neocolonial narratives. Her poems "Ghourbeh" and "Tazakar" have appeared in *Sinister Wisdom*. She is, with Ghadeer Malek, the co-editor of *Min Fami: Arab Feminist Reflections on Identity, Space, and Resistance* (Inanna Publications). Along with Shaista Patel and Nishant Upadhyay, she is also co-editor of the recent *Feral Feminisms* special issue "Complicities, Connections, and Struggles: Critical Transnational Feminist Analysis of Settler Colonialism."

Leah Lakshmi Piepzna-Samarasinha is a queer disabled femme writer, performance artist, and educator of Burgher/Tamil Sri Lankan and Irish/Roma ascent. The author of the Lambda Award-winning *Love Cake*, *Dirty River*, *Bodymap*, and *Consensual Genocide* and co-editor with Ching-In Chen and Jai Dulani of *The Revolution Starts at Home: Confronting Intimate Violence in Activist Communities*, her writings on femme of colour and Sri Lankan identities, survivorhood, and healing, disability, and transformative justice have been widely anthologized. She is the co-founder of Mangos With Chili, North America's touring queer and trans people of colour cabaret, a lead artist with the disability

justice incubator Sins Invalid, and co-founder of Toronto's Asian Arts Freedom School. In 2010 she was named one of the Feminist Press 40 Feminists Under 40 Shaping the Future. She lives between Toronto, unceded Three Fires Confederacy Territories and Seattle, unceded Duwamish territories.

Aemilius "Milo" Ramirez is an accomplished artist, community organizer, and entrepreneur whose life's work redefines gender on multiple intersections of race, mental health, and trans/nonbinary life experience. Milo is the founder of Colour Me DRAGG, a formative 2SQTBIPOC space and cabaret-style showcase in Toronto (2006–2011). Having stepped away from the stage for the last couple of years, after a decade involved in Queer/Trans performance and theatre spaces, Milo begins their next chapter as performance artist innovatively bringing their passion for food making and love of performance together. They envision creating work that speaks to diaspora identity, Peruvian Indigeneity, and uncovering ancestral knowledge.

Nadijah Robinson is a Toronto-based artist and educator working in the media of collage, painting, performance, and installation. She received her BFA from the University of Ottawa and a BEd from OISE University of Toronto. Her work refuses the premise of a white canvas, or a blank slate, and instead uses found fabrics, images, and other materials as a way to reflect how no thing comes from nothing. Nadijah's work archives the stories of communities in which she is strongly rooted, and which are not often represented in conventional art spaces. Her recent projects include *The Mourning Dress for Trans Black Women* featured in Pride in Toronto 2015, a mural completed as part of the Church Street Mural Project in preparation for World Pride 2014, and the curation of a photographic archive of Black musicians and entertainers from the 1930s–1970s for the Archie Alleyne Scholarship Fund. She has shown work with the Art Gallery of York University, Gladstone Hotel, Daniels Spectrum, Nia Centre for the Arts, and as part of the Mayworks Festival for Working People and the Arts.

Danielle Smith has been a practising registered massage therapist with a multi-disciplinary focus since 1996. She has built bridges between the healing arts and performing arts, with a focus on ancestral reclamation and body memory. Danielle has had apprenticeship training in the Arrivals Personal Legacy Process and has co-facilitated workshops throughout Canada, the Caribbean, and the UK. In 2013–2014 she worked with the Chocolate Woman Collective as a somatic specialist, bridging her RMT practice with her personal legacy training. She is currently a student and the resident health care practitioner at Watah Theatre in the transdisciplinary arts program, where she is developing a curriculum and teaching anatomy within a healing justice framework, along with producing performance art, following d'bi anitafrika's SORPLUSI methodology.

Shaunga Tagore is an astrologer, writer, performer, and producer. She is a proud queer, genderqueer, femme of colour cat mama and *Buffy* enthusiast. Her monthly YouTube tarot-astrology readings provide piercing insight, emotional depth, humour and empowerment for survivors, creators, weirdos, queer unicorns and anyone interested in building better worlds for themselves and each other. Her readings have been described as *the healing you didn't know you needed.* She is currently developing a play, *Letters to the Universe,*

part autobiography, part mythology and fantasy, part ancient-future memory, and part ritual. This multidisciplinary and multi-dimensional work is told through theatre, dance, video, song, poetry, and astrology. As a storyteller, Shaunga is drawn to explore themes such as survivorship, cosmic wisdom, ancestral relationships, time-travel, trauma, magic, grief, death, and rebirth.

Syrus Marcus Ware is a Vanier Scholar, visual artist, community mobilizer, educator, and researcher pursuing his PhD in the Faculty of Environmental Studies at York University. Syrus holds degrees in art history, visual studies (University of Toronto), and sociology and equity studies (OISE). In 2014, he was awarded the Slyff Fellowship/ Graduate Fellowship for Academic Distinction by York University. Syrus's research focuses on experiences of marginality and the ways that the presence of racialized, trans and disabled people can challenge "static" social environments. Syrus has authored several book chapters, journal articles, and peer-reviewed publications about disability, the diversification of museums, trans parenting and sexual health for trans MSM, including the widely cited "How Disability Studies Stays White and What Kind of White It Stays" and "Going Boldly Where Few Men Have Gone Before: One Trans Man's Experience of a Fertility Clinic and Insemination" (Sumach, 2009). In 2009, Syrus co-edited the *Journal of Museum Education* issue "Building Diversity in Museums" with Gillian McIntyre. Syrus was voted "Best Queer Activist" by *Now Magazine* (2005), was awarded the Steinert and Ferreiro Award (2012) for LGBT community leadership and activism, and was awarded the TD Diversity Award from the Toronto Arts Foundation in 2017.

Laureen (Blu) Waters is Istchii Nikamoon-Earth Song Cree/Métis/Micmac-Wolf Clan and a member of the Metis nation of Ontario. Her family is from Big River Saskatchewan, Star Blanket Reserve, and Bra'dor Lake, Cape Breton, Nova Scotia. Blu was the national caucus representative for the Toronto Urban Aboriginal Strategy for five years and is currently working at Seneca College as a traditional counsellor, a position she previously held at York University. Blu's gifts include house cleansing, giving traditional spirit names, hand drumming, songwriting, creative writing, full moon conducting and traditional teachings. She is a mother of three and a grandmother of three, a sun dancer, and a pipe carrier.

Melisse Watson is an activist, earthworker, and multidisciplinary artist utilizing performance, visual, aural, and installation art to provoke sociopolitical change and thriving imagined futures for Black and Indigenous bodies. Melisse wrote, directed, and performed in their award-winning show *I Was Born White* at the Toronto Fringe Festival in 2014. Melisse has also performed in the Summerworks Festival and the Rhubarb Festival. Melisse has presented solo and collaborative visual and performance work at the Theatre Centre, the Drake Hotel, Harbourfront Centre, Daniel Spectrum, Buddies in Bad Times Theatre, and Pride Toronto.

Alexandria Williams is an activist and artist who is earning her bachelor's degree at York University in the field of theatre. During her time as president of the York United Black's Student Alliance, she led protests addressing racial profiling on campus and created the collective Cops Off Campus. She has redirected her love for performance to a zeal for Black community advancement through art and positive recreation by becoming one

of the collective members of Black Lives Matter: Toronto Chapter, where she has helped in planning numerous protests and die-ins around the city of Toronto in order to bring attention to state-sanctioned anti-Black violence carried out by the Toronto police force. Fiercely femme and boldly Black, Alexandria is dedicated to demolishing patriarchy and the prison industry complex, and advocating for youth education and mental wellness within the Black community where ever she ends up.

Kate Zen is a community organizer from Shanghai and New York City who has previously worked with domestic workers and street vendors on advocacy for immigrant labour rights in informal sectors. She has written for *Truth Out, Mic, Tits and Sass,* and *Socialist Views.*

Index